NORTH LIGHT BOOKS
CINCINNATI, OHIO
ARTISTSNETWORK.COM

acrylicworks3

CELEBRATING TEXTURE | EDITED BY Jamie Markle

THE BEST OF ACRYLIC PAINTING

contents

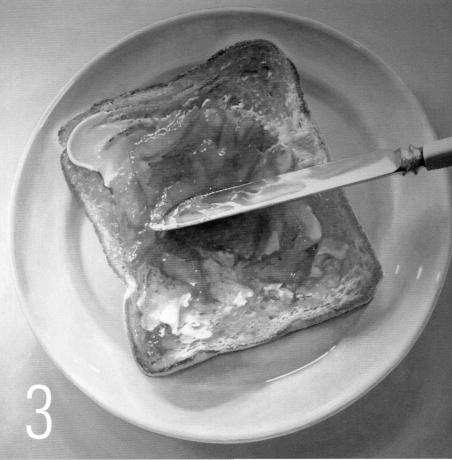

2

3

introduction

SELECTING THE ARTWORK you'll find here in *AcrylicWorks 3: Celebrating Texture* has allowed me not only to see amazing works of art, but to reflect on the theme of this year's book. One of the reasons I chose a career in publishing was so that I can spend more time with creative people, both at work and in my creative life as an artist. After years of working in product development and marketing, it's a great joy to put the skills I've honed to work for you, our community of artists.

The more paintings I viewed in the selection process for this book the more I found myself asking, what is texture really? The dictionary may define it succinctly, but let's just agree that it's a broad topic when it comes to artwork. Artists depict all kinds of objects in their work that represent the full spectrum of textures—glass, rust, water, rocks, fur, skin, feathers, clouds—the list could go on and on. To successfully capture the appearance of a physical object the artist must re-create the tactile, three-dimensional elements of that object on a flat surface. That's no small feat!

Upon whatever surface we paint the physical texture can be smooth, shiny, rough, prickly or pebbly, just to name a few results. So the word *texture* refers both to the visual illusion we're capturing and the physical reality we're creating on the painting surface. We all achieve unique results. Some painters create the illusion of texture so accurately that they fool the viewer's eye into believing that the texture they see has physical dimension upon what is actually a smooth surface. Other artists celebrate texture by leaving physical evidence of the brushstroke or knife work on the surface. And then there are the artists for whom the texture they create in a work takes greater importance than replicating the subject precisely. Of course, many artists employ a combination of these approaches.

Regardless of how we use texture, the more important point is why we use texture. Painting, any art form, is a means of communication for the artist. Artists paint what is meaningful to them, and the use of texture is one of the ways by which the artist clearly communicates with the viewer. Again, the possibilities are endless, limited only by concept, passion and skill. The artists featured here in *AcrylicWorks 3* use texture in their paintings to tell their stories. This book honors their expertise and mastery of capturing realistic texture, and gives them a platform upon which to share their perspective on the world. These paintings communicate what aroused the fascination or affection of the artist. The stories these paintings tell record a moment, share an emotion or relay a concept. Each artist is communicating his or her perception of their chosen subject to you via the use of texture and composition.

As you explore the contents of this book, I encourage you to take the time to savor the textures, both illusory and physical. Delve into the stories these artists have shared, which are as diverse as the textures and paintings within. Enjoy!

—Jamie Markle

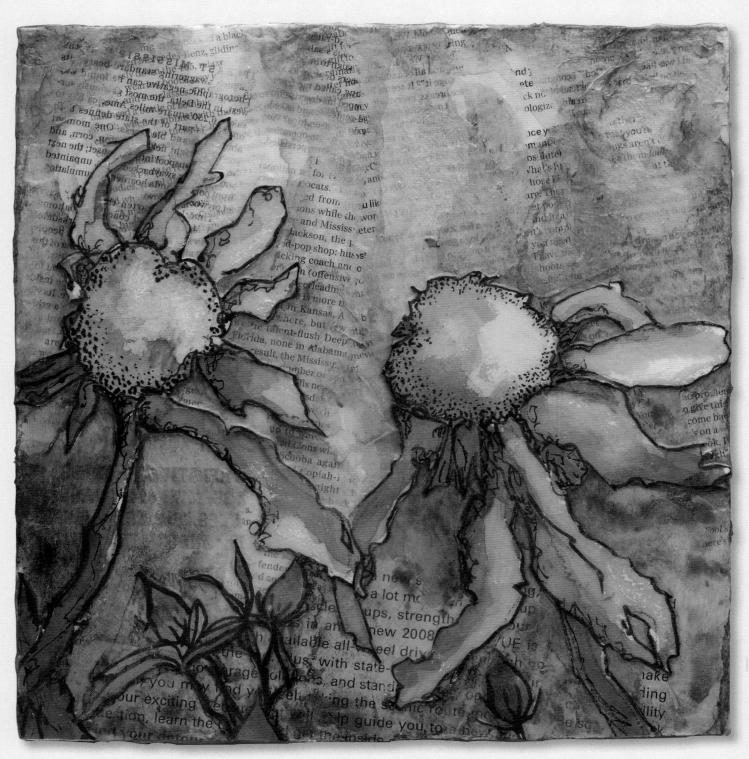

▲ UNTITLED | Jamie Markle
Acrylic and mixed media on board, 36" × 48" (91cm × 122cm)

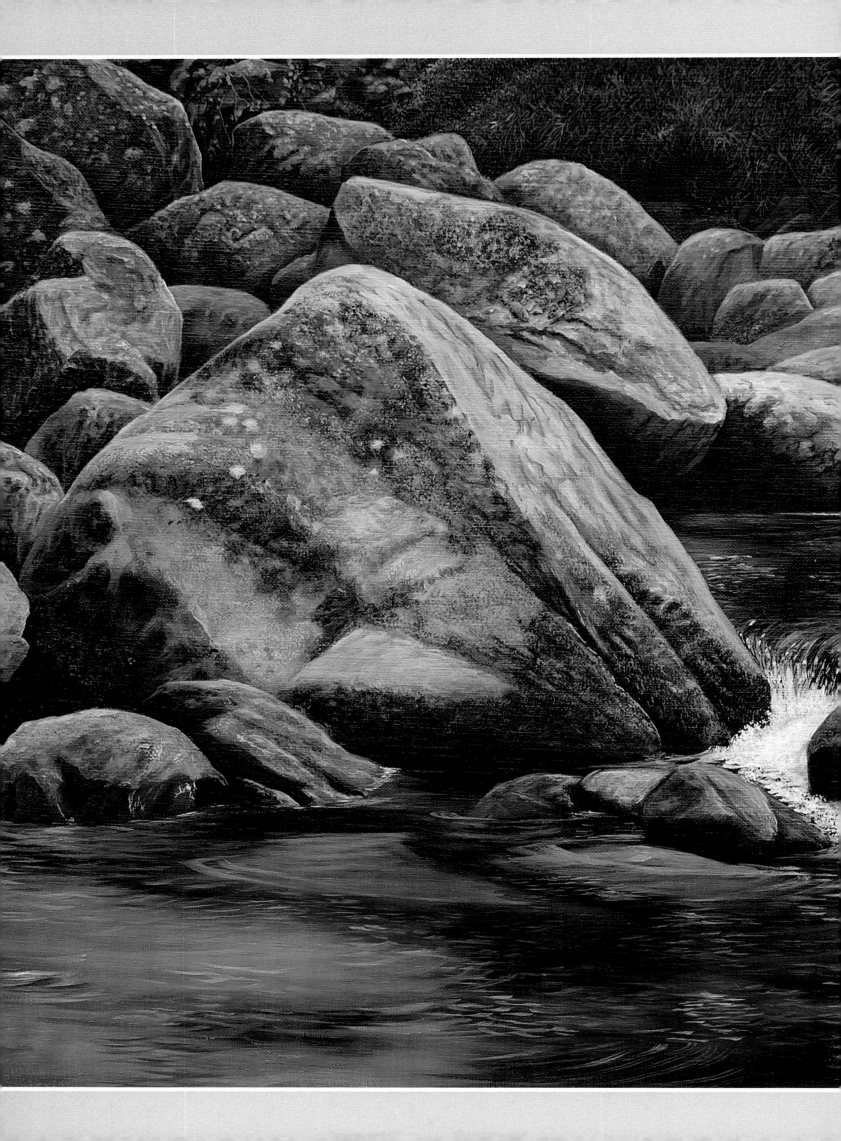

◄ **RINCON DEL RIO** | José Orlando López Molina
Acrylics on linen, 17½" × 23" (44cm × 58cm)

I paint landscapes as a way to express the love, respect
and admiration I have for my motherland, Boyacá, Colom-
bia. I take great pleasure in the personal connection I have
with my art. My art requires great patience to achieve
intricate detail with different mediums like acrylic, oil and
watercolor. I like to make sketches on location and also
take photos for painting back in the studio. I prefer to use
high-quality paints such as Atelier Interactive acrylics.

Landscapes and Scenes 1

I paint from photographs that I have taken. I use a grid pattern, do an intricate drawing, a transparent underpainting and then several layers of opaque painting. In my cityscapes, I tend to be attracted to windows and doors with a lot of reflections. I like looking at a window, seeing inside of it and seeing reflections that are actually behind the viewer, all at the same time. I also enjoy putting many abstract pieces together to create a realistic whole. Textures of glass, metal, wood, concrete and more all represent fun challenges for painting. (See page 66 to view Gratiot's piece *Swiss Candies*.)

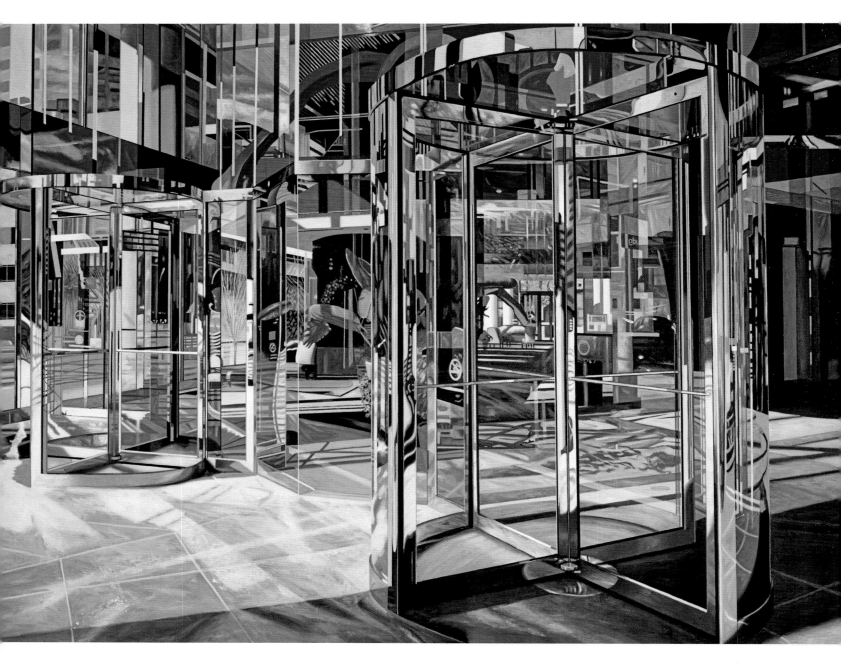

"I feel that my painting not only captures the texture of the brick on the building but also the texture of New York City."
—CATHERINE PELUSO

▶ **WASH DAY** | Catherine Peluso
Acrylic on 140-lb. (300gsm) cold-pressed Arches, 20" × 15" (51cm × 38cm)

New York City is home to an infinite amount of inspiration. When I walk or drive through the city, I am surrounded by textures of all varieties. As we were leaving New York one afternoon I spied this incredible building. I made my husband stop and out came the camera. What I loved about this building was the shadows the fire escapes created on the brick. I usually paint in either acrylic or watercolor. I chose to paint this in acrylic to capture all the incredible detail and the saturation of color.

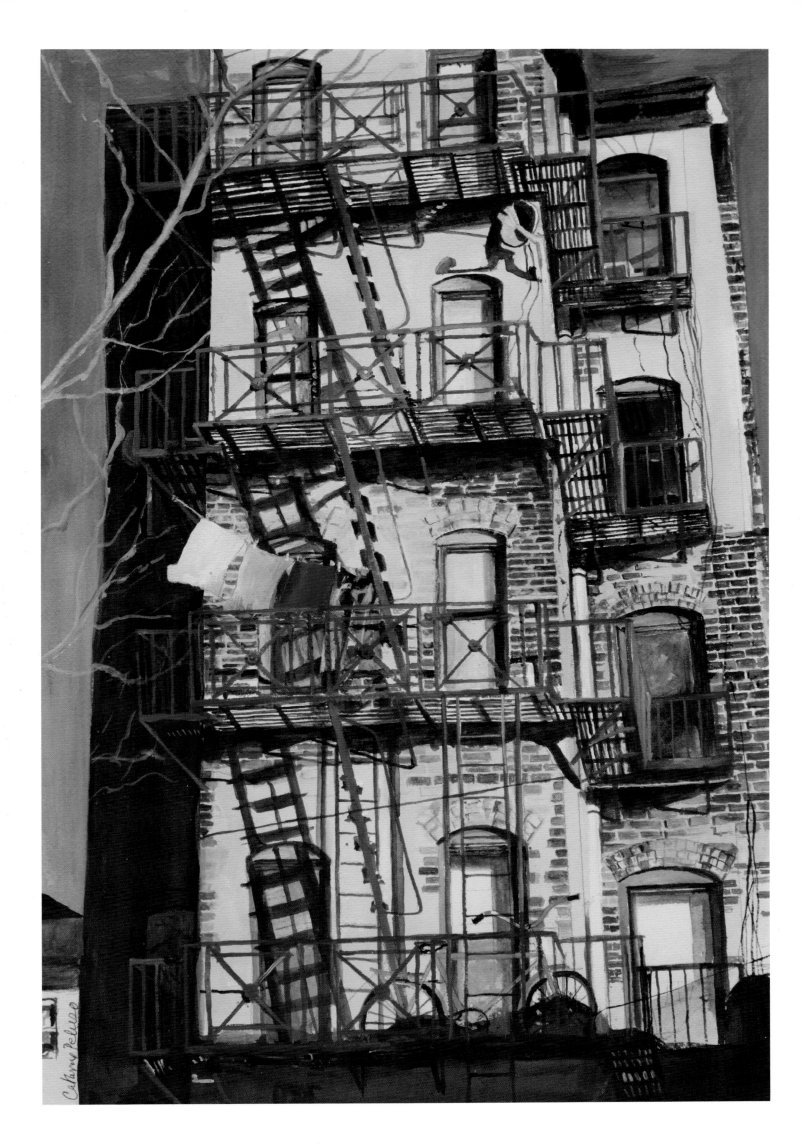

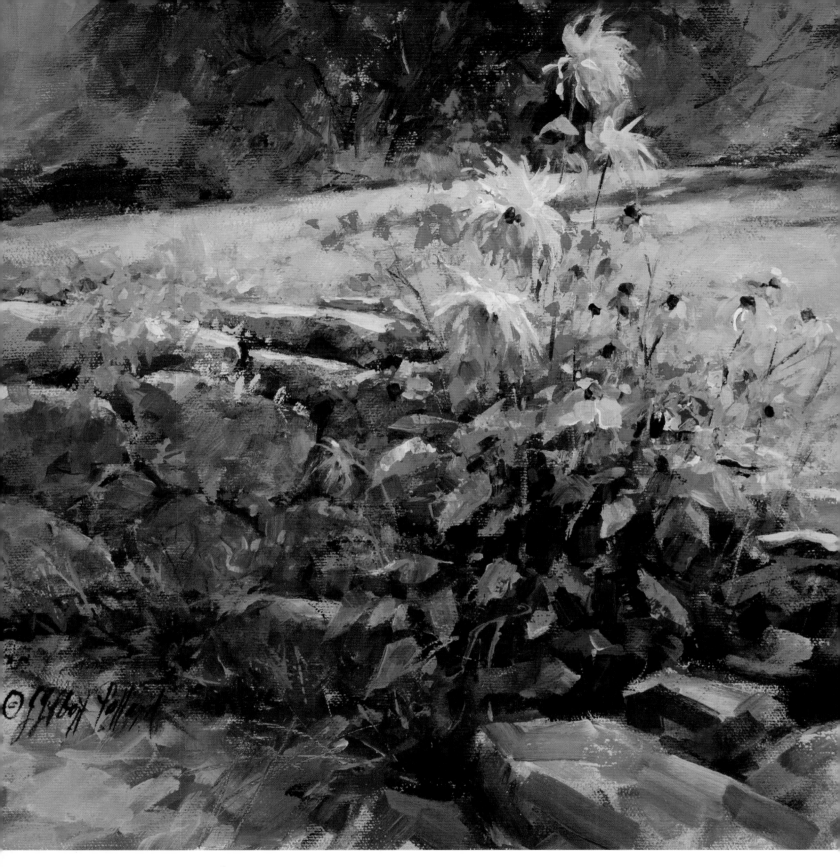

▲ **MORNING BOUQUET** | Julie Gilbert Pollard
Acrylic on canvas, 12" × 12" (30cm × 30cm)

Enchanted with this irresistible scene—a rustic retaining wall in a friend's garden, flowers cunningly sprouting from between the stones—I took numerous photos. The photos gave me shape information, but I had to invent the sunlight as I saw the scene only at dawn and dusk, both before and after the sun had passed over the valley in which this little gem lies.

Many techniques went into creating the textures seen in *Morning Bouquet*: both positive and negative painting, application of color with a palette knife as well as brushes, from wet-into-wet to drybrush to scraping into the wet paint with a dull knife point. I was careful to balance all of these techniques throughout the painting in order to maintain a unified appearance to the paint quality.

This image was painted from a macro photography shot. I captured it right in front of my studio after a freezing rainstorm. It was a challenge to reveal the almost invisible world of crystals of ice on this tiny branch that was only two to three inches (5–8cm) in actual size on a 48-inch (122cm) canvas. Acrylic is one of my favorite mediums that allows this transparency. Another challenge was to convey the shallow depth of field where just part of the image is crystal clear and the rest melting into the background. It was an amazing painting experience in capturing textures, the transparency of the small buds and the reflections of the light.

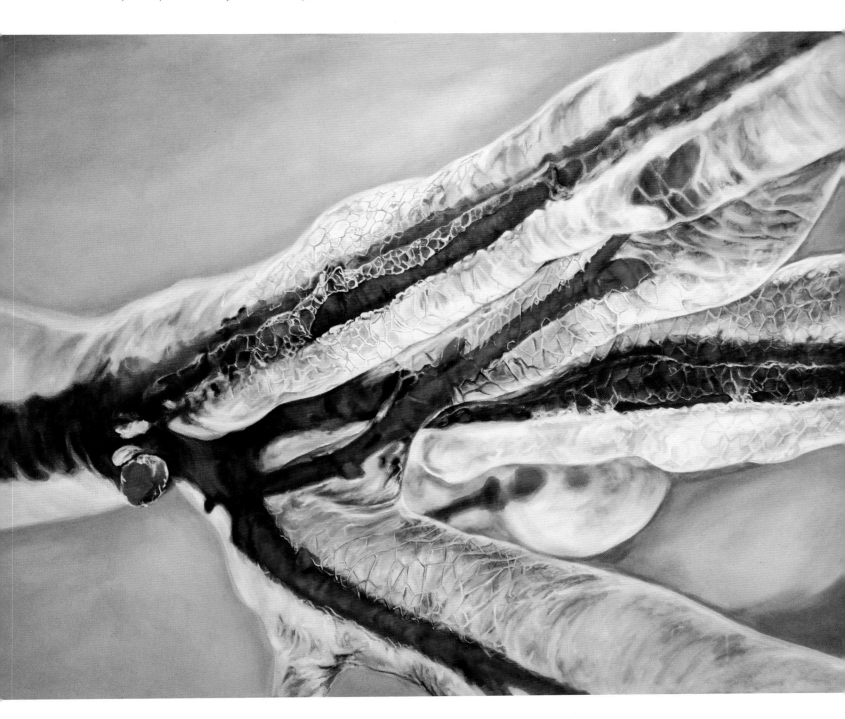

"I love to take advantage of the versatile nature of acrylic by beginning with a watercolor look and finishing with opaque oil-like passages." —JULIE GILBERT POLLARD

▼ **BEHIND CANMORE** | Brian Buckrell
Acrylic on canvas, 12" × 16" (30cm × 41cm)

Behind Canmore is a studio painting that was completed quickly and intuitively. It is one in a series exploring approaches to the region around Canmore, Alberta, mostly focusing on the Three Sisters Mountain Range under varying conditions of season and time of day. I began the piece with an underpainting of Quinacridone Violet. My intent was to be bold with my brushstrokes and lay simple strokes over the ones below. After the first lay-in of shapes and values I applied a light glaze of transparent blue-black to dull the colors and create a harmony toward neutral. I then applied opaque paint in the final layers.

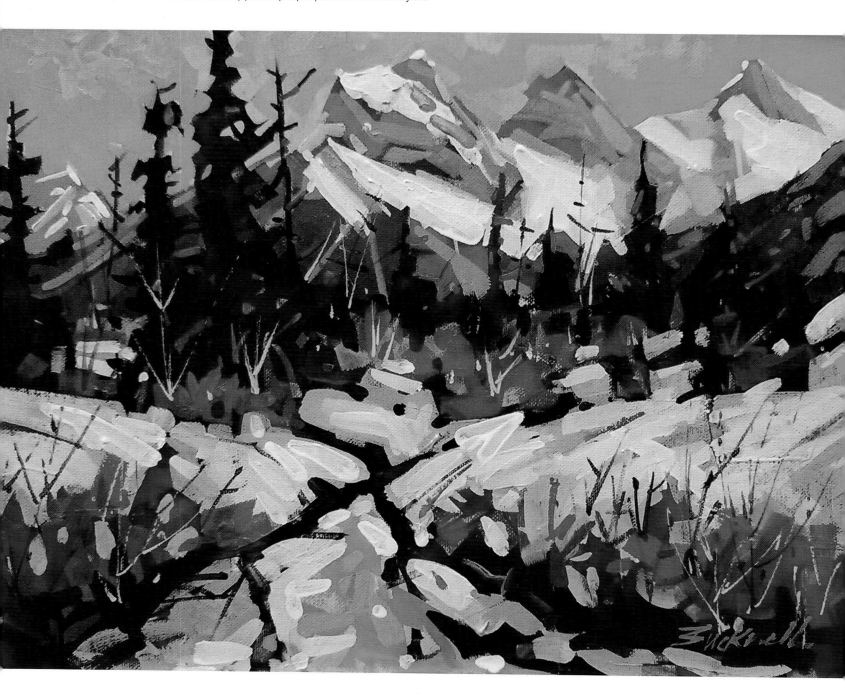

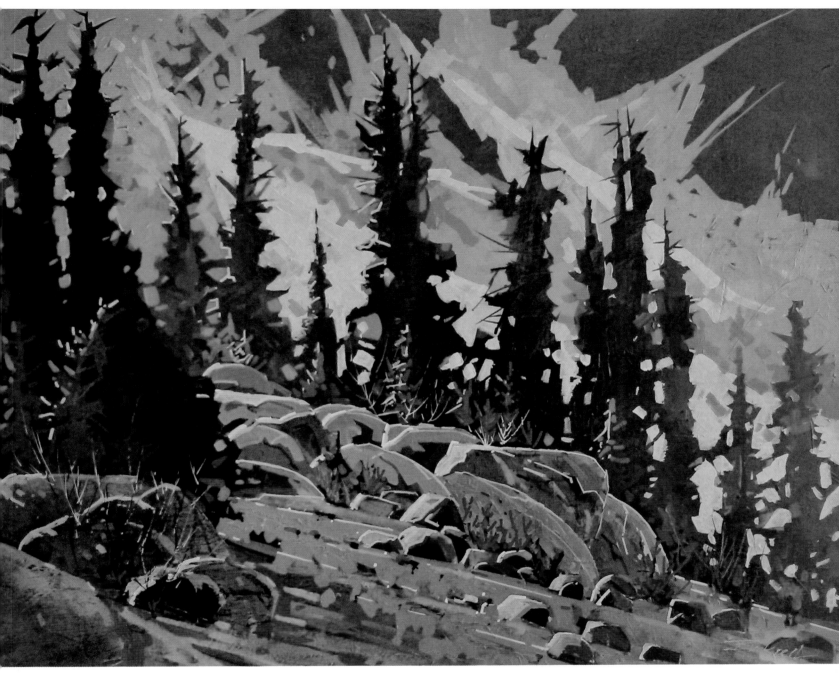

▲ **WHISTLER SLOPE** | Brian Buckrell
Acrylic on canvas, 30" × 40" (76cm × 102cm)

Whistler Slope was completed in the studio. It is one of the larger pieces completed in a series showing simple shapes, angles and colors of Whistler Mountain—all in exaggeration. It was built on an underpainting of transparent Phthalo Blue-Green. During the course of painting, I glazed the opaque strokes with Phthalo Blue and water and with Quinacridone Violet and water and rubbed vigorously. Individual strokes and dots were applied for effect without blending.

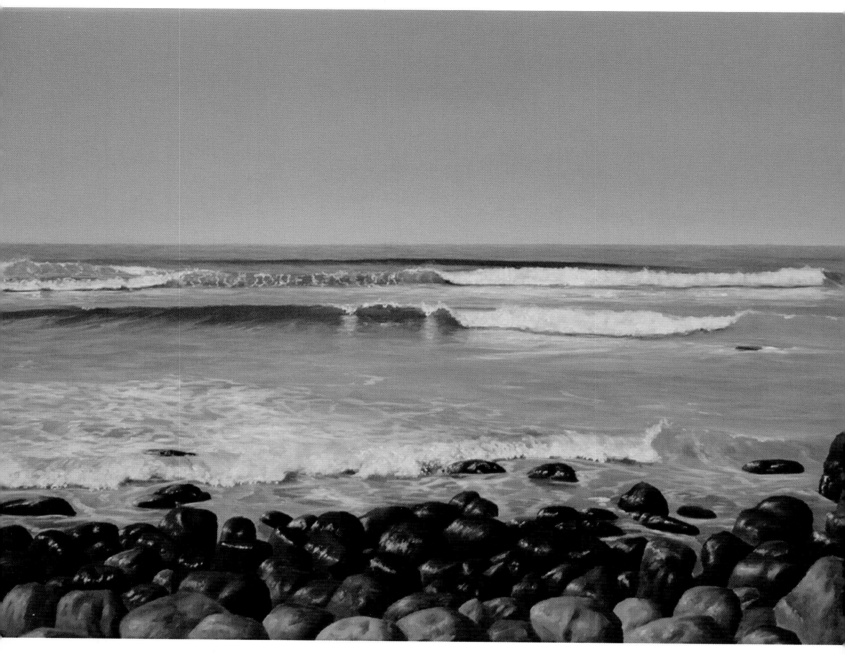

▲ **AMOR PERFEITO** | Martim Cymbron
Acrylic on canvas, 19½" × 27½" (50cm × 70cm)

I went to the beach and took a series of photos, and after selecting an image, my work outdoors was finished. I went to the studio to prepare the painting *Amor Perfeito*. The first step was to draw the main traits and pass them with an overhead projector on to the canvas. I painted the first layer very quickly with a thin ink; then after drying the paint I applied a second layer with thicker ink and with more accuracy. I painted a third layer only on the water and the foam. To paint the transparency of the water, I diluted the ink and added retardant so that the waves of water and foam appear to fade away in a realistic fashion. I am inspired by seasides as a theme because I live on a small island. The sea is all around me. I see it every day in different ways. It served as inspiration for this piece and many other artworks I've done.

▼ **ALL KNOTTED UP** | Esther Sample
Acrylic on canvas, 20" × 36" (51cm × 91cm)

On a cool winter morning, as I walked my local beaches in early light, I was struck by the sun's glow through the simple eel grass that had washed up on the shores. Light has a way of creating magical forms and shadows and it was not lost on me that morning. As I am a studio painter, I enjoy the time I have to work details into my paintings. In *All Knotted Up*, I found myself inspired by pointillism, and took the time to create the sand in this manner. It gave an unexpected new depth to my painting and brought the subject to life. The texture of the sand brings you right into the painting, allows for rich shadows and gives the grains of sand on the rocks a three-dimensional feel.

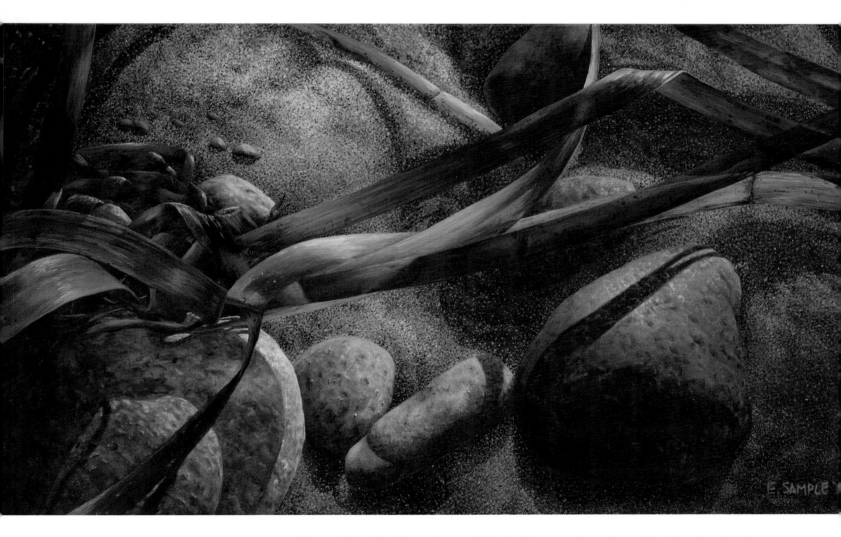

"Spending the time to work in texture and paying attention to details will help bring vibrance and life to your painting." —ESTHER SAMPLE

▼ **SURVIVOR** | Charles Frizzell
Acrylic on stretched canvas, 24" × 36" (61cm × 91cm)

A 1954 Packard, sunburned, rusting and sitting in the weeds. What caught my eye was the still bright chrome, with the mesmerizing reflections in that convoluted Art Deco grill and bumper. Acrylic, my medium of choice, was especially suited for this subject with the very dark recesses, the precise shapes and the contrasting high values. The sharp smooth edges contrast with the rusty faded paint on the auto body, while the headlights appear transparent and the turn signals clouded. A smooth gradation of the sky is tricky with acrylics, and I have found that it works best for me by starting with a moderately large pool of paint, then working from dark to light, adding lighter hues as I progress downward. Acrylic's quick drying time works well for achieving smooth gradations, hue transitions and textural details. (See page 54 to view Frizzell's piece *Albert*.)

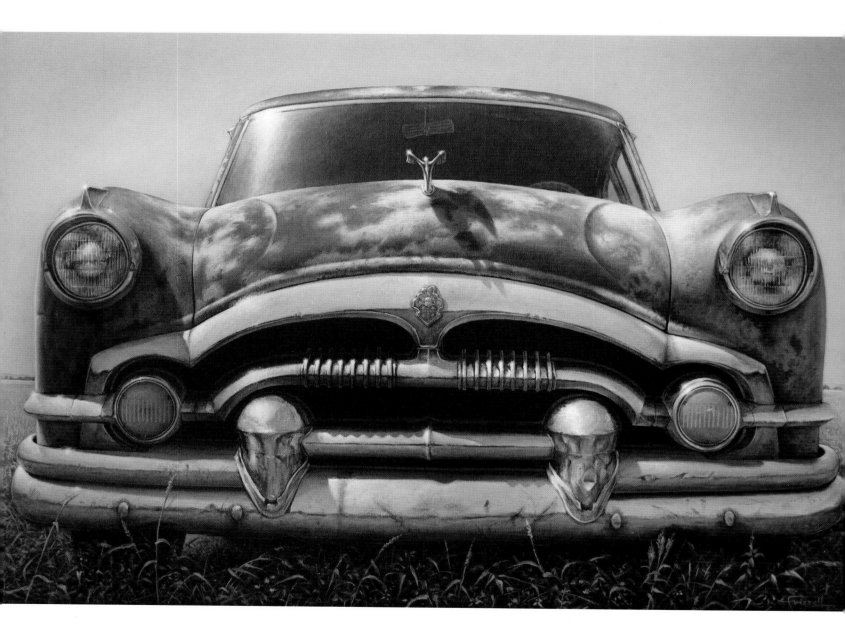

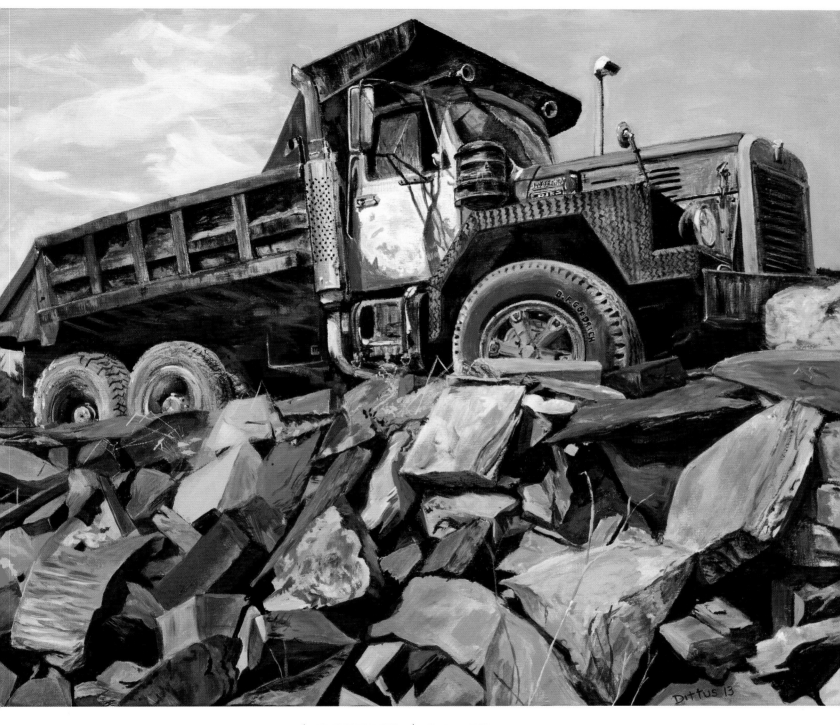

▲ **SLATE TRUCK** | Chrissey Dittus
Acrylic on canvas, 16" × 20" (41cm × 51cm)

Slate Truck was inspired from a call-to-artists by the Slate Valley Museum in Granville, New York. The theme was "Slate as Muse." As I photographed piles of slate, I found some nice images but nothing was exciting me. I was drawn to the top of the truck, but didn't like the composition. A month later we went back to the quarry and there it was parked on a drive-way looking like it was sitting on a pile of slate. Perfect! I loved how the truck looked so worn from years of hard labor. I feel the slate pile and the old truck depict the smooth yet rough textures of their makeup. My technique was to focus on the darks in the slate in order to get the right shadows and tones. I have tried many mediums but favor acrylics because of the many colors available and ease of use.

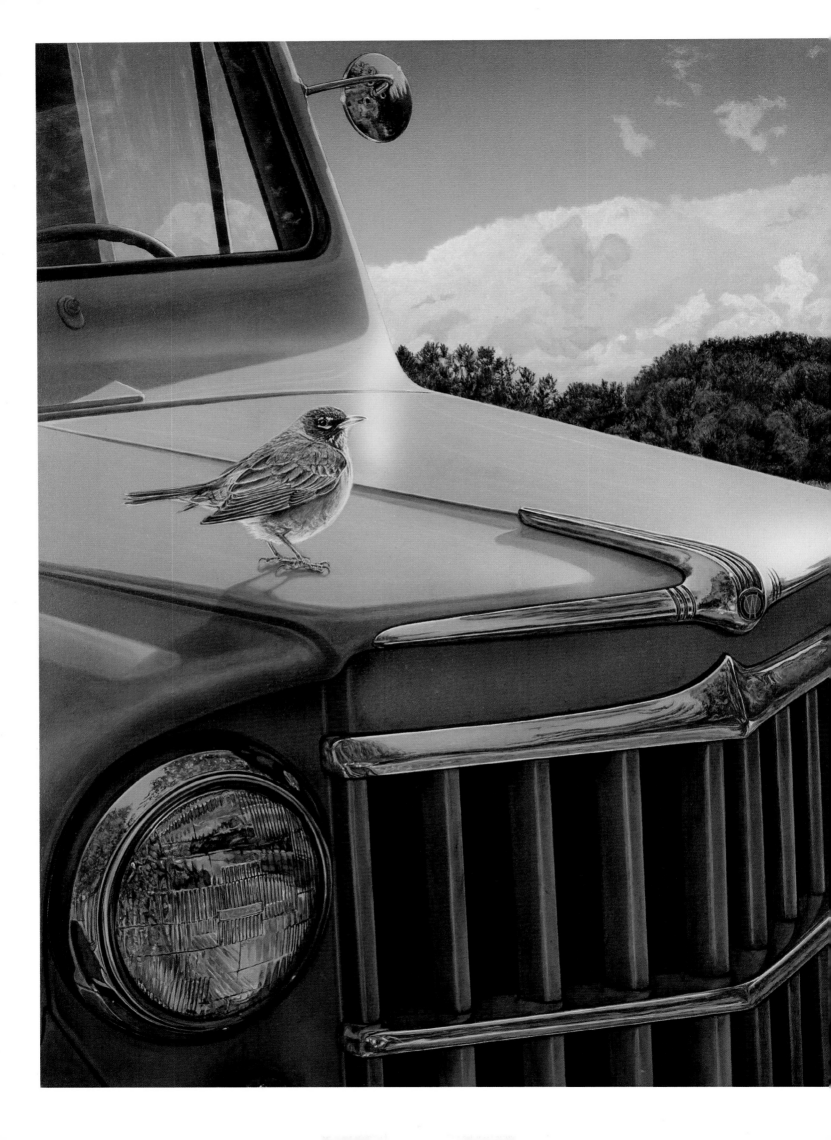

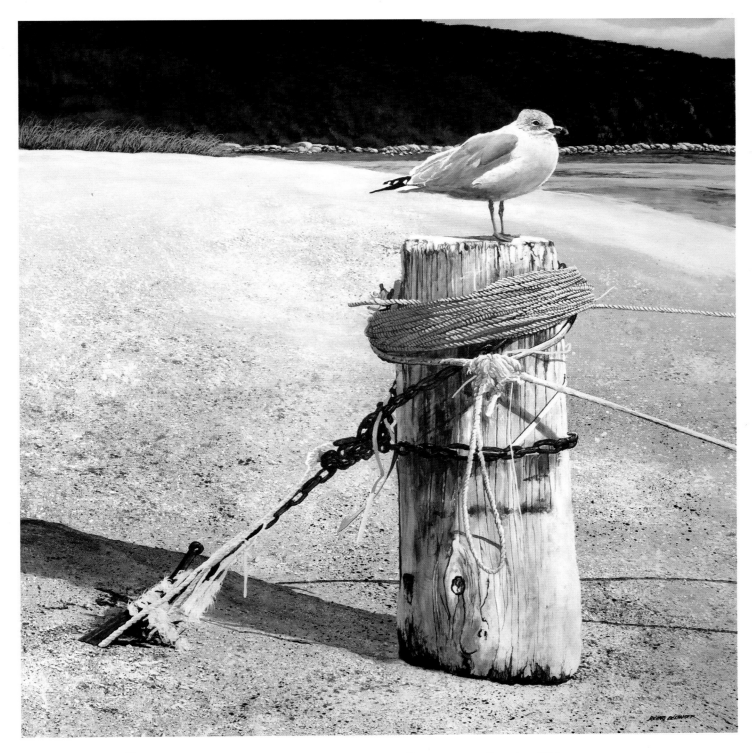

◀ **ROBIN HOOD** | Randy Van Dyck
Acrylic on panel, 18" × 14" (46cm × 36cm)

▲ **RESTING** | Richard Belanger
Acrylic on wood panel, 36" × 36" (91cm × 91cm)

The inspiration for this piece came from its title, *Robin Hood*. I knew I was going to include a classic vehicle, but what make and model? When I came across this Willys Jeep basking in the summer sun I instantly knew it was the one. I enlisted the aid of an airbrush to lay down some of the smooth gradations, which are so hard to achieve with acrylics, on the hood and in the sky. Everything else was done with brushes using a combination of wet blends, transparent washes and a dry-brush technique. I really enjoyed trying to capture the textures of the oxidized paint contrasting against the shiny chrome and dirty windshield. The organic shapes of the clouds and trees are accented by the feathered robin, and the whole piece is pulled together by the warm lighting that envelops the scene.

I noticed this wooden post on the edge of the shore in Charlevoix, Quebec. This old timber was fascinating with all the different textures of weathered wood, ropes and rusted chains plus some nice cast shadows. It felt incomplete, so I added a seagull perched on top. Of utmost importance right at the beginning is to cover the sky area with paper towels because the next step can be quite messy. I masked off the pole and the seabird with liquid frisket and I splattered paint on the panel with a fully loaded brush, achieving different textures for the ground. After the splattering, it was a question of refining the details of the landscape — light on top, shadow parts darker — readjusting the values, obtaining a certain degree of realism.

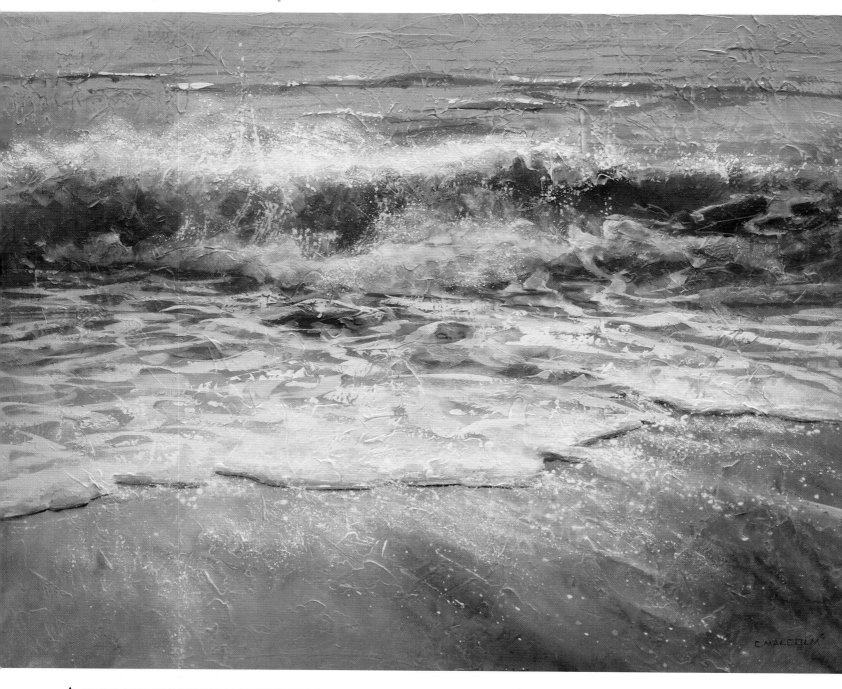

▲ **SHORELINE STUDY 00514 (SANDY BEACH, NEW BRUNSWICK, CANADA)** | Carole Malcolm
Acrylic on canvas, 36" × 48" (91cm × 122cm)

"I love that it's impossible to predict the exact outcome since the paint will find the crevices in the textured canvas as it's drying and produce something different each time." —CAROLE MALCOLM

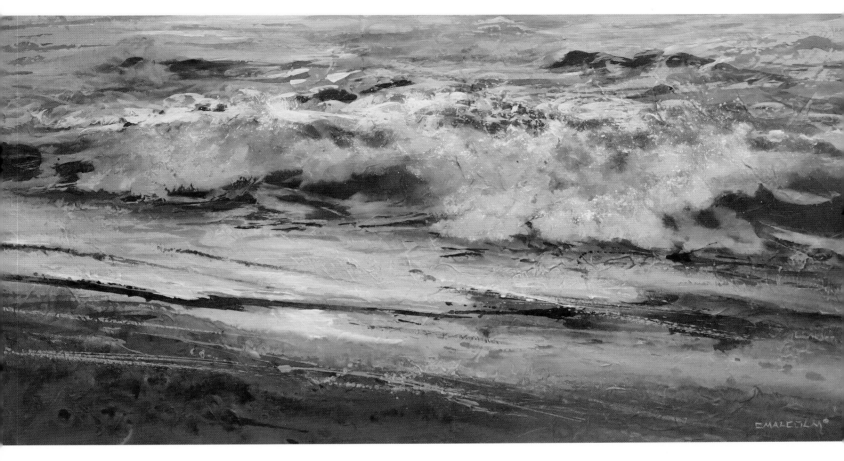

▲ **SHORELINE STUDY 19314 (SANDY BEACH, NEW BRUNSWICK, CANADA)**
Carole Malcolm
Acrylic on canvas, 24" × 48" (61cm × 122cm)

After using watercolor for many years, I happened to attend a demo given by a Golden paints representative using liquid acrylics and I was hooked! It meant I could move to canvas and introduce texture. The transition was seamless since many of the same techniques apply; I just needed bigger brushes and tools. My canvas is prepared by troweling on modeling paste to build up texture. Once that is dry I wet the canvas and start the painting wet-into-wet. Many washes of color are applied by pouring, spattering, rubbing and drybrushing as I progress toward completion of the painting. Both *Shoreline Study* pieces were painted from a photo and on-site sketches.

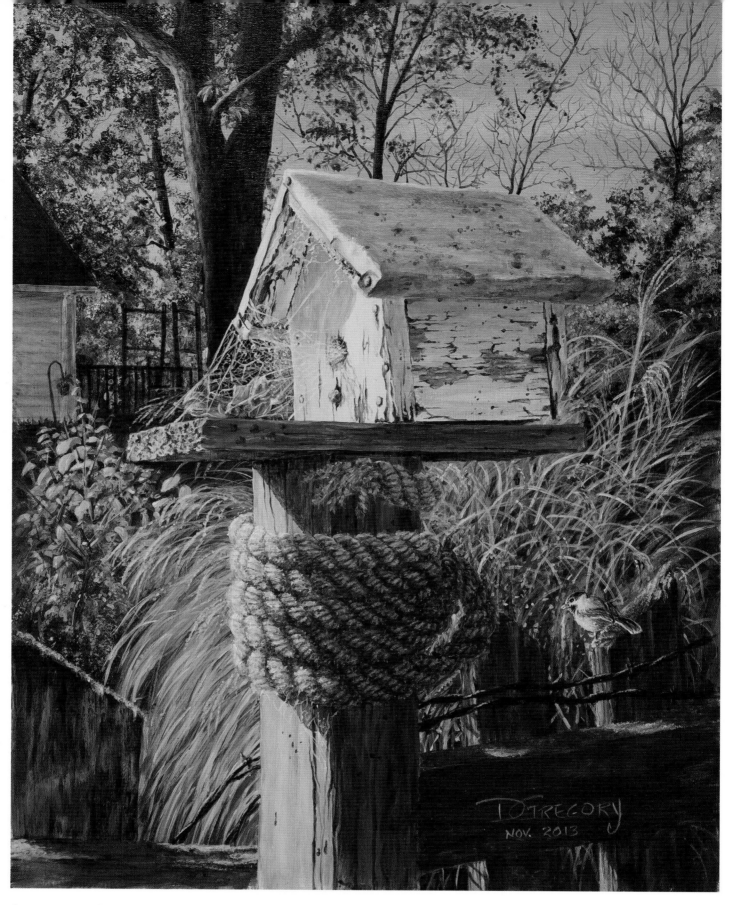

▲ VACANCY | Debby Gregory
Acrylic on Masonite, 14" × 11" (36cm × 28cm)

Rustic images have always been one my favorite subjects, and since I live on a lake I never lack that type of inspiration. Armed with a camera or phone I'm always searching for those glorious moments that I want to share with the world. *Vacancy* was one of those moments, and it was the many textures that prompted me. After viewing different angles and elements, this is the view I chose

to reproduce while leaving out nonessential elements. Since every painting is new to me, be it an idea or reproduction, each one is also an experiment and a challenge. The main challenge here was the rope. With combinations of white, Yellow Ochre, Chromium Oxide Green, Burnt Umber and slight touches of Cadmium Orange, I was able to achieve the frayed, weathered look I wanted.

"Look to nature to evoke memories. Paint to capture mood and create a moment suspended in time."

—PAUL MORGAN CLARKE

▼ **TRACKS** | Paul Morgan Clarke
Acrylic on board, 20" × 20" (51cm × 51cm)

This painting evolved from a family walk in a beautiful area called the North Pennines in England. I produced a drawing on location and took a variety of photographs from different angles. Acrylic allows me to build up layers of paint that help to add texture and increase luminosity to convey a feeling of light. I started the painting with thin washes of acrylic using large brushes and gradually built up layers of the paint using smaller brushes to emphasize the texture of the flowers. I also paint in egg tempera, and this has influenced my technique of painting in acrylic where I use small brushstrokes to convey light, mood and atmosphere in the landscape.

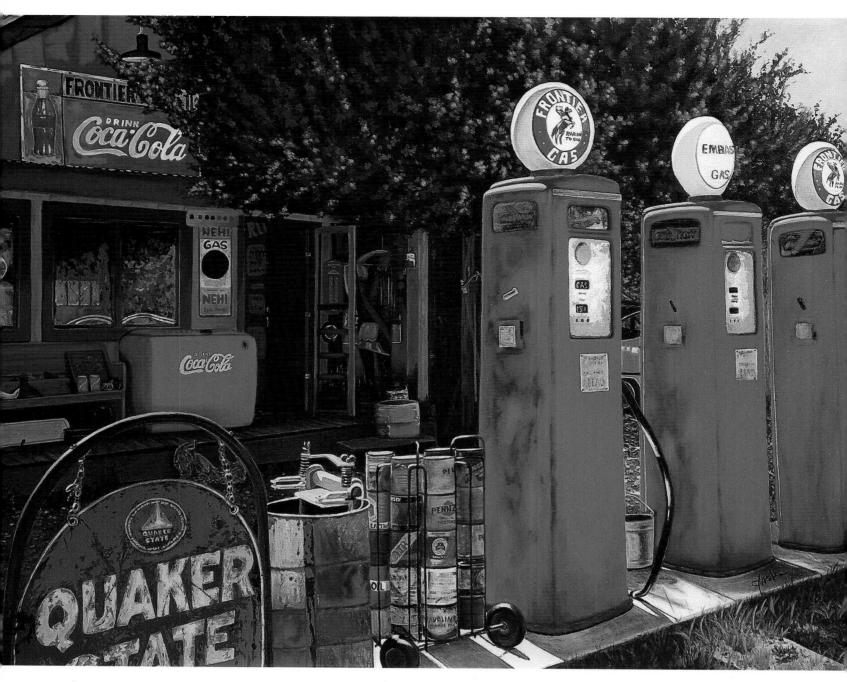

▲ **QUAKER STATE** | John Jaster
Acrylic on wrapped canvas, 30" × 40" × 1½" (76cm × 102cm × 4cm)

▶ **LOCATION, LOCATION, LOCATION** | Misty Martin
Acrylic on composition board, 48" × 36" (122cm × 91cm)

As I get older my fascination with Americana increases. The cars and carousel animals and country store gas stations that were so common in my youth are quickly becoming extinct. *Quaker State* is another attempt to capture the essence and beauty of these objects before they completely disappear from the American landscape.

What mainly drew my interest to this scene was the rust and aging of the Quaker State sign and the barrel and the oil cans. It gave me an opportunity to play around with thick acrylic glazes to create texture. While normally a glaze is thin and transparent, to get the ridges and broken color of the rust I used very thick applications of glaze with spots of colors partially mixed throughout. When one layer got tacky I pushed another thick layer into it to mold edges and creases around the rust spots. It's hard to walk by the painting without rubbing my fingers along the rusted edges of the sign and the barrel. (See page 36 to view Jaster's piece *Soldier's Burden*.)

Peeling paint. Weather-beaten woodwork. Rusted ironwork. Crumbling plaster. This is the imagery that fascinates me. Distressed architecture tells so many stories. The story of inspired creation; the story of steadfast utility; and eventually, the story of neglect, abandonment and decay.

I'm fascinated by the allegory that can be found in the degradation of the man-made environment. And as an artist, I'm fascinated by this degradation in terms of its drama and the subtlety of changing patina, texture and structure.

Acrylic paint is my medium of choice for picturing this degradation in my signature photorealistic style. Acrylics let me achieve the extra-fine detail and the complex color enhancements needed to produce a visually stunning photorealistic image. Acrylics also let me paint the layer upon layer needed to coax out the relentless, intractable dynamic of aging.

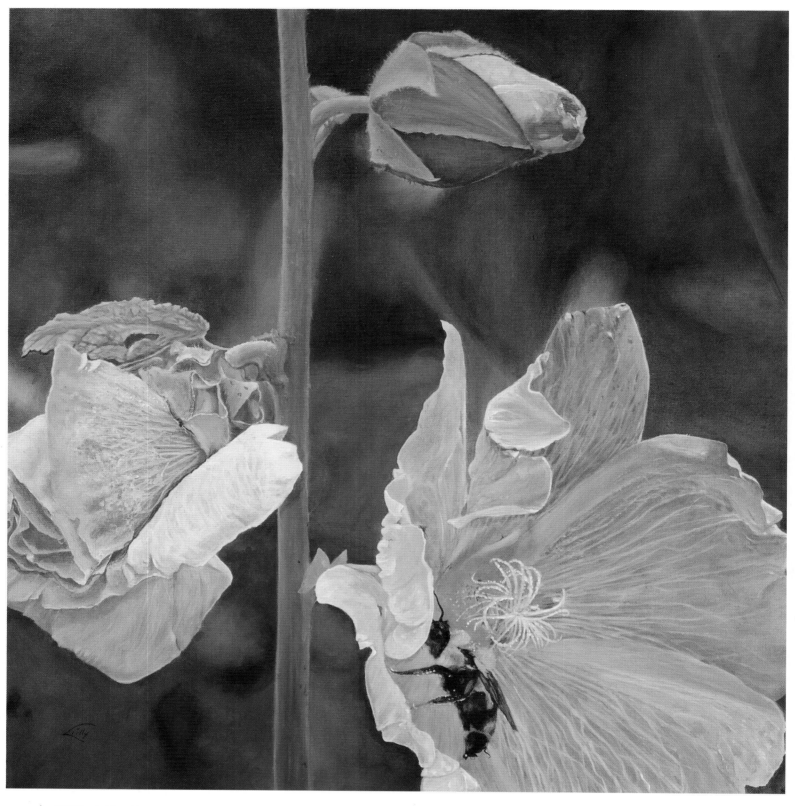

▲ **BZZZ** | Kitty Kelly
Acrylic on canvas, 36" × 36" (91cm × 91cm)

I look for the unusual either in lighting or, as in the case of *Bzzz*, the color of the hollyhock. I began by putting the background in first, blending the colors with my hands. Acrylics allow me to do this by using the wet-into-wet technique. I can also use a thicker paint and define, accentuate and provide textures, for example, the hairlike fibres on the bud of the hollyhock and pollen on the anthers of the flower. Acrylics dries quickly; therefore, it enables me to use glazes or, if I choose, to change or improve a section by just painting over it. If I had to choose one word to describe why I love acrylics, it would be *versatility*.

The painting *Bzzz* hangs in our home. When friends and children visit and are looking at the painting, I ask them if they have ever touched a bee and, of course, they say "no," so I tell them they can touch this one. When they do, the pressure from their finger activates a sound bite that was installed on the back side of the canvas and emits a buzzing sound. They always jump back, laughing.

▼ **HERE COMES THE SUN** | Kitty Kelly
Acrylic on canvas, 36" × 36" (91cm × 91cm)

Before I put paint to canvas, I decide on how I want to emphasize a certain portion of the painting, composition, values, etc. My setup differs from *Bzzz* because I decided to put the background in last. If the blossom "pops" after doing this, then I know I'm good to go and now I can put the finishing highlights on (my favorite part).

I love to go into my flower garden right after a rain when the sun is just coming out. I knew I had to put this picture down on canvas and share it with others as soon as I saw those raindrops!

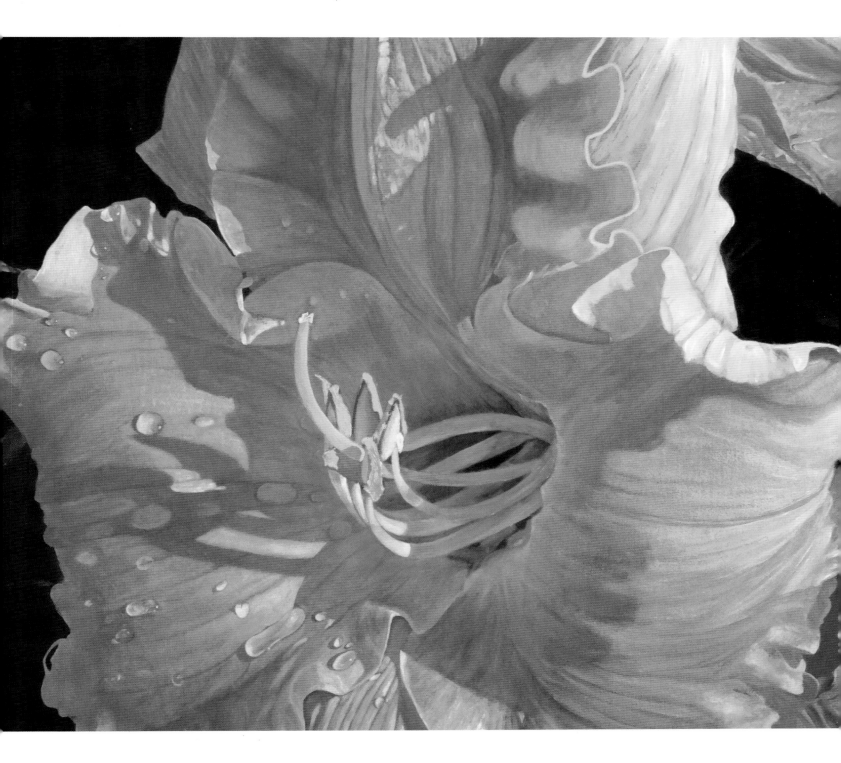

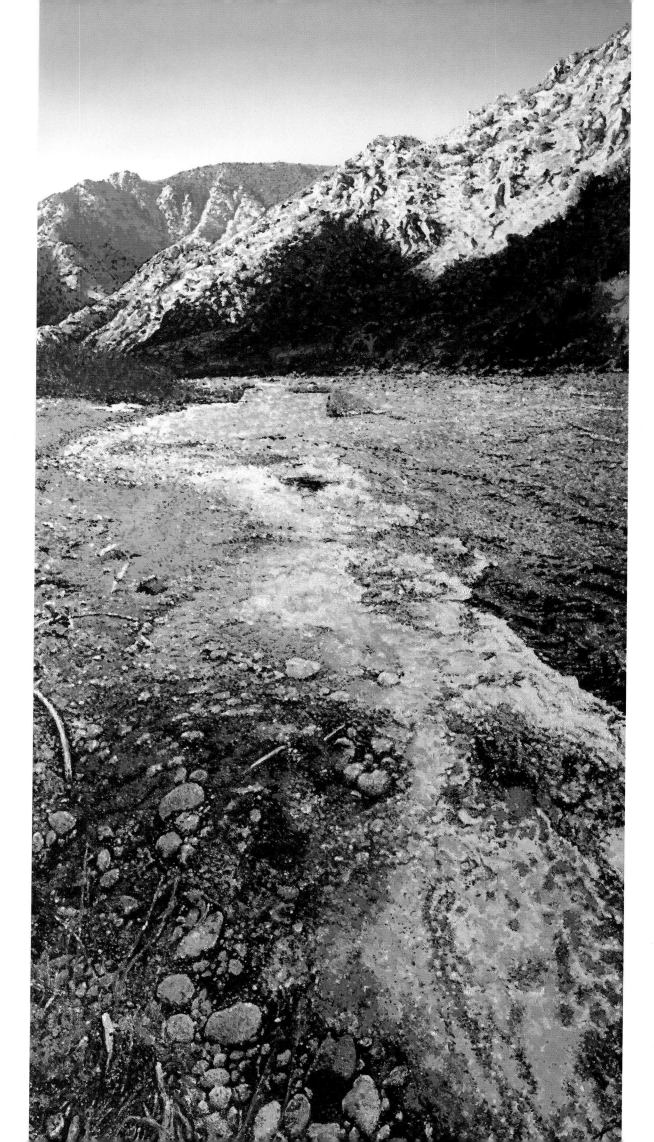

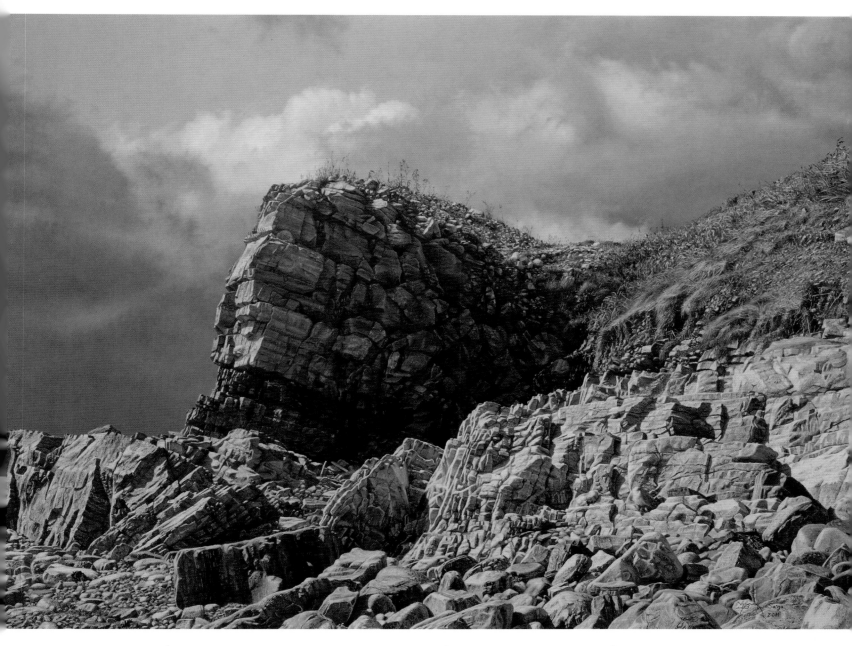

◄ IN THE FLOW | Darien Bogart
Acrylic on panel, 48" × 24" (122cm × 61cm)

It was another clear, beautiful, crisp winter's day in Colorado. We drove the winding road that parallels the Arkansas River towards the mountain town of Salida. It's a gorgeous route through the deep canyon walls that protect the river and create its home. I've taken this trip many times and each one presents me with yet another visual treasure.

Shadows and light upon the water and endless variety of textures that surrounded me created a tapestry for the senses. I took many notes standing in the icy water and captured as many images with the hope of expressing the spirit of this place. There is something about that magic moment of knowing you're *In the Flow*. (See page 95 to view Bogart's piece *Follow Your Muses*.)

▲ FACING THE ELEMENTS | Brian LaSaga
Acrylic on panel, 24" × 34" (61cm × 86cm)

I kayak and hike to collect material for my work, and sometimes I may drive to certain locations. All my work is done in my studio where I work from my photos. Sometimes I may incorporate elements from other images of mine using Photoshop to manipulate these elements until I arrive at a composition I'm happy with. I will then print a photo of this final image and paint directly from it. These working photos can be anywhere from 8" × 10" (20cm × 25cm) to 13" × 19" (33cm × 48cm). It helps to be a good photographer when composing and creating high realism paintings. I love to paint weathered textures and subjects I'm familiar with that are native to my area. All artists should paint what inspires them and what they love. Nature has so much to offer each and every one of us. (See page 76 to view LaSaga's piece *The Barn Door*.)

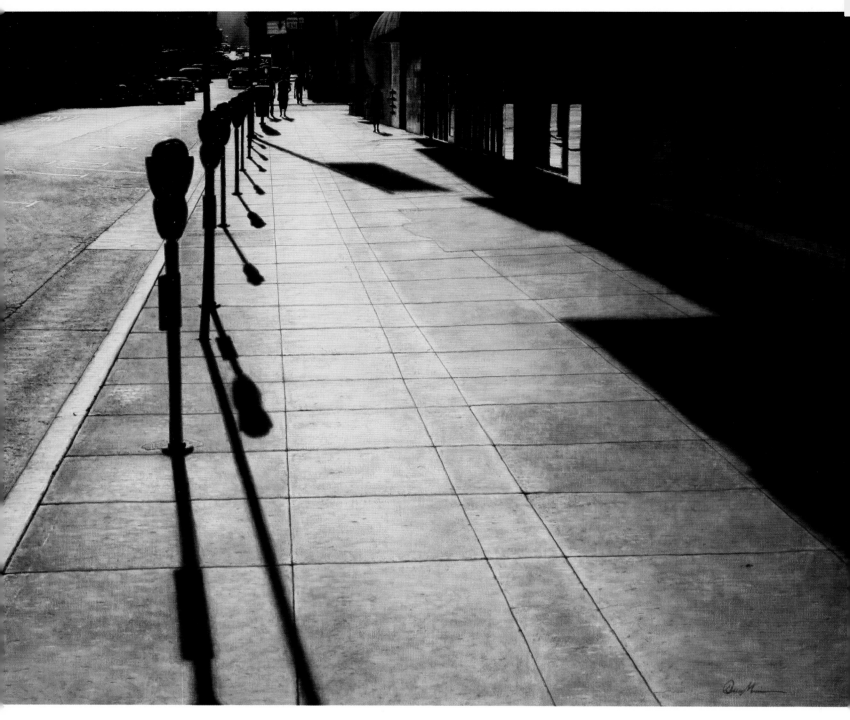

▲ TIMELESS TENDERLOIN | Andrew J. Morrison
Acrylic on canvas, 24" × 30" (61cm × 76cm)

▶ TRAIN DEPOT | Ron Craig
Acrylic on board, 36" × 24" (91cm × 61cm)

When I transitioned from drawing years ago, I began with acrylics for their relatively lower cost, ease of setup, use and cleanup. (I am entirely self-taught.) I still prefer them for highly rendered work. Initially born from frugality, my technique remains minimalist: hand-sketched canvases, thin brushwork, dry-brush blending, painting "back-to-front, dark-to-light."

The Tenderloin district in San Francisco possesses its own some-what eerie, almost ancient rhythm. Creating the weathered texture of the pavement and gritty sidewalk was critical to this scene's re-creation.

Part of experiencing our environment is tactile; thus, actually depicting texture in an image or scene assists in evoking a visceral response the artist seeks to elicit.

An abandoned depot, built to last a lifetime, erodes. Steel eaten by rust, soot-coated bricks, an errant weed insisting nature into the scene: These textures hold the depot's history—the effort on construction, the footfalls of past travelers, the rumble of train cars, the lost conductor's calls, as well as its demise. I use acrylics to tell the depot's story. The quick drying time benefits the layering process required to achieve proper tones and detail, while retarder and glazing mediums enhance paint flow and blendability. Rendering the depot's complex textures, I celebrate the structure's life, from creation to function to decay.

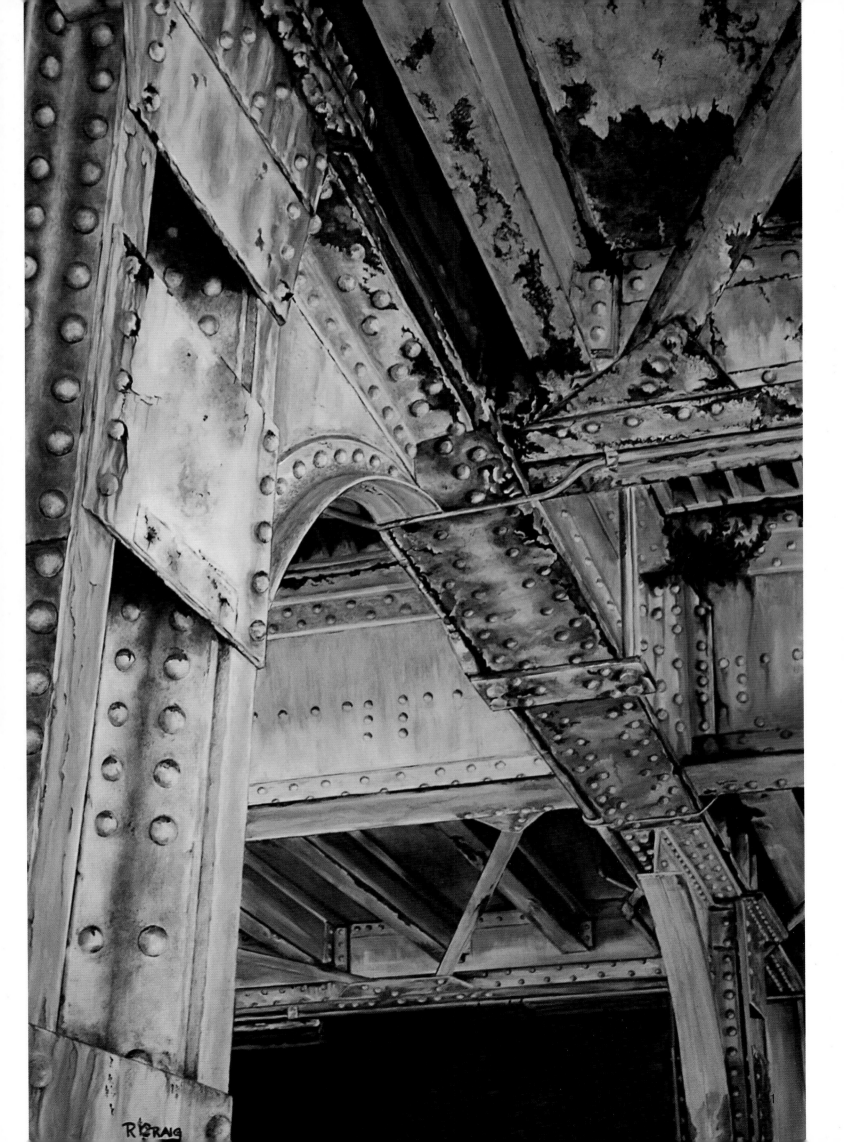

Fluid acrylic on 140-lb. (300gsm) cold-pressed Arches, gallery wrapped and varnished
24" × 34" (61cm × 86cm)

Struggles in the Southwest was inspired by a trip to Mission Tumacácori in Arizona. I studied ancient cultures in college and have always found learning about cultures from the past as fascinating as modern life. I felt the graveyard at the mission epitomized the difficult times in 1691 when Father Kino established the mission at an O'odham village.

My approach was to pour a few layers of fluid acrylic, then use a brush to strengthen the colors and texture in the crosses, which for me signified the strength of conviction of the missionaries and the Native Americans who worked at the mission. The rocks and sparse twigs and grass suggest the difficult times and the desolate environment in which they lived. The theme of my work is to explore cultures through color, allowing me to share a bit about the present and the past. (See page 37 to view Rimpo's piece *Moving Up*.)

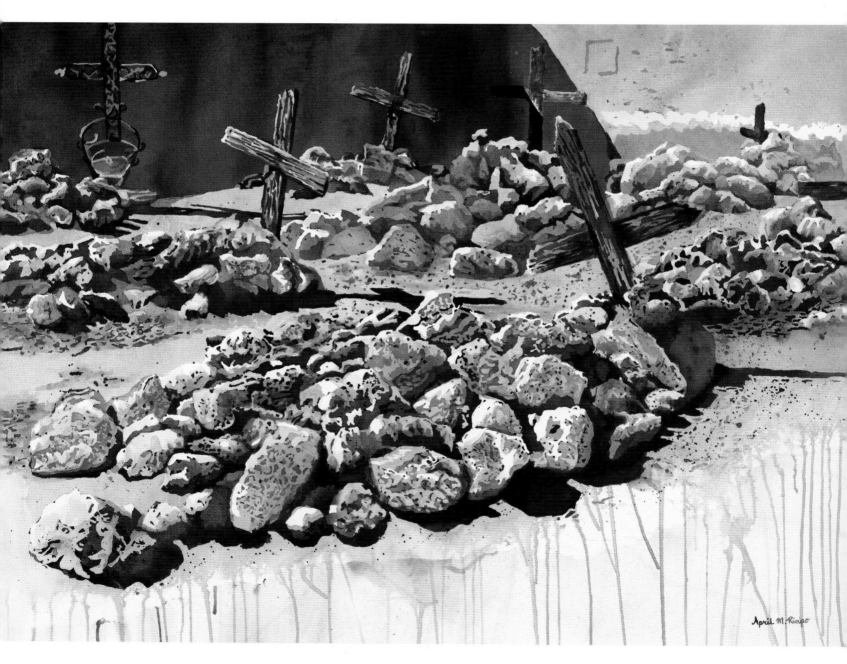

"Be sure when using techniques to create texture that the texture is appropriate to your message and not done just because you can." —APRIL M RIMPO

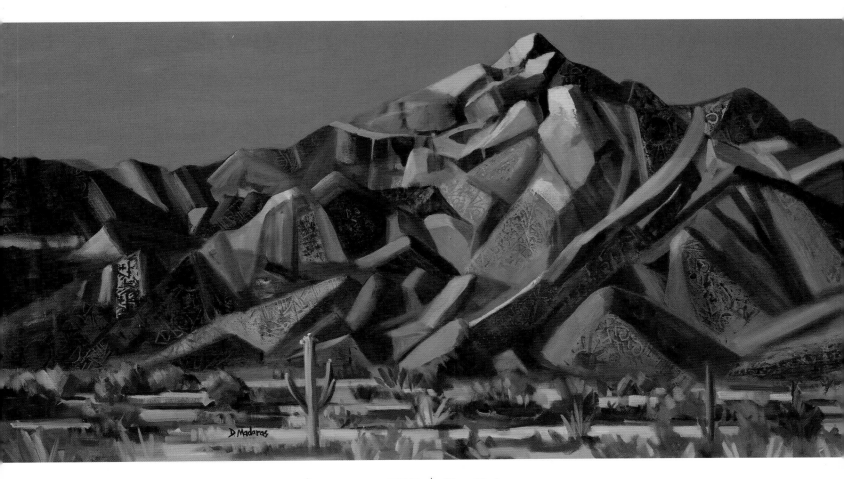

▲ **PIESTEWA PEAK** | Diana Madaras
Acrylic on canvas, 24" × 48" (61cm × 122cm)

When asked to create a painting for an event in Phoenix, Arizona, I chose *Piestewa Peak*. The mountain, formerly Squaw Peak, was renamed in honor of Lori Piestewa, the first Native American woman killed in combat. I worked from a photograph and after sketching shapes on the canvas, I began laying in color. I don't like to predetermine color, but rather let it evolve intuitively as I work. That is my true creative journey.

I researched Native American symbols associated with Lori's tribes (Hopi and Navajo), then carved these onto a linoleum block and stamped the images onto the painting. I also stamped desert animal images onto the faces of the rocks.

After a Phoenix couple read an article announcing the event, which included a small photo of the painting, they called to purchase *Piestewa Peak* sight unseen. They loved the painting and they loved the story.

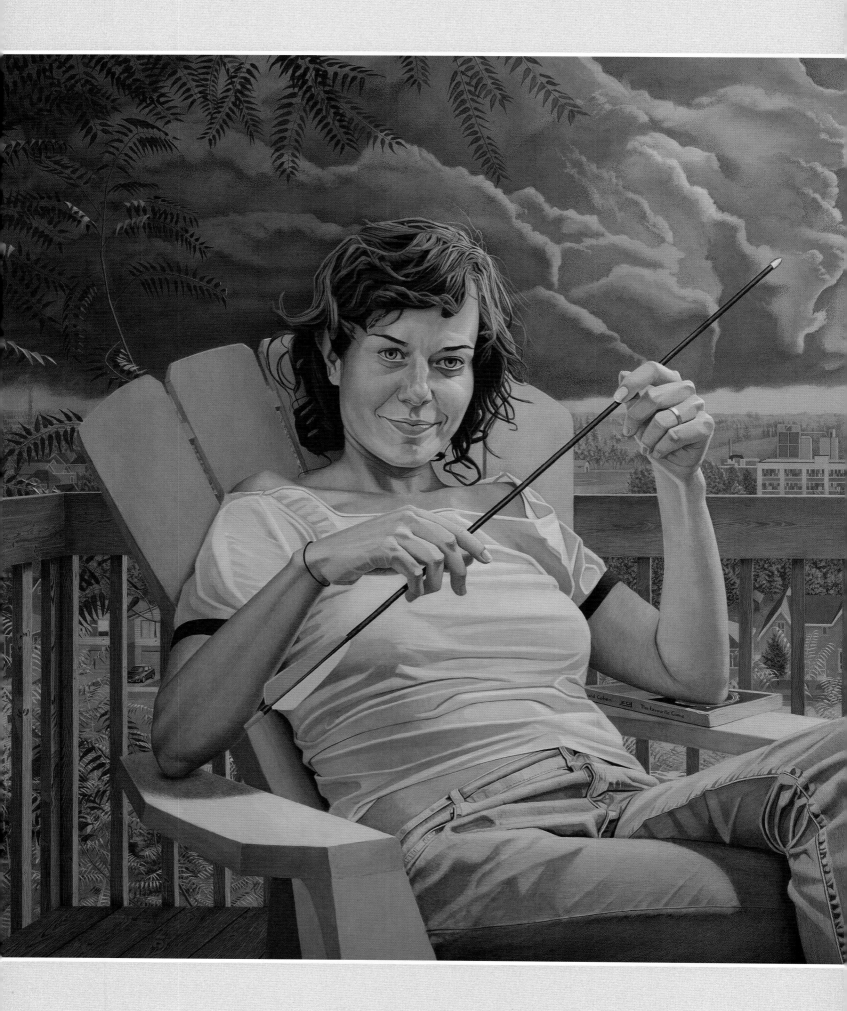

◄ **ARROW** | David Caesar
Acrylic on hardboard, 30" × 49"
(76cm × 124cm)

It took over 700 hours to com-
plete this painting and roughly
100 photos were used as
reference. Acrylic is a medium
I'll likely be using for decades
to come due to its versatility. I
prefer a flat quality—the flatter
the better!—and used Liquitex
Ultra Matte Medium to achieve
this. I also use sandpaper. If
the paint starts to build up too
much, I sand it down and start
fresh. I decided to abandon my
comfort zone with this piece,
essentially starting with the
foreground with no plan as to
what the surrounding environ-
ment would include.

Portraits and Figures **2**

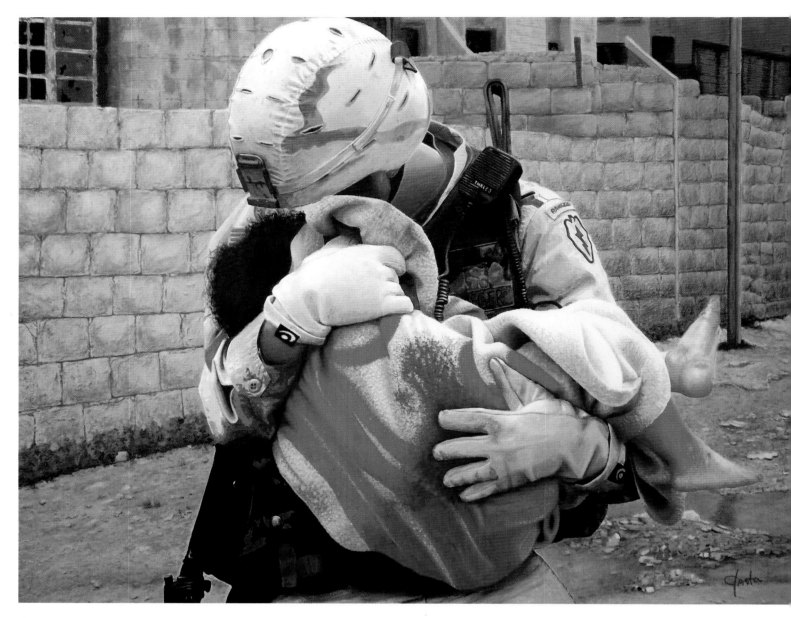

▲ **SOLDIER'S BURDEN** | John Jaster
Acrylic on wrapped canvas, 30" × 40" × 1½" (76cm × 102cm × 4cm)

In all of my paintings I use areas of abstraction to emphasize areas of realism. I seldom know how realistic the overall painting will be until I see how bold and undefined the abstract areas are. In *Soldier's Burden* I started with the shadow areas underneath the soldier's arms, the canteen belt and the dark area where his name is located. I used bold patches of color to draw the eye. The next layer of abstraction, the uniform sleeves and the gloves, is more realistic but still shows color separation rather than smooth blending. At this point I have surrounded the child in the blanket with two of my three layers of abstraction. The effect is to highlight the realism of the blanket. My third layer of abstraction is the background wall and buildings. This pushes the whole figure forward.

The fast drying time of acrylics allows me the freedom to try out colors and building contrasts with the different elements of the scene I am creating. I do all this on the canvas. In this painting, for instance, I changed the look and feel of the wall five or six times before it felt right. (See page 24 to view Jaster's piece *Quaker State*.)

▶ **MOVING UP** | April M Rimpo
Fluid acrylic on 140-lb. (300gsm) cold-pressed Arches, gallery wrapped and varnished, 24" × 14" (61cm × 36cm)

My paintings are done in the studio from photographs I've taken on site. I love to share bits of our culture through my art—a view of things people love to do or traces of our history. In *Moving Up* I felt the rugged textures of the cliff were critical to capture, which I achieved through progressively darker layers of poured fluid acrylic. I thin out the paint to the consistency of watercolor so I can gradually build transparent layers. Masking fluid is applied to block out areas that I want to retain from previous pours. After three pours I shift to a brush to add details and gradual transitions. It was important to integrate the climber with the environment, so I used similar colors for his skin tone and relied on highlights and complementary colors for his clothing to keep him visible. (See page 32 to view Rimpo's piece *Struggles in the Southwest*.)

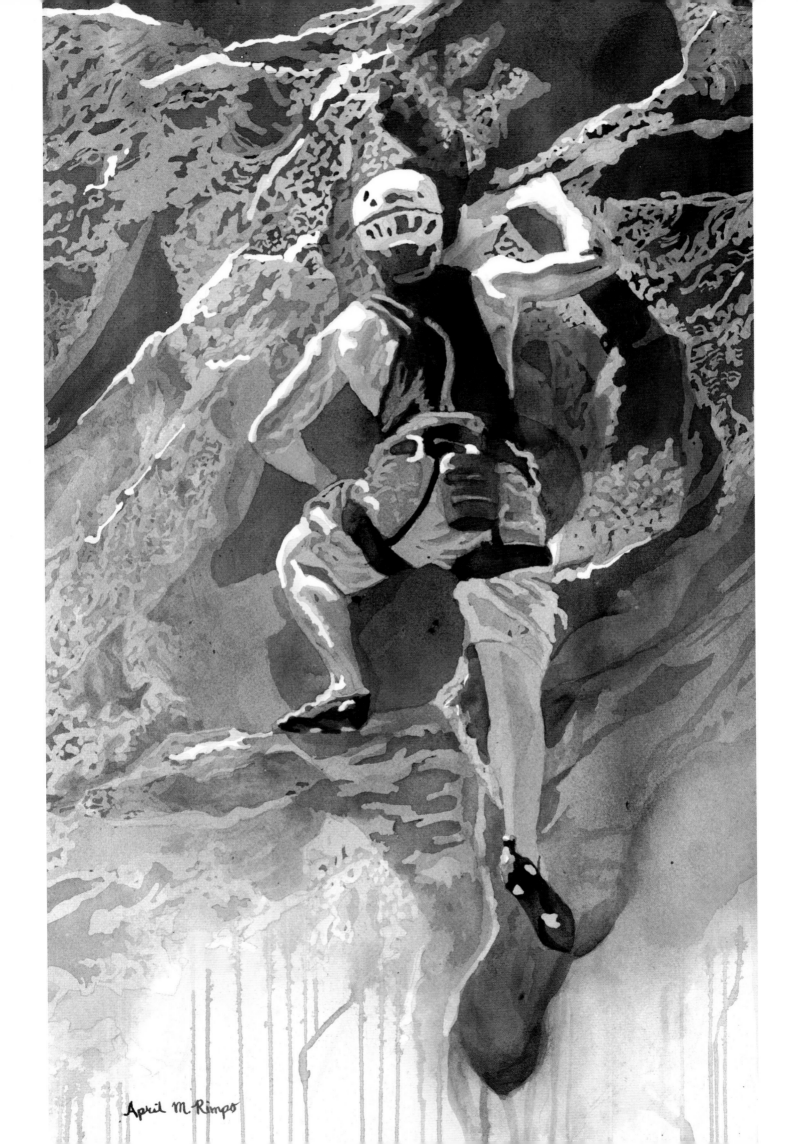

April M. Rimpo

◀ **THOU ART WITH ME** | Sharyne E Walker
Acrylic on canvas, 30" × 24" (76cm × 61cm)

I hired a professional photographer to capture my sons in several poses before I ended my tour of duty in the U.S. Army. I kept the shape of the clothing but changed the colors to fit my chosen color and value scheme. My favorite format is 70-20-10 (value, color). The story of this painting is a mark in time when their father passed away suddenly at the age of 37; he is represented as the transparent young angel pointing to a message in the clouds, which reads "Love."

▲ **RUNNING WITH SCISSORS** | Christina Ramos
Heavy body, fluid and Interference paint, tar gel and matte medium on canvas
12" × 24" (30cm × 61cm)

I was selected for the honor of representing the Golden paint company as one of their Working Artists. During my extensive training with the company, I was introduced to many products that I had never used before in my traditional portraiture. I wanted to explore new possibilities by incorporating some of these products into my work. I began using gels, mediums and fluid paints to create abstract acrylic pours. I loved the randomness of this process—the natural movement and mingling of the different colors and viscosities of the products. Through this experimentation, my *Pour* series of paintings was created. I wanted this series to be fun and to reflect my personality. I have used myself as the model in this painting.

"No matter what you originally thought you were going to do, be willing to change course to take advantage of accidents and surprises. Many of them are gifts—far better than anything you could have planned." —JOANNE BEAULE RUGGLES

40

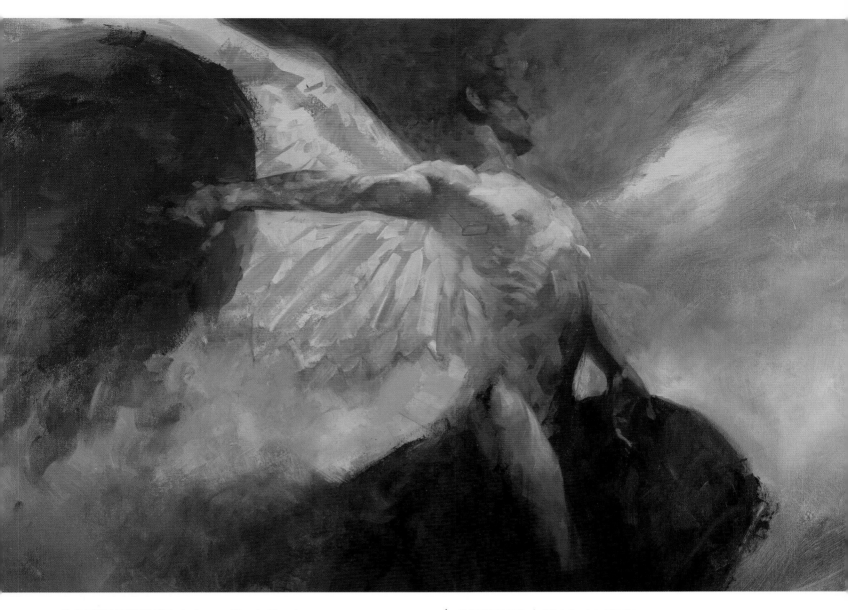

◄ DON'T PUSH ME | Joanne Beaule Ruggles
Acrylic with India ink and collage materials on 80-lb. (170gsm) cover stock paper, 40" × 26" (102cm × 66cm)

My mixed-media process starts by positioning a collection of nonobjective abstract paint marks, shapes and textures, as well as adhering collage materials upon my paper substrate. I call this an "environment," the product of intuitive creative play. When this preliminary improvisation starts to be interesting, I pull back and sit with the work for a while. Invariably I'll begin to see a possibility of something that already exists in that environment. My next task is to reveal the image the painting already holds. My specialty is the human figure, so it is really not particularly surprising that (quite often) I find bodies.

▲ DAEDELUS | Christopher Moeller
Acrylic on canvas, 30" × 40" (76cm × 102cm)

The myth of Icarus speaks to the transformation that happens in every person's life. We all know about Icarus, the youth who flew too high and paid for his hubris. We hear less often about his father, Daedelus, who flew with no less daring, but with greater success. He was a generation older than Icarus. Perhaps wiser. His transformation into a creature of flight wasn't a youthful one, swooning with hormones and reckless abandon. His was the measured transformation of an adult man, comfortable with who he was. He didn't need to go to the sun. For him flying was miracle enough.

Painting with acrylics is a sensual, physical activity. It's messy and alive and passionate. I like to paint fearlessly without a lot of preliminary work and without worrying about making mistakes. Acrylics let me paint that way.

▲ **THE ARRIVAL** | John Walker
Acrylic on panel, 24½" × 26¾" (62cm × 68cm)

I began *The Arrival*, one of a series of paintings combining realistically painted portraits with flat, graphic elements and texture, with a sealed and gesso-primed MDF panel. Because I wanted only to apply texture to the area around the subject, I drew her in place with pencil. Next, I roughly applied a relatively thick and uneven layer of gesso with a brush around the area the subject would later occupy. As the gesso began to dry, I dragged a putty knife over the surface, compressing and flattening the high spots, leaving a beautiful, random texture to overglaze with color.

▼ **AVIAN COMMUNICATION IN THE APOCALYPTIC MIND** | John Walker
Acrylic on canvas, 24" × 24" (61cm × 61cm)

What's in a phrase? Sometimes an entire painting. This is one of those pieces that began life as a simple string of words that evolved into a larger concept. Once I had the basic idea sketched out, I shot some quick reference photos of the subject and then developed a color rough. The details were developed from imagination as I painted the finished piece. I generally prefer the solidity of working on a panel's hard surface, but here the medium weight texture of the canvas worked to my advantage as I blended some of the softer edges of the painting.

"My work is about telling stories, both real and imagined."
—JOHN WALKER

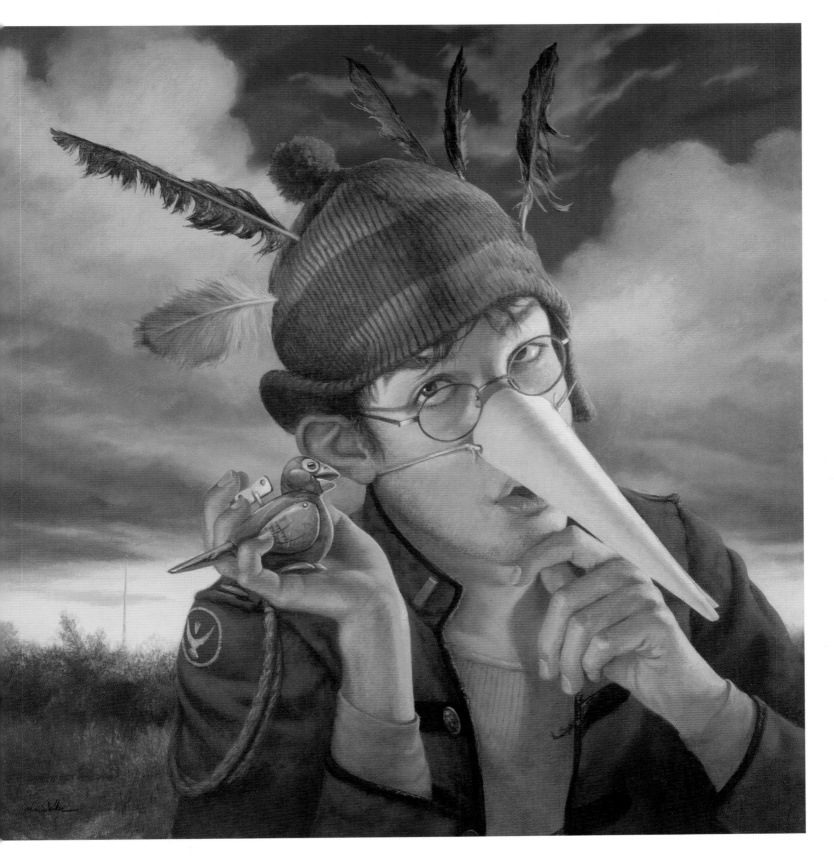

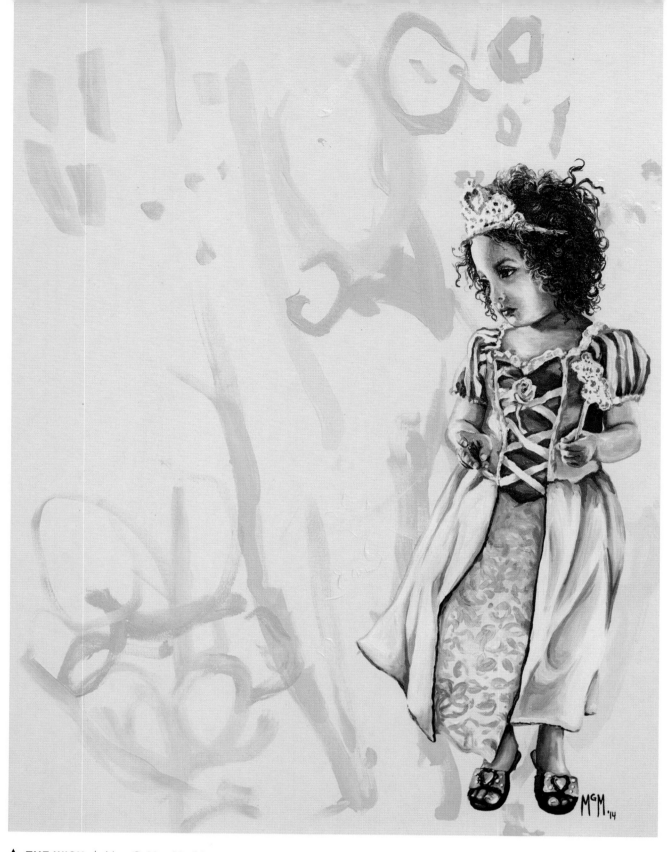

▲ **THE WISH** | Mary Golden-Musick
Acrylic on canvas, 40" × 30" (102cm × 76cm)

This is from a series of collaborative acrylic paintings called *Yoked* completed with my four-year-old daughter, Atlas Elizabeth. She paints the background with acrylic, and I paint a moment of our lives on top of her work. My portion of the collaboration begins by drawing an image that represents her work and emotions. I then use acrylic for the entire portrait painting, working in several layers to achieve depth. Her childlike painting contrasted with my more realistic portraits creates an interesting combination of textures. *Yoked* means bonded together, which describes my relationship with Atlas perfectly. I have a connective tissue disorder and cannot be active with her, but we can go to my studio and paint. No matter how sick I may get, this is something we are bonded together to do.

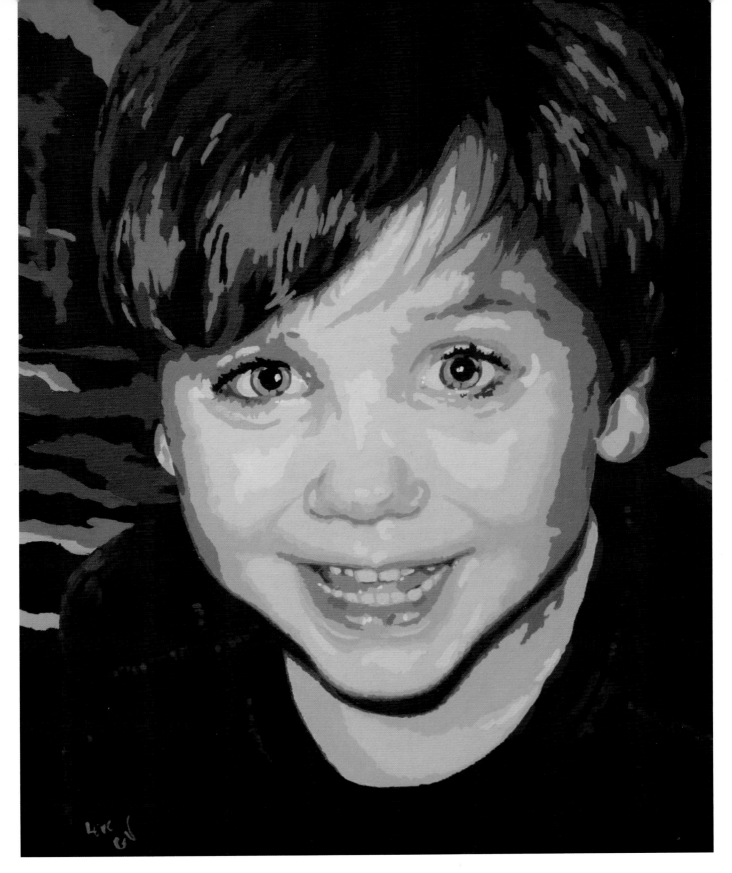

▲ **RHYS** | Vickie Dorsam
Acrylic on Fredrix Creative Edge gallery-style cotton canvas, 30" × 20" (76cm × 51cm)

Opaque and quick-drying, acrylic was the only choice when I decided to do portrait posters of my grandchildren. I worked from several photos plus one I had edited in Photoshop, which was new for me. The different values and temperatures for large areas were mixed in sealable containers and sprayed with distilled water (to help prevent mildew) plus a few drops of "slow dry." For smaller areas I made a palette using a clear plastic, lidded salad container and mixed my paint on a wet paper towel placed in the bottom. I could then spray and cover it to keep it wet between sessions. I kept the transitions close in value to portray Rhys's smooth skin.

"The paintings of my grandchildren proved to me that painting what you love makes the best art."
—VICKIE DORSAM

45

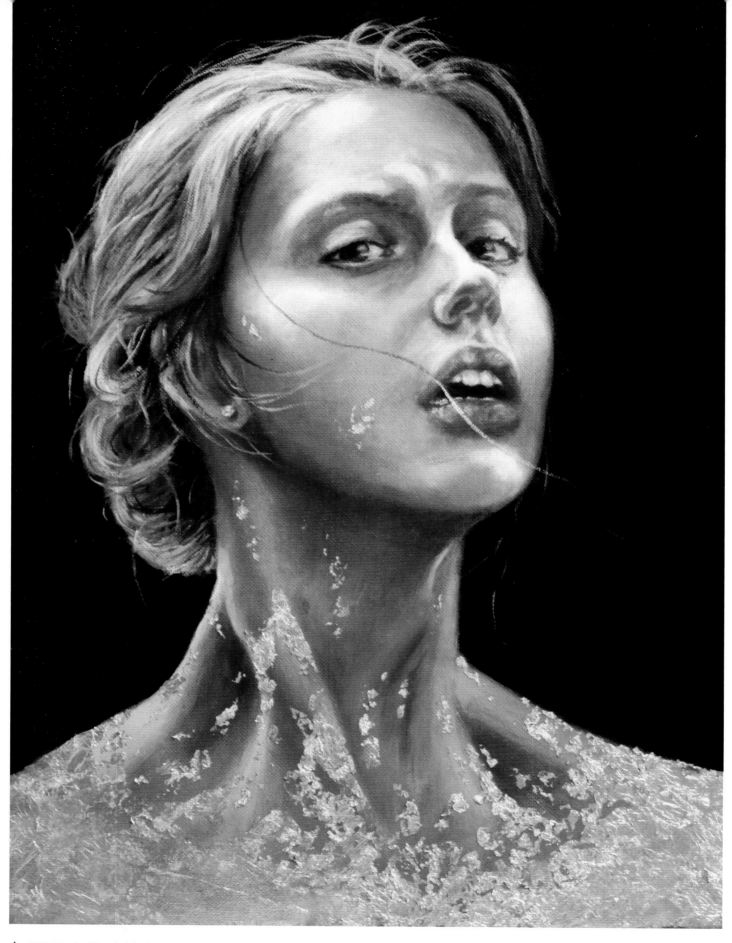

▲ MIDAS | Claudia Hanley
Acrylic with gold leaf accents on canvas, 20" × 16" (51cm × 41cm)

For *Midas*, I worked from a photograph of myself before applying gold leaf and gold acrylic paint in the final stages of the work. When I painted the face, I used a filbert brush and several washes of paint in order to blend the colors and produce a smooth texture. Since gold leaf is so delicate, it fell apart easily and lent itself well to the distressed effect that I wanted to create at the edges of the golden areas. The worn texture builds a sense of movement in the painting, giving the impression that the gold is climbing up the girl's neck.

▼ MADEMOISELLE DU CARNAVAL | Lisa L. Cyr
Acrylic and mixed media on paper over Masonite with wooden
framework, 12" × 9" × 1" (30cm × 23cm × 3cm)

Much of my work has a spiritual, mythological or psychological
relevance where the interplay between the external world and the
inner realm plays an important role. In my painting *Mademoiselle du
Carnaval*, a female figure emerges as an interpretation of the real,
ideal and spiritual all-in-one being. The conceptual, poetic environ-
ment sets an imaginative stage for the almost spellbound character.

To create the texture-infused painting surface, I experimented with
a variety of alternative tools, techniques and acrylic paint viscosi-
ties and mediums. I employed mixed-media tools such as a plastic
bottle with a special applicator tip, a frayed toothbrush, natural and
man-made sponges, sticks, wire and custom-wrapped brushes
using heavy-body, fluid, interference and ink-based acrylic paints
mixed with water, acrylic matte medium and self-leveling clear gel. I
then combined these on my custom working surface by sponging,
spattering, dripping, stamping and marbling.

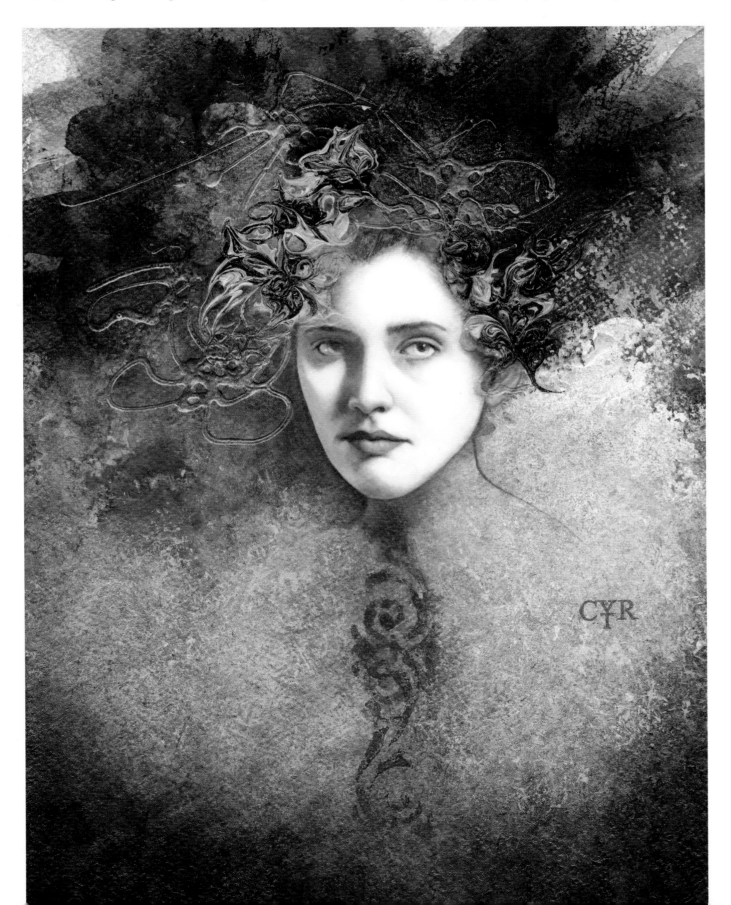

▼ **IT ALL COMES NATURALLY** | Jessica Lynn Grant
Acrylic on 300-lb. (640gsm) cold-pressed paper, 14" × 11" (36cm × 28cm) triptych

The versatility of acrylics allows me to create many different textures. In this painting I utilized acrylic paint in a variety of ways. To smooth the texture of the skin I slightly diluted the paints with water. For the flowers I used the paint straight out of the tube and layered it to give the flowers color and thickness. When I begin a painting I generally work off an image in my head that represents some type of theme or concept. This triptych represents something that connects all people, surpassing all cultural or language barriers: death and nature. As we grow in life we absorb the world around us including the knowledge we gain. And as we die we go back to nature from whence we came. The baby's upturned face is focused on the future yet to be, the young man is staring straight ahead in the present, and the old man is contemplating his past.

▶ **NORTHERN PAIUTE** | Barry Sapp
Acrylic on canvas, 24" × 18" (61cm × 46cm)

Originally I was sparked to paint a Northern Paiute brave by a headpiece I had seen in an old Hollywood western movie worn by one of the extras in several winter scenes. After researching the validity of the headpiece, the thought of adding additional textural elements, such as a hairpipe breastplate, animal tooth necklace, leather shirt and braided hair, as well as the Native American model's face, stimulated my imagination to execute the painting in a somewhat impressionistic style. The texture of the fur headpiece was the most challenging. Using a couple of stencil brushes with a light touch and some softening techniques brought the textures of the headpiece to fruition.

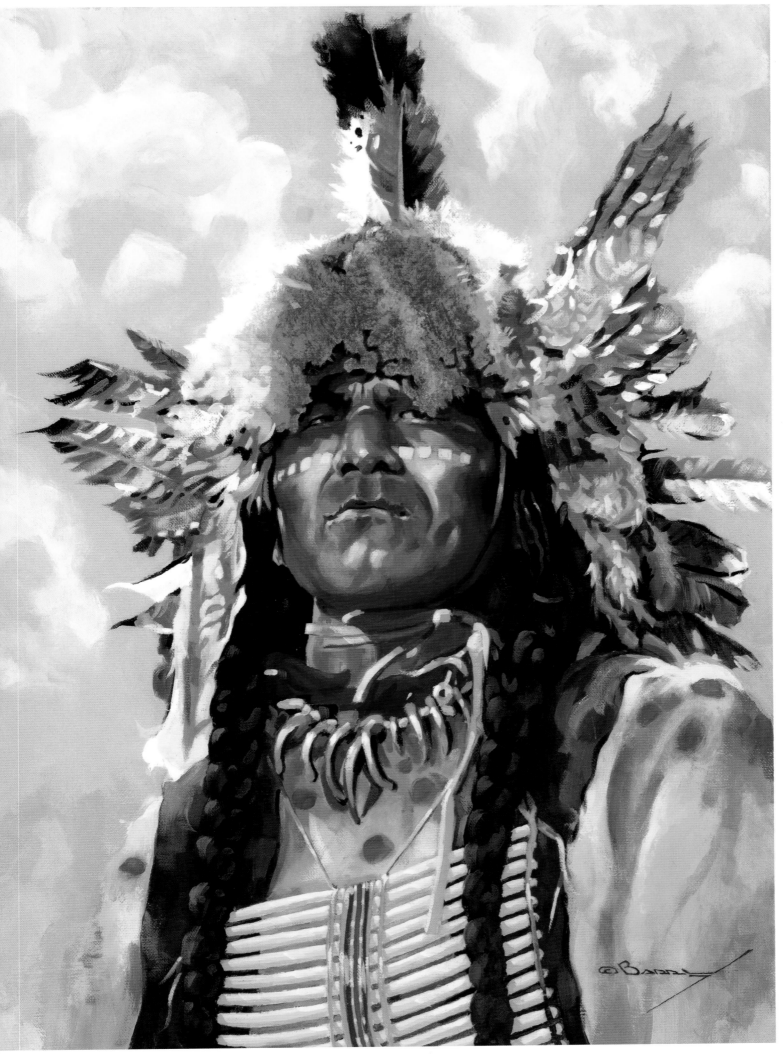

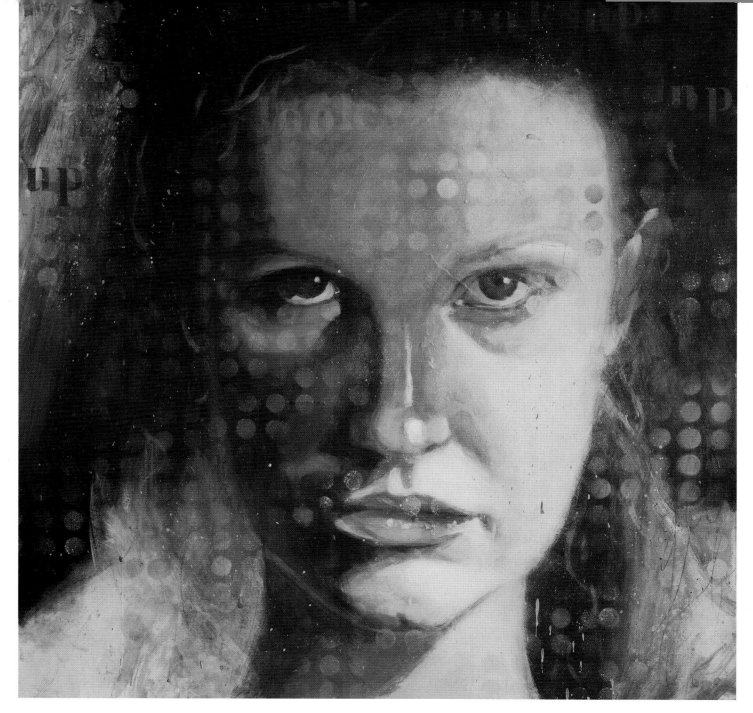

▲ **LOOK UP** | Jean Pederson
Acrylic paint and mediums on deep gallery canvas
36" × 36" (91cm × 91cm)

▶ **THE BLUE YEARS** | Craig Cossey
Acrylic on 140-lb. (300gsm) hot-pressed watercolor paper
29" × 21" (74cm × 53cm)

In my painting process, texture is an important element of design described by either visual or tactile characteristics. I can feel the rough or smooth properties of my surface, and I can see the illusion of texture through marks made on my painting surface.

Acrylic painting lends itself to layering, integrating a multitude of techniques and products to enhance surface quality. I really enjoy the process of layering, building rich depth to the painting.

In *Look Up*, I used both visual and tactile techniques to build texture. The painting incorporates a series of symbols for communication; handwriting, stencilled letters, dots for computer programing and Morse code. The icons represent our growing need to look up and engage in our environment, talk to those beside us. Let's learn to put down technology for a few hours every day.

I think that every painting has some aspects of an emotional self-portrait. I don't think that all the visual rough edges should be smoothed out. I don't think that all the emotional rough edges should be smoothed out either. For people who support themselves with their hands and bodies there is a pride that comes from the work. As we (I was a carpenter for over forty years) age and lose our strength, it hurts. In the painting the deteriorating farm symbolizes that loss. *The Blue Years* is about the loss of physical pride as we age. (See page 80 to view Cossey's piece *Father and Son*.)

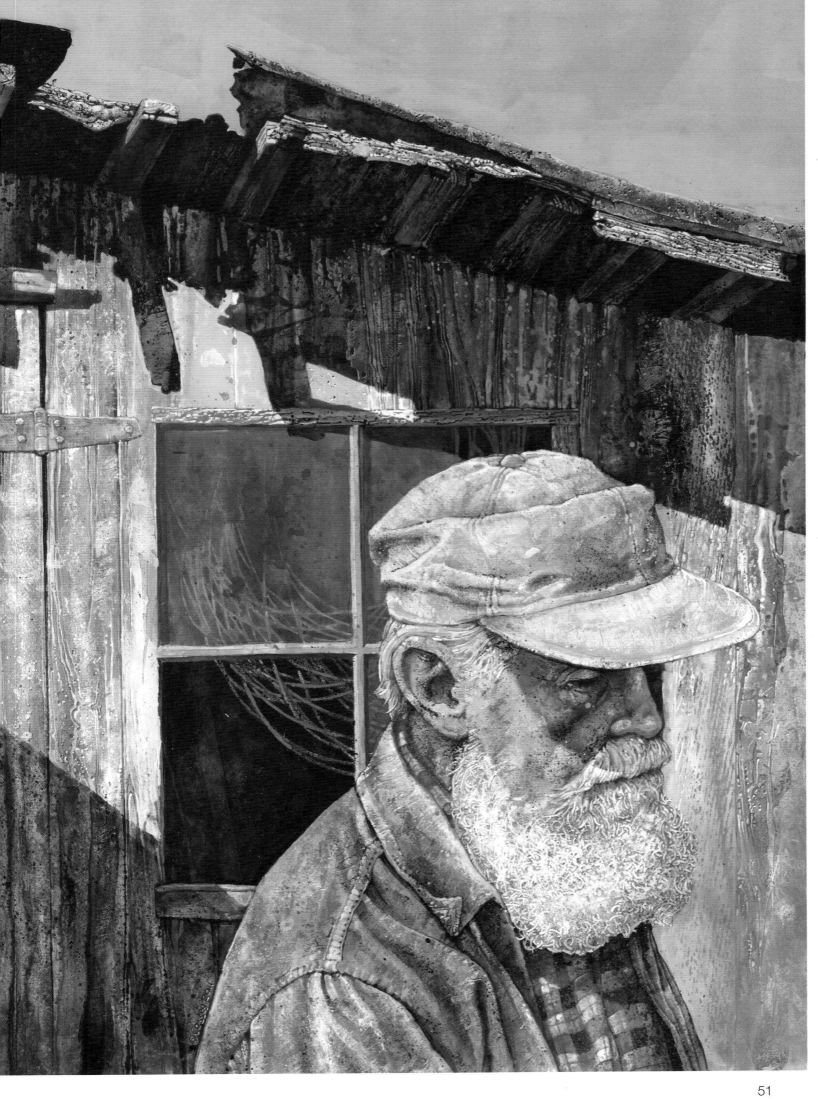

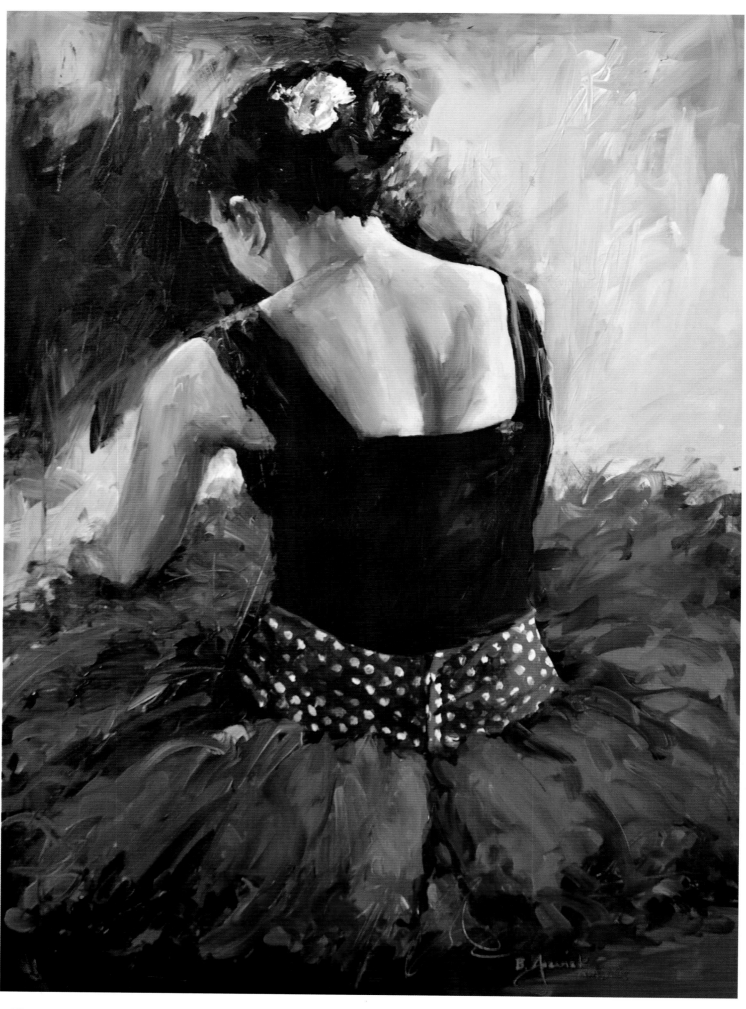

"Prioritize: Paint first, do chores later!" —BEV JOZWIAK

◄ **THE RED PRACTICE TUTU** | Bev Jozwiak
Acrylic on Ampersand Gessobord, 24" × 18" (61cm × 46cm)

My studio is small. It has wonderful north light and functions, but I didn't think oils were the right fit for me, with drying time, chemicals and odors. Primarily known for my watercolors, there are times when I want more of an impasto oil look, which sometimes in acrylic is hard to do. There are products you can buy to keep your paints wet longer, but I just use the heavy-bodied paint and lay it on thick. I paint on Gessobord because its slick surface lets the paint move with ease. After painting an undercoat of orange (Golden's Indian Yellow Hue and Graham's Quinacridone Red) and letting it dry, I paint with an energized hand and quick technique, letting the brushwork show, blending edges and even using a palette knife to scrape through the paint down to the original layer of orange.

▼ **JAZZ SINGER** | Elizabeth St. Hilaire
Collage of hand-painted and handmade papers on deep-cradled birch panel, 20" × 24" (51cm × 61cm)

This piece was an experimentation with highly textured hand-made paper by local artist Judith Segall. Judy provides me with handmade papers from her studio in any color my heart desires. *Jazz Singer* utilizes a full range of fleshtones. I was not sure how a portrait would work with such textured paper, but I thought I'd give it a try. Ultimately this has become one of my most popular and well-loved pieces for the emotion and the love of music in the expression of the singer. I couldn't have done it without branching out to this highly textured paper that I was almost afraid to try. (See page 97 to view St. Hilaire's piece *Seeing Stripes*.)

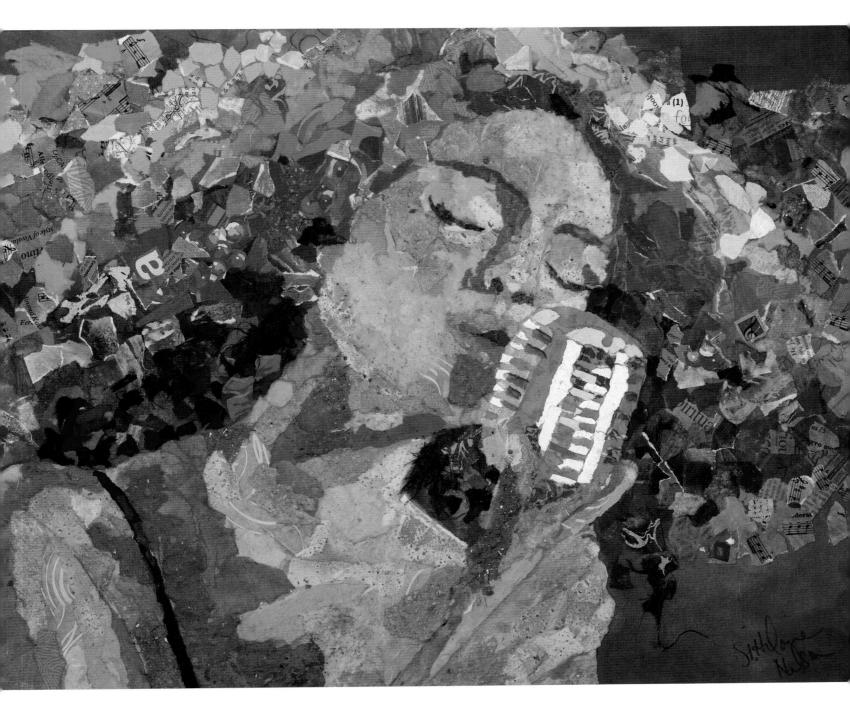

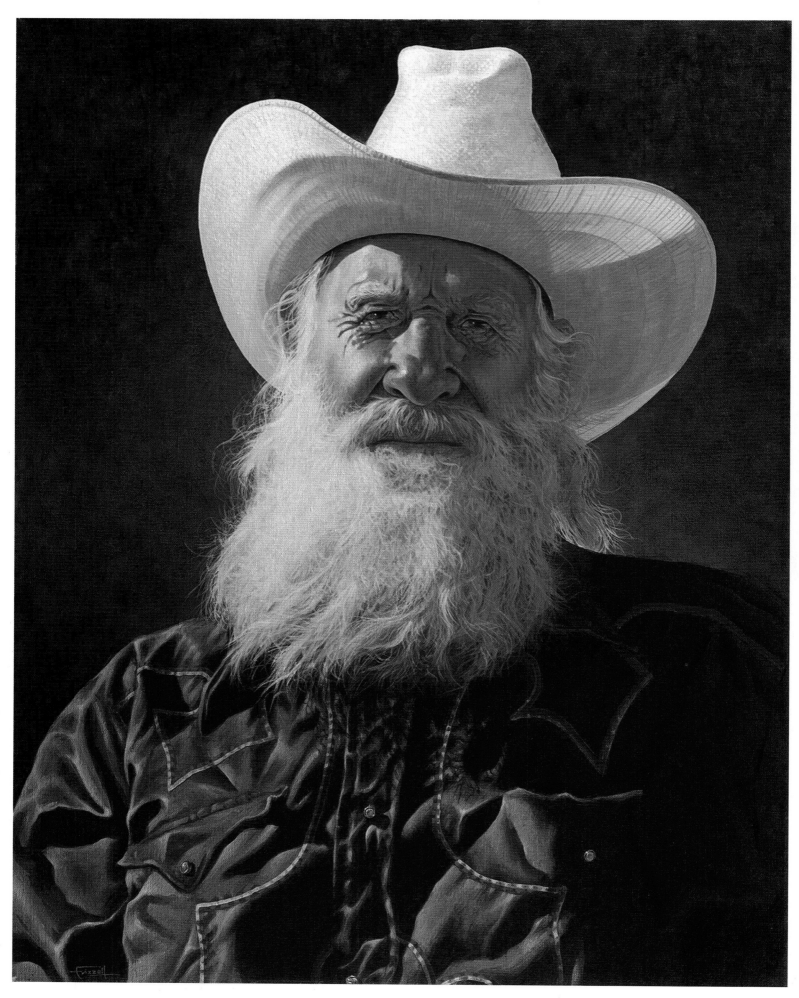

"I want to paint as through my technique were invisible. I want my effort to be in the form and texture created by light, not brushstrokes." — BILL HARVEY

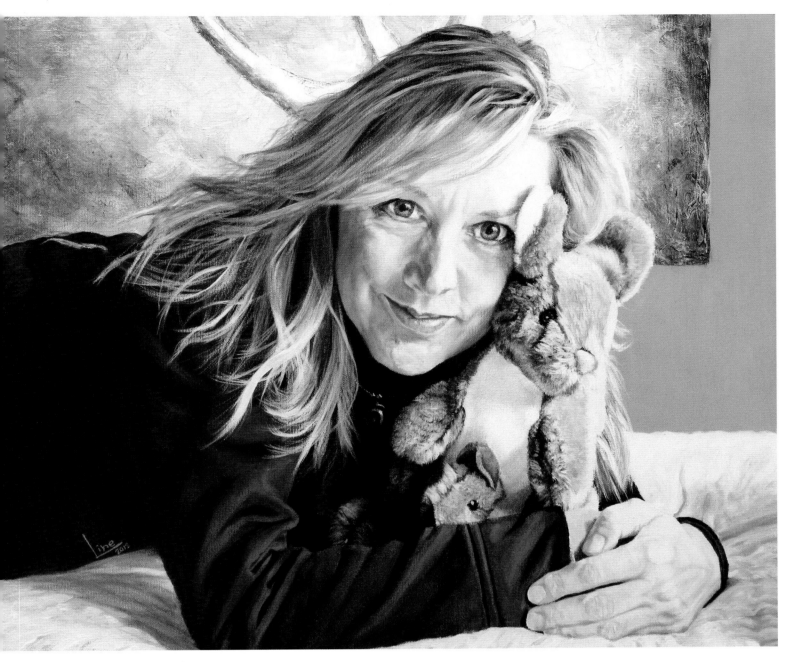

◀ **ALBERT** | Charles Frizzell
Acrylic on stretched canvas, 30" × 24" (76cm × 61cm)

▲ **HUG** | Line Potvin
Gesso, acrylic paint and retarder on stretched canvas
16" × 20" (41cm × 51cm)

A former hard rock miner, Albert was a well known old-timer in the high-altitude mining town of Victor, Colorado. Several sketches and photos in the afternoon sun provided the information for this portrait, along with a later sitting in my studio. Acrylic was the perfect medium to pull out the intense colors and contrasts in this portrait, as well as the texture of his hat, his beard and the crispness of his new shirt. The deep shadows and brightness of his beard accentuated his rugged features. I find that acrylics are easy to scumble, drybrush or glaze to create gradations of value and texture, and the fast drying time is great for passages like the beard in this painting. Glazing to build up the shadows was very effective while maintaining form and keeping the feel of the texture in the clothing and the figure. The background started as a solid dark color, over which I loosely brushed lighter warm hues to create visual depth. (See page 16 to view Frizzell's piece *Survivor*.)

As a portrait artist, my challenge is to capture the personality of my subject through the eyes, the smile or the pose. Because of its many mixing possibilities, I was able to use my own blend of acrylic mediums to create transparency of the human skin. Just as with an onion, I add layers upon layers, from opaque to thinner ones. The blue veins on the hand were painted in between layers; otherwise the skin would look like plastic. My original painting in the background is a mixture of sand and acrylic medium. But in this representation, I used acrylic paint applied with crunched cellophane, which gives it its rough texture, in contrast to the kangaroo's fluffy fur, Lyne's smooth fine hair and the comfy ochre-colored bedspread. My best friend, Lyne, and I had so much fun doing this photo shoot, but unbeknownst to us at the time, she would become a two-time cancer survivor!

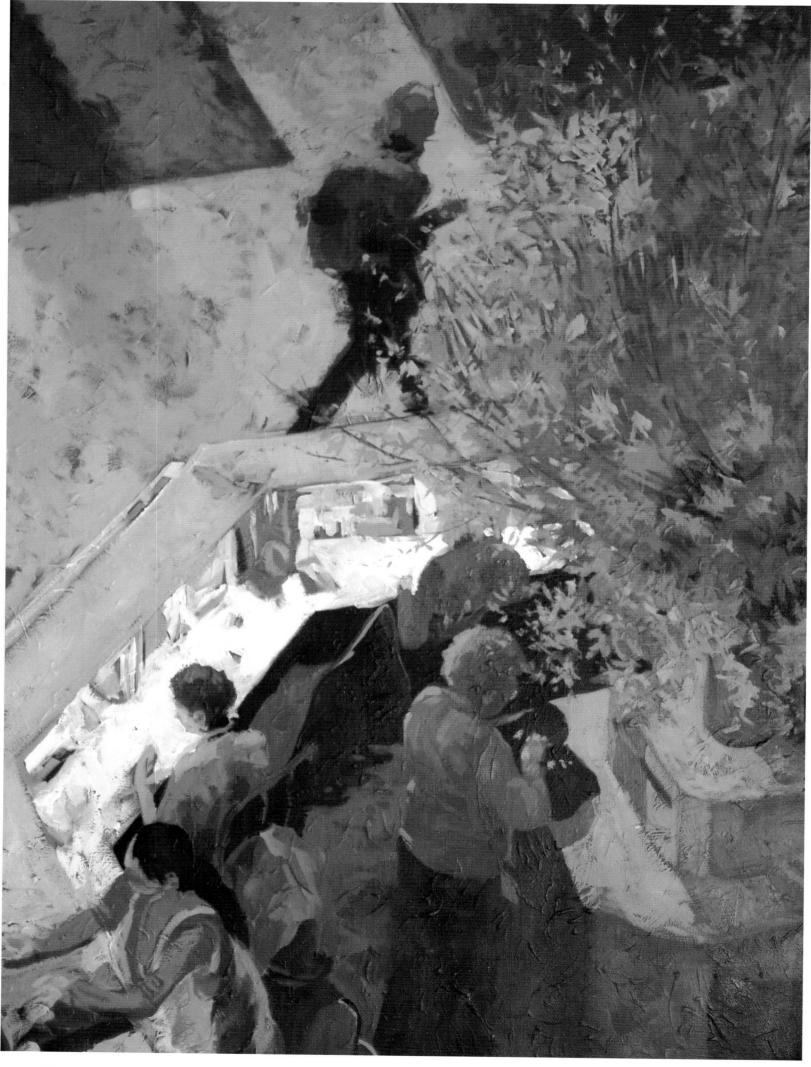

◀ **INFORMATION** | Mark E. Mehaffey
Acrylic on canvas, 40" × 30" (102cm × 76cm)

▲ **SURF CITY HERE WE COME** | Jaclyn Garlock
Acrylic on canvas, 80" × 132" (203cm × 335cm)

It happens to all of us. We work hard on a painting and realize when done that it either does not hold together or just does not say visually what we had in our head. So began *Information*. This painting started life as something completely different. There were heavy layers of acrylic (I now use both heavy-bodied Holbein and Golden acrylics) on the canvas from the painting I had finished but had not signed. After seeing it with fresh eyes every morning for the better part of two weeks (I usually hang paintings on my studio wall for one to two weeks so I can do a daily evaluation before finally signing them), I became disgusted with my effort and painted over the entire canvas with Cadmium Red Light, entirely covering the previous work. That layer coupled with the layers of paint from the painting underneath left a wonderful textured layer of acrylic paint, which to my mind's eye seemed to perfectly fit the movement of both the figures and the texture of the large forsythia. *Information* said everything I wanted it to say and was signed immediately upon completion.

Intense color and dominant imagery are the main elements in my work. I want bold paint, a variety of textures and subjects that are larger than life, art that speaks for itself. It is representational. At a glance I hope to depict a second in time. For me to capture this in a painted image, I need to mimic the instant with a careful setup and photo session as though I am directing a movie or a play. There may be several short situations to act out and lots of photos. These references can then be combined and rearranged to compose the image I finally use to relate my idea. The end result of this direction is a theatrical expression in painting. This image is of the historic Surf Ballroom in Clear Lake, Iowa. It is where the last concert with Buddy Holly was played before the fateful plane crash. It was the day the music died.

"Sometimes we paint stinkers (yes, we all do!).
We just have to let them go and begin again."

—MARK E. MEHAFFEY

57

◀ **DEATH OF WALKING BIRD** | Sandra Kuck
Acrylic on canvas, 48" × 36" (122cm × 91cm)

I admire the works of Chuck Close; he inspired me to paint in acrylics. Acrylics allow me to paint in great detail. I treat acrylics like watercolors and dilute them with Liqutex medium. Each day I mix all of my colors in individual jars, and I prepare to apply each color in thin layers with an air gun. This is an extremely tedious process.

For this painting I worked from photos. Textures are an important part of any of my paintings. I concentrated on the texture of her weathered skin and coarse hair in contrast to the softness of the fur surrounding her neck and hands.

"Don't get a real job, get a real life." —WAYNE EDWARDS

▲ **REFLECTIONS AT SLEEPY BAY, TASMANIA** | Wayne Edwards
Acrylic on canvas, 39" × 87" (99cm × 221cm)

The title of this work describes the picturesque location and the emotional perspective of the subject, which is my wife, Deborah. The painting was based on a photographic happy snap, an intuitive recording of a family member being total absorbed by and in the landscape.

The confluence of granite boulders and pristine waters suited my "color glimpses" technique. The grays (of many hues) allowed the textures of the land to sit solidly while the section of technicolor water ebbs and flows into the bay.

Such a tranquil composition seems unlikely because of the paradoxical nature of the design elements: two focal points, two extremely different textures and the incorporation of technicolor and monochrome. Much of the landscape was painted from memory, so it would seem that both my wife and I were profoundly moved by the beauty of Sleepy Bay.

▼ **ALEGORÍA A LAS COSAS PERDIDAS** | Ada Fabiana Rivas Frangos
Acrylic on stretched canvas, 29½" × 39" (75cm × 99cm)

I believe that behind every assumed daily fact and feeling are secret untold stories. I am passionate about imagining those stories in my daydreams. That's how the process begins, then I write ideas as clues, poems or sketches. This painting is an allegory where she represents the lost things with objects like keys and lenses, also a clock as a metaphor of the lost time. She is surrounded by poplars that are looking at her. They know where she is hiding, but she tells them to be in silence; that way people couldn't find the door, the mental connection to remember where the things are.

"Make your art an experience because experiences are unforgettable for the soul."
—ADA FABIANA RIVAS FRANGOS

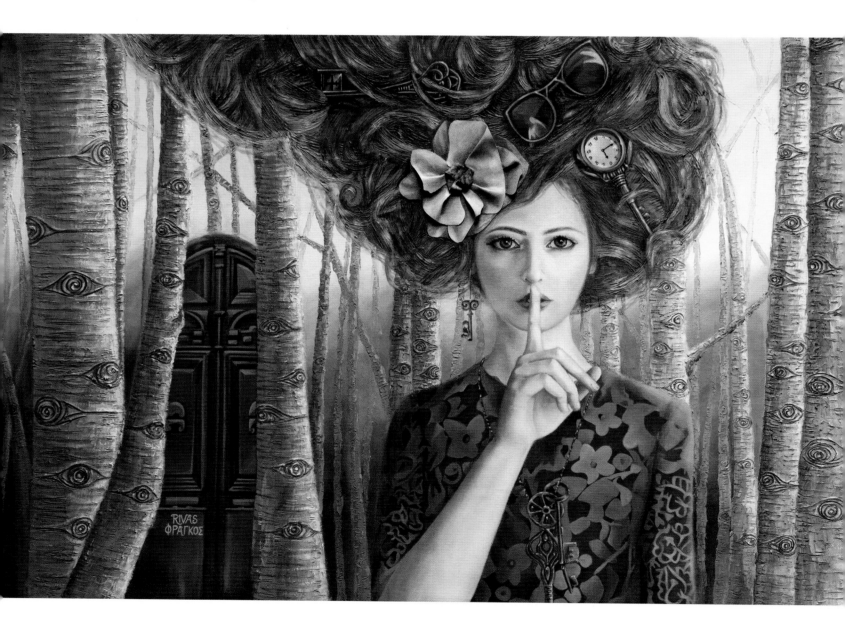

▶ **ENGAGING HER INTELLECT** | Anita Dewitt
Acrylic on canvas, 40" × 30" (102cm × 76cm)

As a figurative artist, I like to work from both life and photographs. Inspiration usually dictates my choices. *Engaging Her Intellect* is an example of my abstracted realism collection. I originally began working this way as a means to control watercolors on a large-scale basis. I found that this style went well with my acrylic work also because it placed my focus on brushstrokes and values, as well as technical excellence. *Engaging Her Intellect* is a wonderful example of how texture and brushstrokes can create movement in paintings that captivate the viewer.

◀ **TOYS IN THE ATTIC –
ANIMAL PARTY**
Kathy Hildebrandt
Acrylic on hardboard panel
24" × 36" (61cm × 91cm)

I love creating detail and acrylics allow me to do it quickly and easily. Since I don't like seeing brushstrokes in my work, my paintings rely on the ability to imply to the viewer the different textures of an object that make it look real.

My still-life work starts with the setup and it can take a lot of time before I'm happy with the composition. I then transfer my detailed drawing onto my support, which has been lightly toned with a thin layer of Quinacridone Gold. Being a detailed painter, I typically work one object at a time from top left to bottom right. Acrylics allow me to create the impression of different textures quickly, whether it's the shine of a metal or ceramic surface, the soft fuzzy texture of a stuffed animal or the flat appearance of paper.

Still Lifes and More 3

▲ **INDIAN TEMPLE SERIES II** | Sophie Sorella
Acrylic on Masonite, 24" × 30" (61cm × 76cm)

▶ **LITTLE TREASURES** | Margaret Nisbet
Acrylic on canvas, 19½" × 15¾" (50cm × 40cm)

The expressive nature of the figures and the exciting texture of the stonework drew me to paint this piece. While in the temple I was able to make some sketches of these exotic figures. I found the broken noses, chipped faces and missing fingers particularly engaging. I positioned myself in such a way that the main figure's gaze rests directly upon us—serene and welcoming—while the figures behind her strain to see just who it is that is looking at them. I like the idea of "us, watching them, watching us."

Back in the studio I began by applying rough generous layers of gesso to Masonite using a palette knife. Once it had fully dried I painted the whole board in Raw Umber to act as my midtone. I wanted bold, crisp pockets of color in this painting, with minimal blended areas, in order to capture the pronounced highlights and deep shadows. The fast drying nature of acrylic paints worked well to help me achieve this.

Little Treasures is a still-life painting of things I love. Each object is carefully chosen for its emotional value, color, texture and form. In my studio I set up the still life and paint directly from life.

Using acrylic tube colors, liquid acrylic medium and soft brushes, I work from dark to light in thin glazes. By layering subtle tone and color changes for each object, I establish its form and texture. For lighter areas and highlights I use varying degrees of thicker paint.

The versatility of acrylic with its quick-drying nature allows me to glaze countless layers of paint upon paint until I have achieved the subtle transition of light and shade that makes my work so realistic.

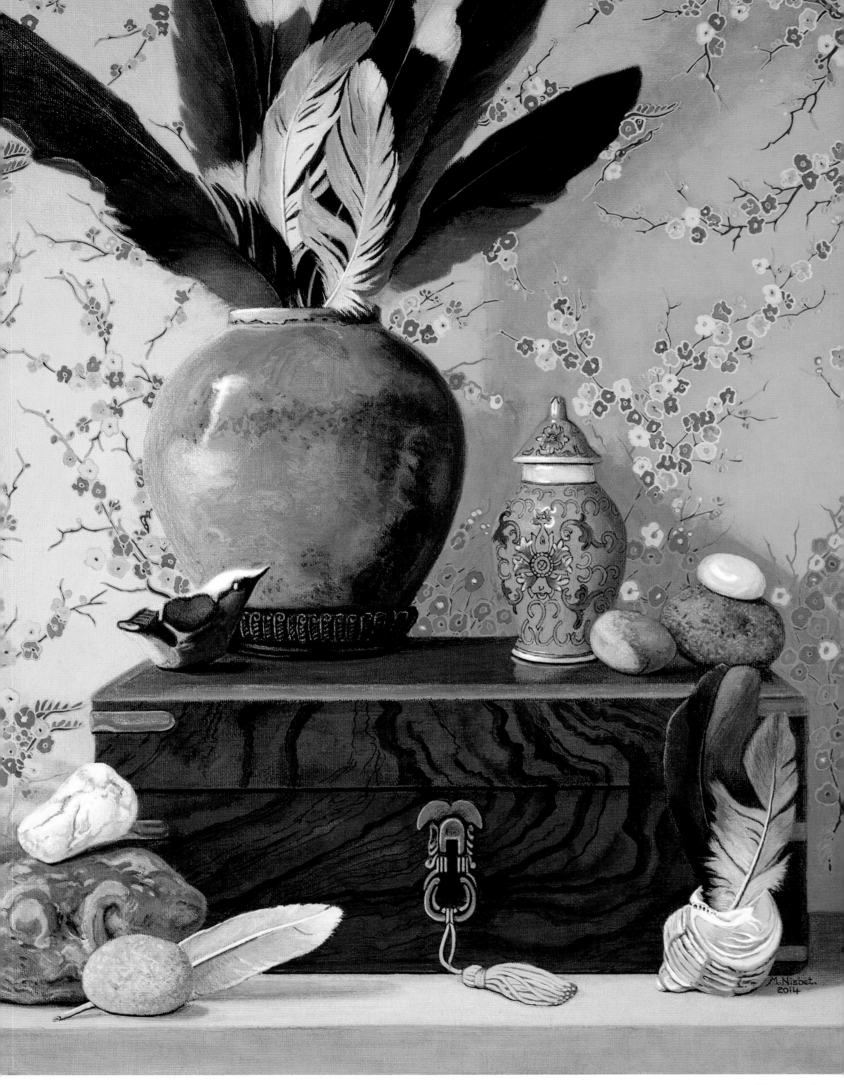

"If you are painting something that is crazily complex, pay attention to one detail at a time so that you don't feel overwhelmed by the entirety of the image and be patient with yourself, and have fun." —ROBERT B.R. GRATIOT

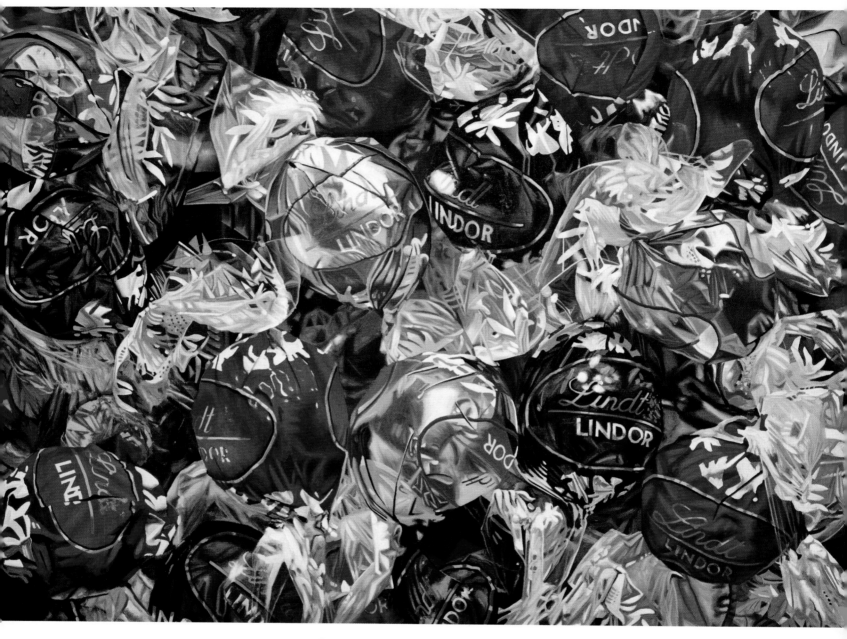

▲ **SWISS CANDIES** | Robert Gratiot
Acrylic on canvas, 32" × 46" (81cm × 117cm)

My still-life paintings often share many elements with my cityscape paintings, and the painting process is exactly the same. The Swiss candies, being wrapped in shiny foil and then rewrapped in clear cellophane, offer a terrific venue for painting all sorts of abstract areas of colorful textures, putting them together like pieces in a jigsaw puzzle, and creating a rather realistic whole. For me, it is a pretty tough job, but it's also a lot of fun and very satisfying in a goofy sort of way. (See page 8 to view Gratiot's piece *1999 Broadway, Denver*.)

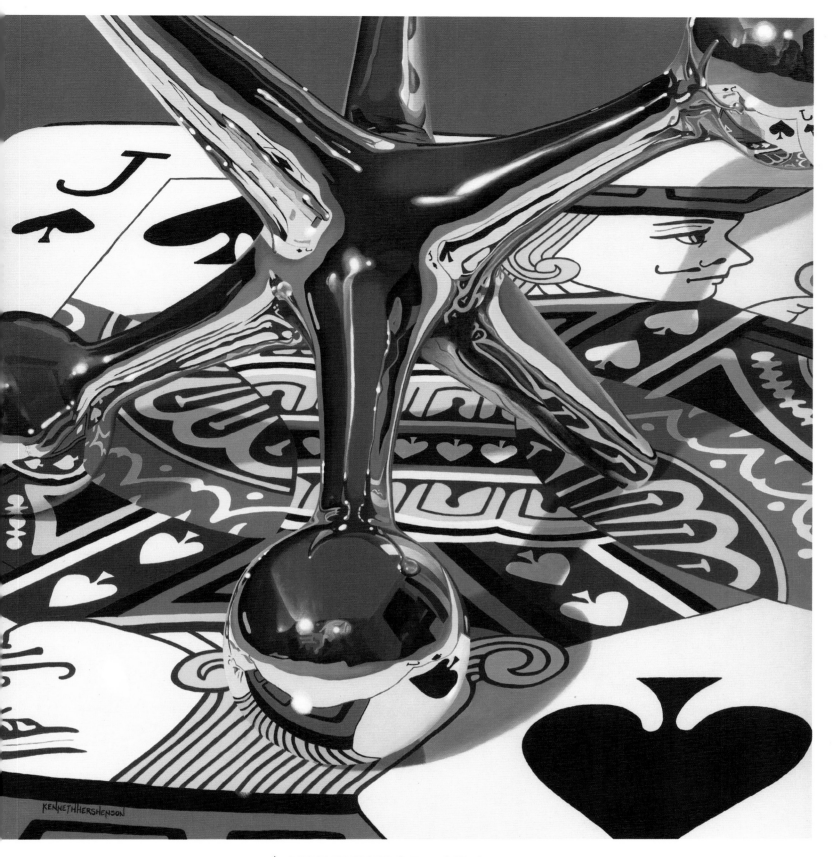

▲ **A PAIR OF JACKS** | Kenneth Hershenson
OPEN acrylics on wrapped canvas, 36" × 36" (91cm × 91cm)

This is the second painting in my acrylic series titled *I DO Know Jack!* in which I use wordplay titles utilizing the ubiquitous children's toy. I'm fascinated by the sleek magical texture of reflected images on metal. The challenge of capturing reflections on this complex geometric shape is a driving force for me as well as using humor in the titles. Years ago I worked with watercolor and colored pencil but felt compelled to create larger paintings. I decided to stick with water-based mediums, so acrylic was the natural choice. I use Golden OPEN acrylics to give me more time to blend areas on my large canvases. I typically start with several hundred photos from setups and then, after laying out my image to canvas, allow more painterly things to happen outside of the jack.

▼ **ROYAL BLUE (JAPANESE ARITA)** | Bruno Capolongo
Acrylic on five panels, 24" × 24" 2½" (61cm × 61cm × 6cm)

Royal Blue was painted from life with acrylics because the medium allows many layers that dry quickly for immediate delivery to the gallery. In this painting a tinted mixture of gesso and gel medium was applied unevenly in areas with a large palette knife. The bowl was drawn in and sealed with a self-leveling gel. The cracks and crevice texture is largely illusion, but founded upon the actual texture applied earlier. The idea is to tease out an illusion of more texture from the relatively modest gesso texture beneath by taking cues from the character of the surface. The result is a painting that is equally abstract and highly realistic. This image was kept minimal to focus on the beauty of the bowl and to keep it contemporary.

"The numerous acrylic mediums available today make acrylics unrivalled in the area of textural possibilities." —BRUNO CAPOLONGO

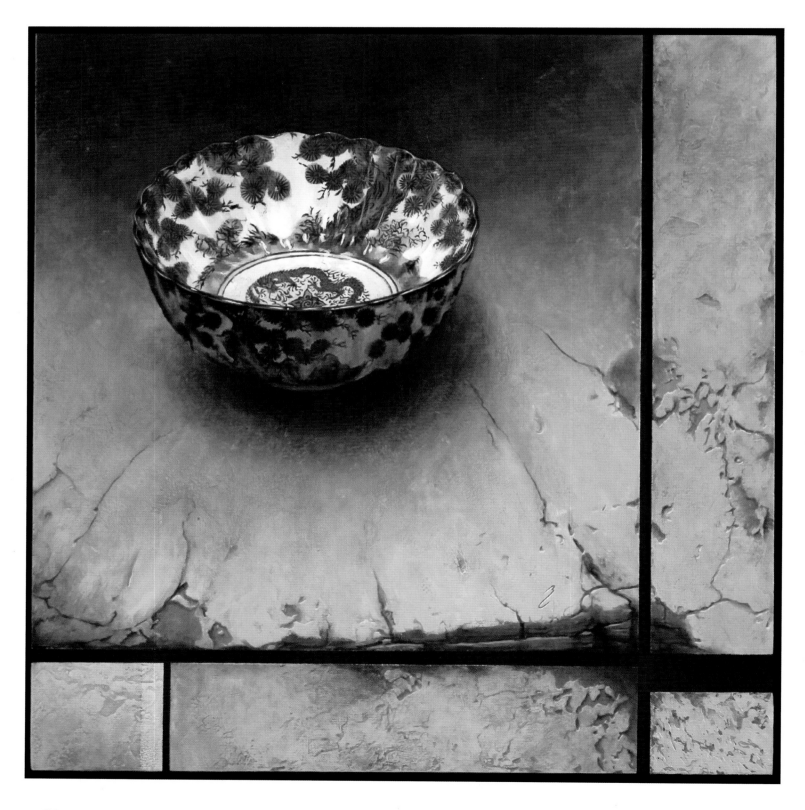

▲ **BURANO MEETS MURANO** | Philip Evans
Acrylic on Crescent 310 cold-pressed illustration board, 100% rag
20" × 20" (51cm × 51cm)

This painting was painted in my studio. I always draw my first subject in great detail then use a simple grid system to visually transfer my image straight to a prepared surface using a light sepia acrylic outline. I have a large library of photos I have taken and construct my paintings using those as reference material for many different subjects.

My technique is building, glazing, underpainting, often quite thin semitransparent layers of acrylic. I highlight with white or lighter colors and lay more acrylic over the surface, building a very pleasing translucent appearance on the original. I am passionate about the process; time is of no concern. Numerous trips to Italy and in particular Venice have influenced my work over the years. My painting *Burano Meets Murano* celebrates textures—Venice is all about ancient stone and texture.

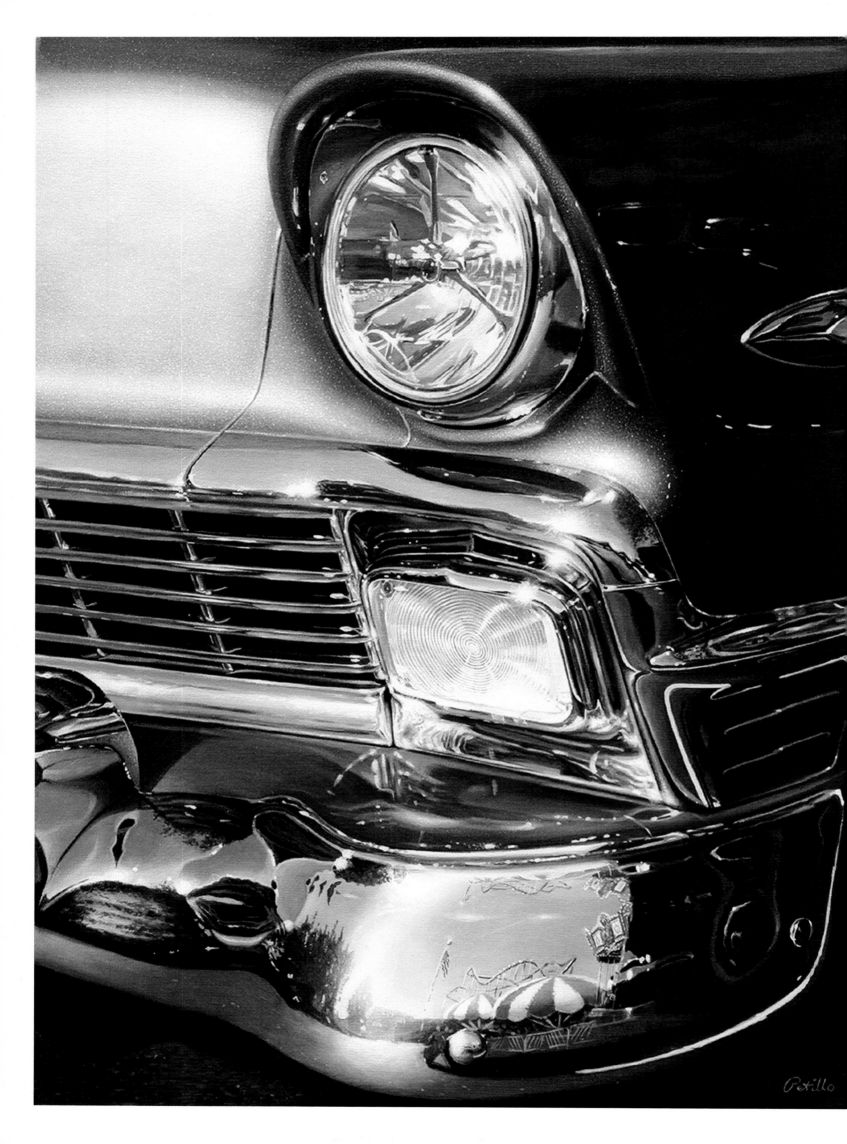

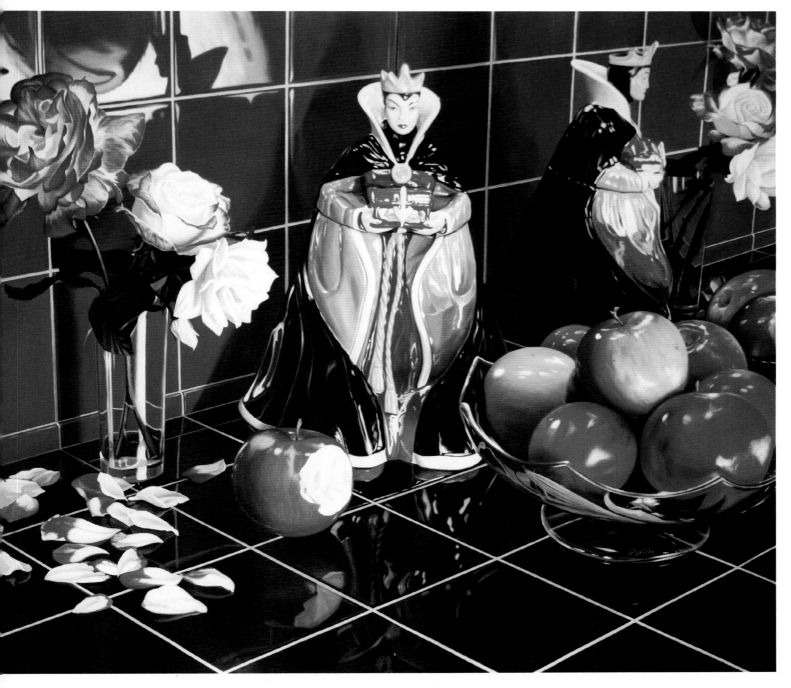

"Mirror, mirror on the wall, this was most challenging of them all." —BOB PETILLO

◄ **SILVER AND CHROME** | Bob Petillo
Acrylic on canvas, 36" × 28" (91cm × 71cm)

This '56 Chevy sparked like a jewel parked ringside at a church carnival in Charlotte, North Carolina. An addition to my *Reflections of America* series, and defining the textural differences between metal flake silver auto paint and chrome, I had a blast applying the paint job on my Mustang to this '56 Chevy Crown Vic. It's all an illusion, of course, looking really real. The roller coaster was added to the actual reflection to create more depth. We know it's all very smooth yet reflecting a variety of textures. It's acrylic paint applied with 4,000-year-old technology; the paintbrush is just a stick with hair on the end of it. Yikes!

▲ **THE EVIL QUEEN** | Bob Petillo
Acrylic on canvas, 53" × 63" (135cm × 160cm)

From *Snow White*, the evil queen, her poison apples and a dying flower pose in the mirror for this most vivid painting. A part of my *Cookie Jar* series, this photorealism piece was painted with a sensitivity to reflections of light and color on a variety of textures. From the glazes of ceramics to the softness of flower petals, the application of acrylic paint was handled with a variety of techniques directly and in combination, building up layers of colors and values.

▼ **THE LAST SUPPER** | Steve A. Wilda
Acrylic on Gessobord, 19¼" × 34¼" (49cm × 87cm)

The concept began with acquiring the wooden plate, the title coming shortly thereafter. A spiritual reference to the cross subtly appears in the ladle and pot handle. The faux table was assembled of boards from my father's barn. Creative comic relief came into play in choosing the food remains of grape stems and wishbone, fairly uncommon elements in still-life art. The conglomeration of corroded metal, crazed ceramic and brittle fabric was a case study in painting textures. Used and abused brushes assisted in the final outcome.

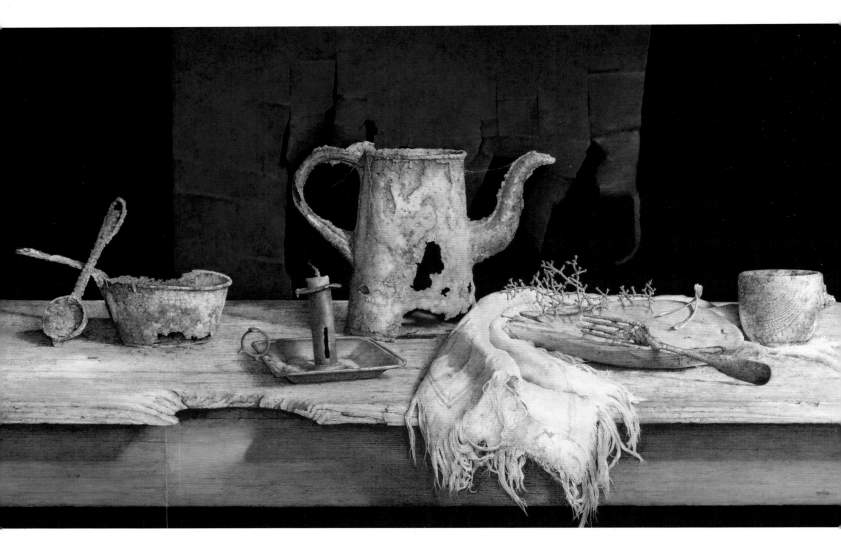

▲ **"WHEN WE GET A LITTLE OLDER..."** | Steve A. Wilda
Acrylic on Gessobord, 10¼" × 16" (26cm × 41cm)

Camaraderie and communication exist between the dolls seated in an antique high chair. It is no question they're in this together, but which is the spokes-doll, the prophet, making the statement? Its intimate, closely cropped composition accentuates the painting's concept.

On the left side, the round end and spindle of the chair's arm adds an element of design. It also forms an imaginary line across the painting to balance with the doll's elevated arm on the far right.

Working in acrylics allows me the freedom to pursue my passion in the character and textures of things past. A parched atmosphere of aging is obtained through dry-brush, glazing techniques and whatever else works in achieving my ultimate goal.

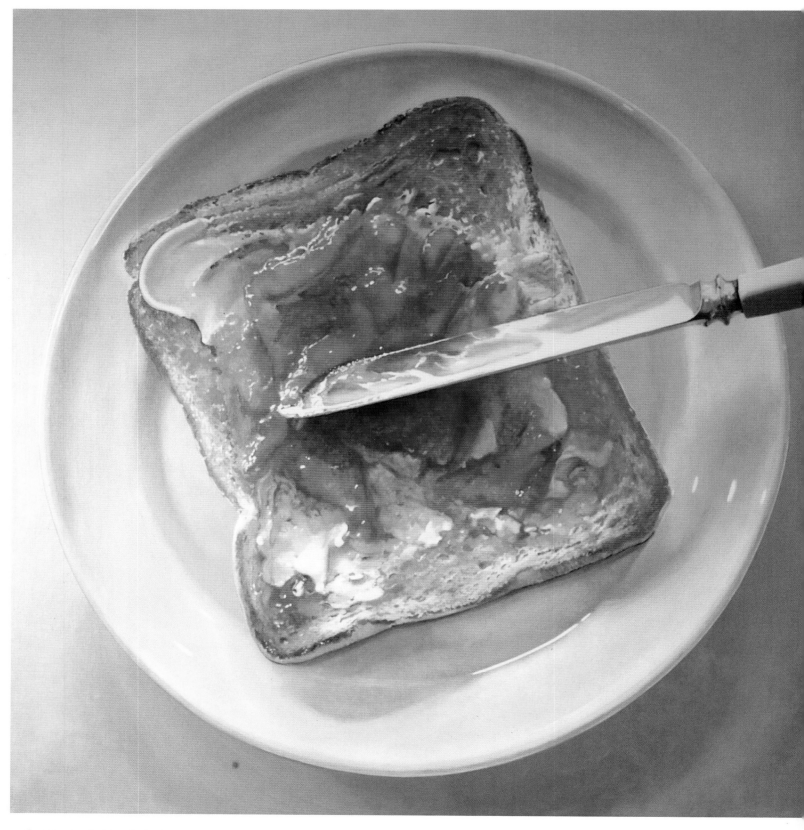

▲ TOAST | Cynthia Poole
Acrylic on fine linen, 27½" × 27½" (70cm × 70cm)

Marmalade is spread lavishly on a piece of buttered toast like an advertising image for jam. The objects were set up in the studio and photographed many times. Both objects and photographs were used to construct the painting: The chosen piece of toast resided in the freezer for reference during the painting process. The geometry of the composition is important: a rotated square within a circle within a square, and the plate and knife are *objets-types*.

A very careful drawing was followed by basic blocking in and then some redrawing. Masking was used while working on the porcelain plate so that the shading—with fan brushes—could be worked up with wet paint and a fast brush without damaging other areas of the painting. Textures of toast and marmalade, painted last, had to be very convincing to convey the reference to adverts and mouth-watering food.

▼ THREE GREEN AMIGOS | Wm. Kelly Bailey
Acrylic on gessoed ¼-inch (6mm) hardboard panel, 12" × 16" (30cm × 41cm)

My subjects vary from landscapes to still life to people. In doing a still life I have the opportunity to choose and stage the "characters" to bring a concept to life. I've always thought it is something wonderful that people from different backgrounds, nations and races can become close friends, even closer than brothers (Proverbs 18:24b) and stand by one another even when facing danger; hence, the three different fruits on a cutting board—like early Christians in an arena or more modern Christians in a concentration camp. Our brave and noble actions are always seen and noted by others, even when such observers are unseen by us. Of all the textures in this composition, the avocado and the oak cutting board with wet and dry areas and lots of knife marks scored into the wood were the most challenging to paint.

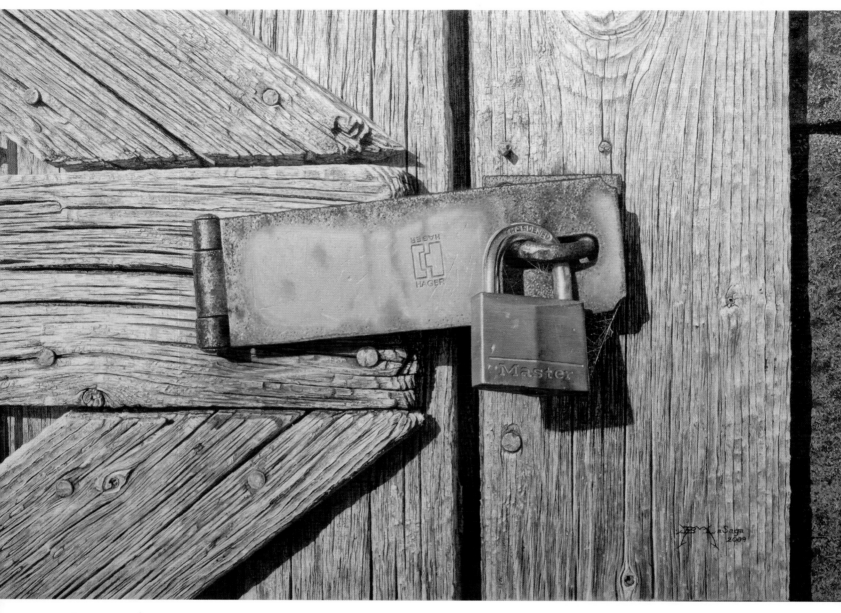

▲ **THE BARN DOOR** | Brian LaSaga
Acrylic on panel, 16" × 24" (41cm × 61cm)

I love working with acrylics simply because they allow me to layer very quickly so my colors blend visually rather than physically as with oils. They are very clean to work with and I love their smell plus they fit so well for my style of working. I use heavy-body acrylics, which I scoop from the jar and mix with my palette knife on a homemade combination palette consisting of parchment paper, cotton rags and a cafeteria tray. My favorite brand is Golden acrylics, but I use the Stevenson and Liquitex brands as well. I use just about every brush except for sable. My favorite is the synthetic brush. Acrylics dry fast and would ruin sable brushes. Since I prefer high realism, I use only water with my acrylics. (See page 29 to view LaSaga's piece *Facing the Elements*.)

Acrylic on gessoed hardboard panel, 15" × 20" (38cm × 51cm)

I started working with pen and ink and decided to give painting a try. I'm from a small town and didn't have access to art instructions or classes, so I learned on my own from trial and error. I found that oils took too long to dry and watercolors could not be controlled. I discovered that acrylic was the perfect medium for me. I loved the layering techniques to achieve the look I wanted and have been using acrylics ever since.

Working in acrylics gives my art realism as I am able to capture the grain in the wooden wharf and use shadowing techniques to create the curves of the barrels and the indentations of the soles of the rubber boots. I captured this fisherman's scene waiting for my nephew to return with his catch. The boots in the painting are his.

Down on the Wharf was completed in my studio with the help of on-site sketches and photographs. I transferred my image to panel using tracing paper, then began with a wash of Burnt Umber to darken my blues. I then laid in the different shapes with reds, earth tones and complementary colors. When I was satisfied with the shaping, I painted the details.

"The magic of acrylic and its drying time is that you can combine many painting techniques to create actual texture and implied texture all in one sitting." —BOB KLING

▲ **BURSTING TO LIFE** | Bob Kling
Acrylic on stretched 10 oz. cotton duck canvas
36" × 48" (91cm × 122cm)

▶ **PEEKABOO BEAR** | Deb Ward
Fluid acrylic on Twinrocker handmade watercolor paper
29" × 21" (74cm × 53cm)

Crewing for a hot air balloon team for over twenty years has given me the opportunity to take hundreds of photos for painting subjects. I wanted to portray the forms that are created by the first bursts of air into the balloon fabric. After a few basic pencil lines on the canvas to establish the shapes and folds, I gave it a quick spray fix. I approach each painting differently and instead of working over the entire surface at once, I isolated each colored shape of the balloon, beginning with the yellow, and painted directly on the canvas with no underpainting, establishing the values of the folds as I worked. Balloon fabric also has small folds going in all directions from being packed away, which adds another textural element. The quick drying time of acrylics allowed me to gently scumble lights and darks to create these small folds.

A friend and I attended the local antique market where I took snapshots of interesting items just as they appeared in the sellers' booths, including these old teddy bears awaiting a new owner. This painting became one of several created for a paint trial for Chroma Atelier Free Flow paints. I like to paint with fluid acrylics in a watercolor-like manner on watercolor paper and have had some Twinrocker handmade paper in my stash for years, waiting for a time when I felt my skills were well honed. Now that some of my paintings have appeared in books and magazines, I could finally justify its use! I tried to show texture via the thread in the rag rugs on which the bears sit, the stitches in their paws and noses, by scumbling areas of their fur and lifting other areas, using a fan brush to indicate fur, and indicating the shiny plastic of their eyes and noses. Since the largest bear was partially hidden behind the rest, his eyes covered, the title became obvious to me!

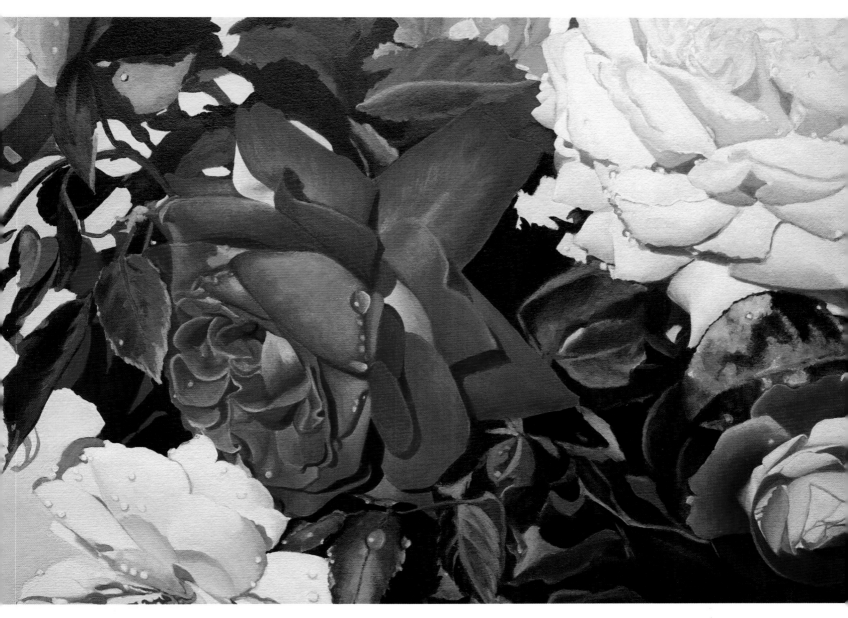

"Work is love made visible." —KAHLIL GIBRAN

◀ **FATHER AND SON** | Craig Cossey
Acrylic on Baltic birch plywood, 47" × 24" (119cm × 61cm)

When I think of texture I think of a variety of surfaces. There's also emotional texture, a variety of feelings and thoughts during the painting process. I experience from loss to hope, from peace to anger while I paint. The variety comes from a patchwork quilt of emotions stirred from my memories. All the emotions make a richer painting. I don't have a concise explanation of my work. I can say that it comes from my heart. (See page 51 to view Cossey's piece *The Blue Years*.)

▲ **ARIA** | Victoria Chiofalo
Acrylic on 300-lb. (640gsm) cold-pressed Arches
22" × 30" (56cm × 76cm)

Acrylic's versatile medium allows me to control fluidity with water as my medium. My garden is filled with roses and I consider them my models. Photographs were used due to the roses' short life span. This painting was a challenge since I had to glaze. Diluted colors were applied for transitions of hues and their smooth texture. I have a red glass to view my painting as it progresses to check my values. It is very helpful to have a diminishing glass to see the overall of my work. While painting I feel how each brush-stroke caresses the petals like a constant love affair until it has to stop to achieve its final goal.

"Remember light is light and dark is dark." —TANYA REMY

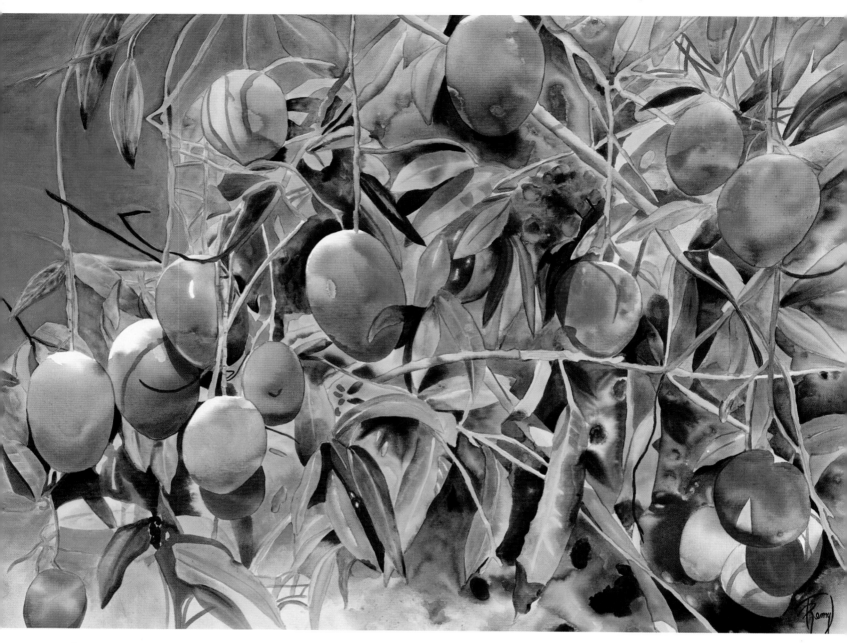

▲ **MANGOES** | Tanya Remy
Liquid, medium and heavy acrylics on stretched canvas, 48" × 60" (122cm × 152cm)

Painting with watercolor for twenty years, I was amazed at how acrylics helped my paintings come to life. I accomplished *Mangoes* by using heavy acrylics to build up the branches and leaves, then medium acrylics for the sky and to soften the painting. Finally I wet each mango with water and applied liquid acrylics for a watercolor effect.

Photography has been my inspiration in creating all of my different painting subjects— whether my photos or photos from clients. I drove by this beautiful mango tree and stopped for a photo. There was a hand-painted sign on the tree that read "Mangoes—don't even ask." I delivered a copy of the painting to the homeowners who were in their eighties. They traded the painting for a box of mangoes.

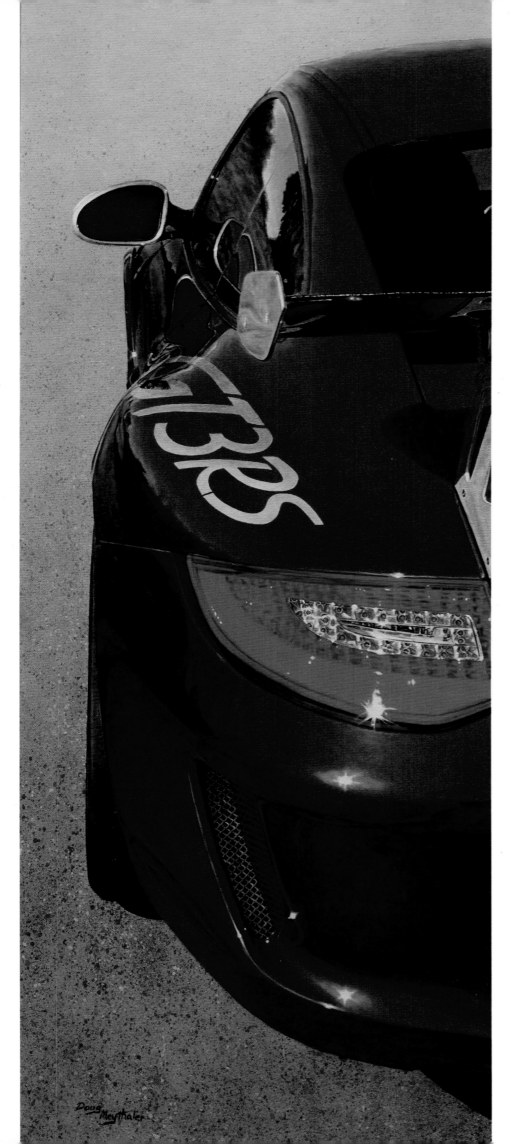

Doug Meythaler

◄ **GT3RS** | Doug Meythaler
Acrylic on Crescent watercolor board
30" × 12" (76cm × 30cm)

As a studio artist I love going out and photographing my own reference material from car shows and other events. Working from these photos allows me the time necessary to accurately capture the details of my subject matter in a photorealistic approach. Working with glazing techniques also takes time and patience. However, the finished look of depth and vibrancy is the payoff. In this piece the challenges were to capture the beautiful lines of the car and the look of highly polished metallic paint while also painting the surroundings that are reflected in the mirrorlike finish.

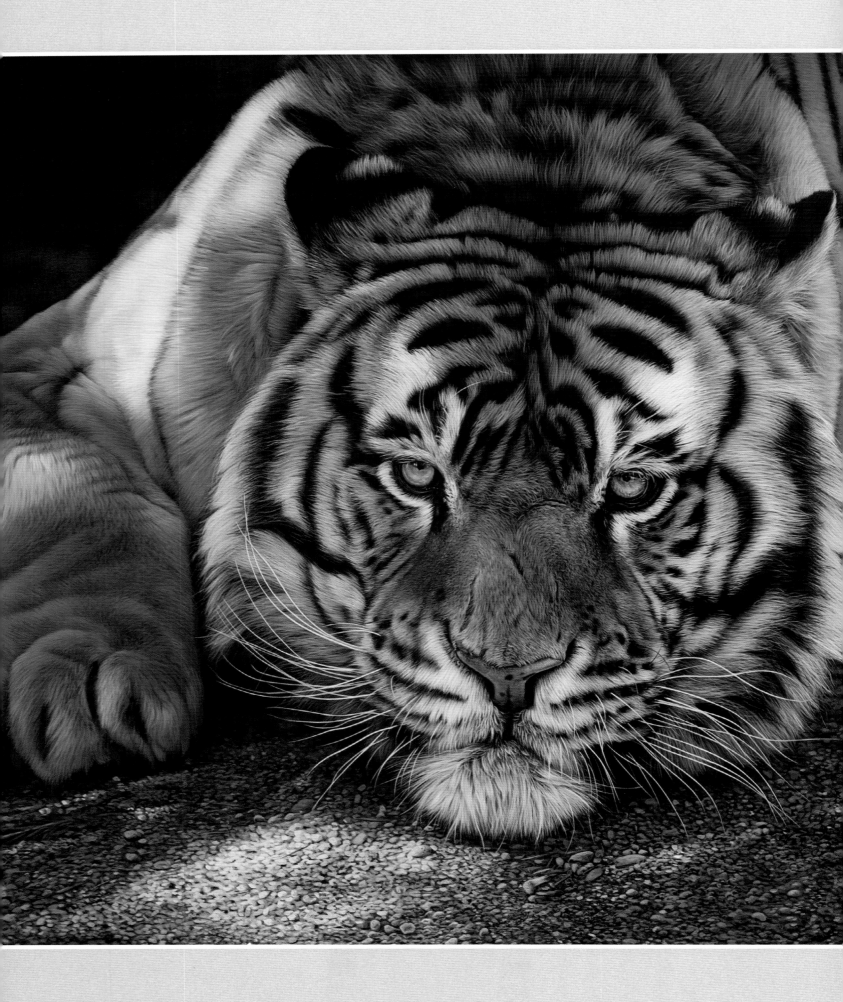

Acrylic is an extraordinary medium that allows me to work in my own way and rhythm. Acrylic allows for great sharpnesses and magnificent transparencies. The quick dry time is key because I like working with gels and mediums to create glazes. It takes great patience but it suits me. I start out with a black or very dark background, then gradually build the lights to the brightest whites.

My paintings are always an expression of a situation in my personal life. The symbolism of animals allows me to stage situations that reflect the most striking moments of my life; to help me try to answer the existential questions that haunt me. This painting expresses a moment during a particularly difficult time in my life, where my vital energy, which I considered indestructible, showed a weakness. Even the most powerful of big cats needs to rest and to isolate itself one moment to review and get back a few of its strengths.

Animals and Wildlife 4

"I just let the paint drip in a very random way and let the artwork create its own energy and movement that I follow and expand upon." —MARCO ANTONIO AGUILAR

▲ **INK MASTER** | Marco Antonio Aguilar
Acrylic on canvas with gold and copper leaf, 12" × 24" (30cm × 61cm)

Ink Master is from my *Splash of Color* series. I first primed the canvas with black gesso and then drizzled watered-down white gesso all over it. I moved the canvas around, causing the white gesso to drip in different patterns. This is a very organic process and every painting is different. Next, I blocked in the octopus and painted him in black and white. After the black-and-white painting dried, various color washes were applied to create the desired colorful effect. Next, I hand-applied sheets of genuine gold and copper leaf for some extra highlighting and texture, followed by a high gloss varnish over the whole thing. The resulting image is one full of various textures, and the multiple layers give it a sense of depth.

▲ IVORY | Eleni Kastrinogianni
Acrylic on canvas, 31½" × 31½" (80cm × 80cm)

Acrylics allow me to express myself spontaneously, experimenting with bold colors, forms and textures. My painting process begins by building layers on top of layers of paint with no predetermined designs and color palettes, trying to eliminate the terrifying blank canvas. With the use of nontraditional painting tools such as my hands, credit cards, brayers, toothbrushes, or bubble wrap, I create random marks and lines, which change constantly from the beginning until the final piece emerges in unexpected ways. I spray water on wet paint, drip, splatter, sprinkle and turn the canvas upside down to create a rich and textured surface. I work primarily in acrylics but love to incorporate inks, pencil, spray paint and collage in my paintings. Acrylics give me the freedom to combine all these different mediums and the flexibility to change my imagery until the last minute.

While birding in a park in Connecticut, I stopped to photograph these beautiful rhododendrons. I loved how the light was filtering through the leaves and petals. Nearby I observed a group of goldfinches and I thought what a wonderful combination! The yellow, violet, green and red complements were artistically very appealing to me. Acrylic is such a versatile medium that it's perfect for achieving the soft almost tissue-paper look of the petals and the tough, hardy texture of the leaves of the plant. By painting opaque and transparent layers and by using wet-into-wet and dry-brush techniques, I can create hard and soft edges where I want them. I generally use Liquitex and Golden and I've recently been experimenting with Chroma, which is nice. I don't use retarders or mediums, only water. (See page 93 to view Mullane's piece *Nestled Inn.*)

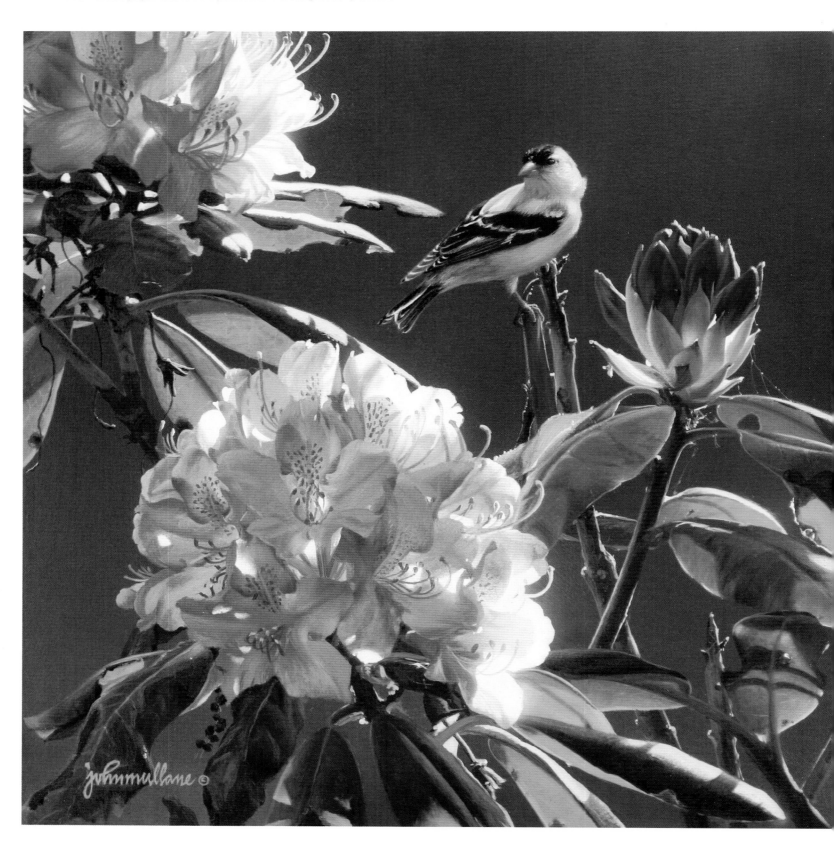

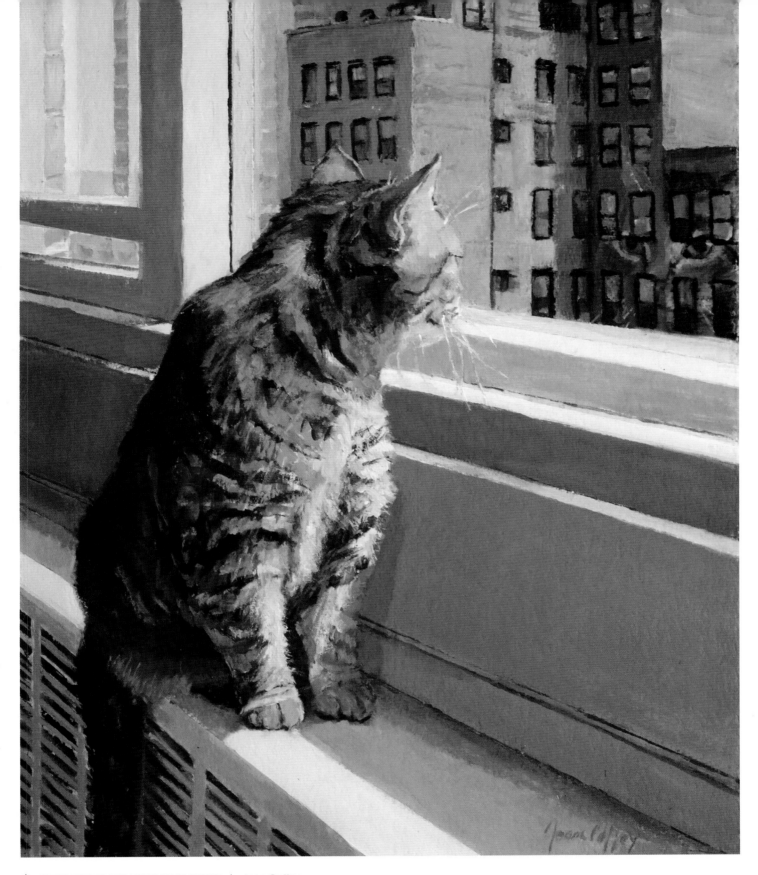

▲ **CITY KITTY ENJOYS HER VIEW** | Joan Coffey
Acrylic on 300-lb. (640gsm) cold-pressed Arches
14" × 11" (36cm × 28cm)

After years of painting with watercolors and oils, I began working in acrylics for convenience while traveling. The benefits of this forgiving medium were immediately apparent: It can be painted thin like watercolors or thick like oils, it is quick drying for immediate overpainting, and it is nontoxic and easy to clean up. I have never looked back!

This painting is based on photographs aided by my previous sketches and paintings of the city kitty, Mocha. I use Golden and Liquitex heavy-body paints with water. The detailed background was the biggest challenge and the most time-consuming part of the painting. I painted Mocha and her reflection last, pretty quickly and with total enjoyment.

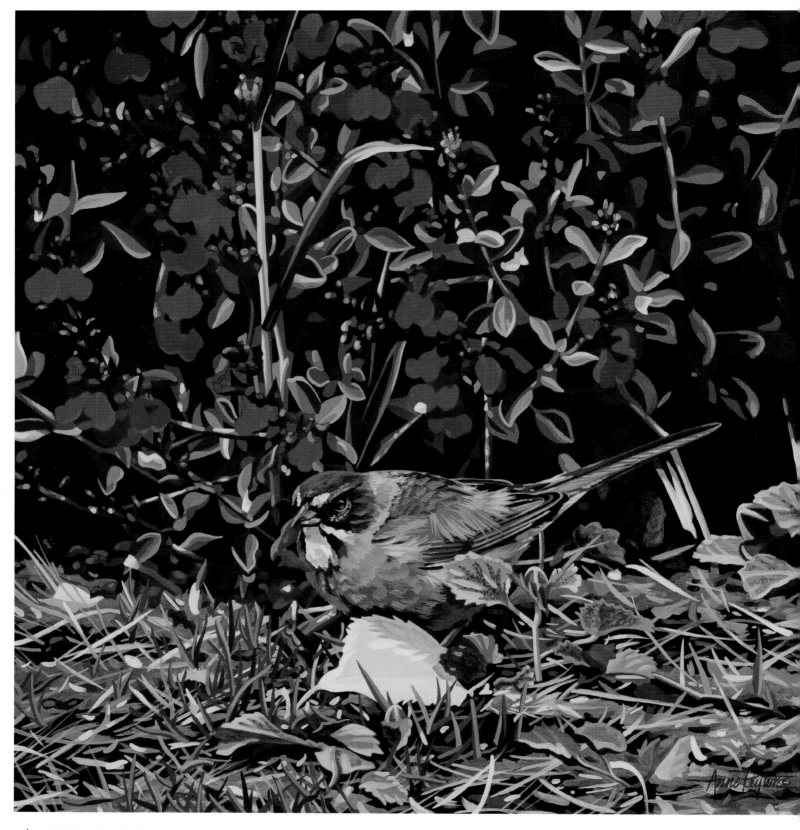

▲ **PICKING FLOWERS** | Anne Peyton
Acrylic on Ampersand Gessobord, 12" × 12" (30cm × 30cm)

Sometimes a painting needs to be created just for the fun of it. *Picking Flowers* filled that requirement for me. Desert subjects occasionally provide the opportunity to paint with bright and unexpected colors. In depicting the salvia flowers, I got to use passionate reds, pinks and purples, which were a special treat as my palette is usually more subdued. As I observed this green-tailed towhee moving among the plants, he picked up a flower in his bill, and the title and the painting idea were born. This small painting has many different textures all juxtaposed against one another: the smoothness of the leaves and flower petals, the roughness of the grasses, and the soft textures of the feathers. Pure joy to paint!

Inspired by my love of horses, *Humble Reflections* expresses the reflective nature and gentle personality of horses. I had developed a close relationship with this particular horse, named Guiness, who had survived colic surgery and other injuries. He was frequently on stall rest and spent much time gazing out of his window as if looking out at the world, longing to run free.

To plan out the composition I created a contour drawing on bristol paper based on a reference photo I had taken of Guiness. I then made a photocopy of my drawing and transferred the drawing onto the stretched canvas by placing the photocopy on top of the canvas with graphite paper in between. A ballpoint pen was used to trace over the lines. Once the drawing was transferred, I developed the painting, section by section, with such techniques as wet-into-wet and glazing.

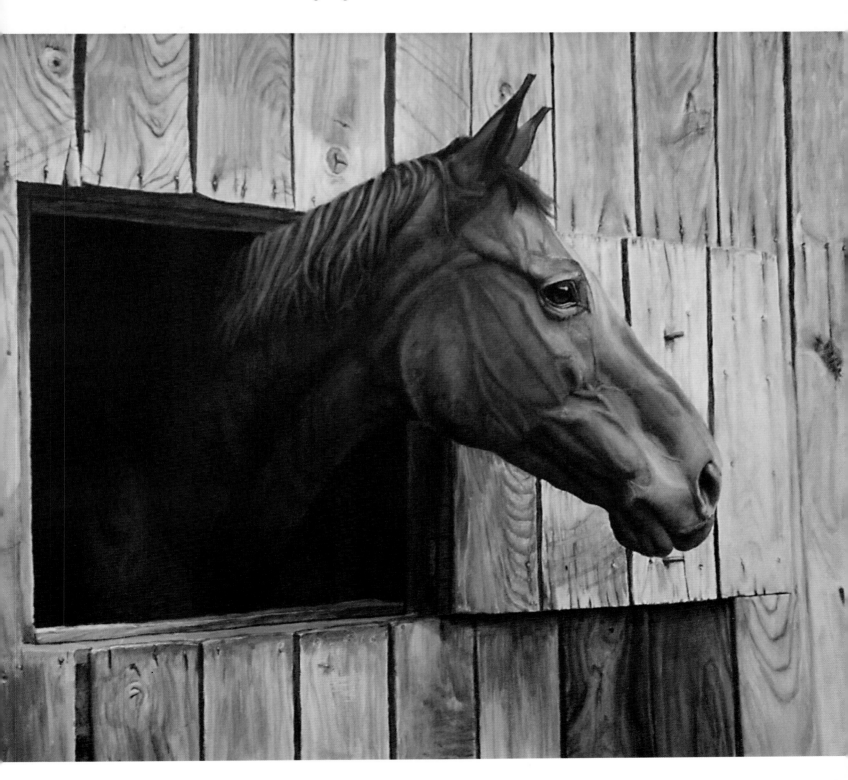

▼ **SPRING MORNING – GRAY FOX** | Kevin Kohlman
Acrylic on hardboard, 18" × 16" (46cm × 41cm)

As a wildlife artist, I enjoy the challenge of creating realistic-looking textures in my paintings. In this piece I want the viewers to imagine that they can reach out and feel the soft fur of the gray fox as well as the rough surface of the sunlit rock.

To create the rock's textured appearance, I first used a paint roller to apply gesso on hardboard. This produced a moderately textured surface. Next, I painted the rock with a light cream color. After this layer dried I painted over it with the primary rock color. The final step was to remove some of this top layer of paint by gently rubbing it with a slightly damp cotton swab to create the illusion of sunlit rock texture. I had never tried this technique before, but I was extremely happy with the results.

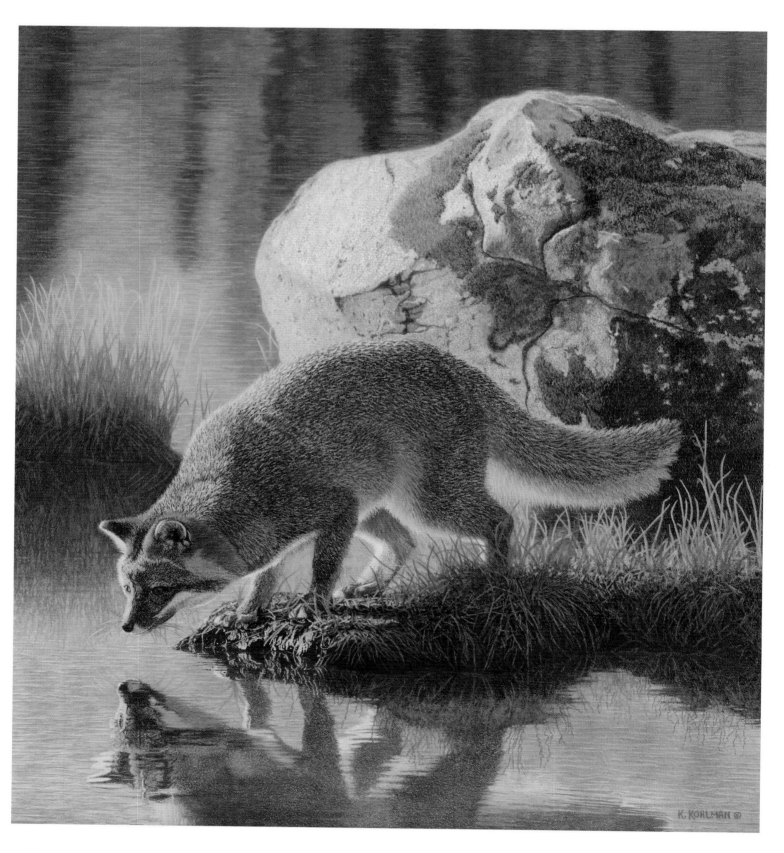

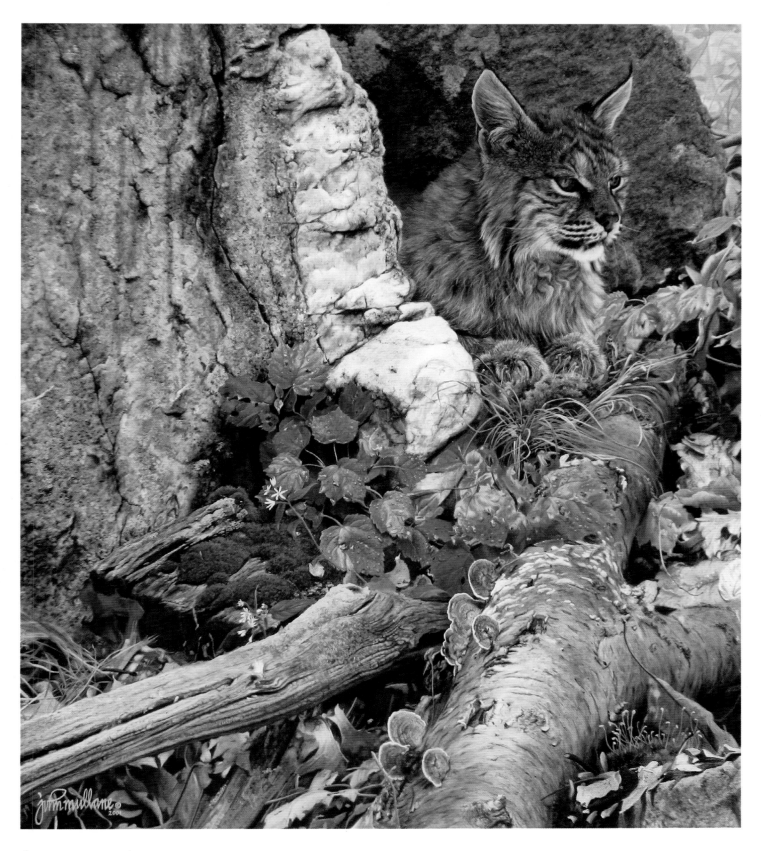

▲ **NESTLED INN** | John Mullane
Acrylic on Masonite, 19" × 16¾" (48cm × 43cm)

Of all the North American cats the bobcat is my favorite. I photo-graphed this particular cat on a game farm in Montana. I took many shots, but one while he was resting spoke to me most. When I returned home I was out hiking with my boys and we came upon this den, and I immediately put the two images in my mind together. The composition was full of everything I love to paint! Rocks, leaves, lichens, moss and fur kept me busy working for months, but I enjoyed painting it all—even the dew on the leaves.

I've always been fascinated by Mother Nature's endless varieties of textures, and acrylic is the perfect medium to achieve the effects I'm after. The fast drying time lets me build layers quickly. I use old brushes, sponges, a palette knife at times and a toothbrush to splatter where I want to create more detail. (See page 88 to view Mullane's piece *Gold and Rhodes*.)

When beginning a painting, I start with only an idea, color range and composition. When I work with acrylic and collage in multiple layers, changes occur in the flow of the moment. *Flamingo Foliage* began with the idea of flamingos, tropical colors and a horizontal composition. Initially, four to five large shapes are painted in one color that covers the canvas with an awareness of the negative space. Flamingo shapes are lightly drawn in for placement and size. Additional layers of paper and paint are added in a color-balanced way using a combination of small and large shapes. There are always "aha" moments, and I find that if I keep working, the problems will resolve in inventive and creative ways.

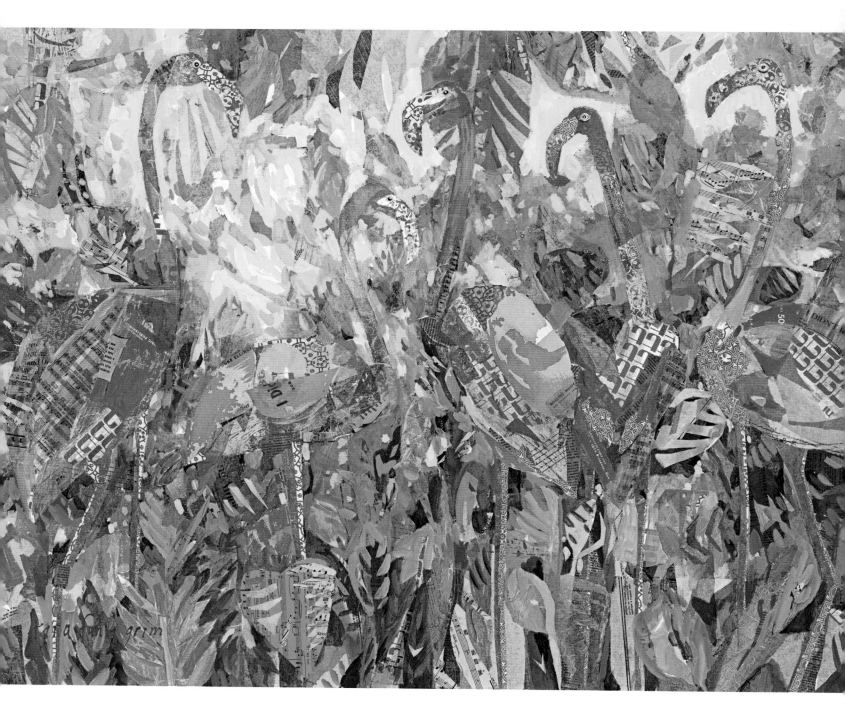

"Each painting is an adventure and a journey into the unknown!" —TARA FUNK GRIM

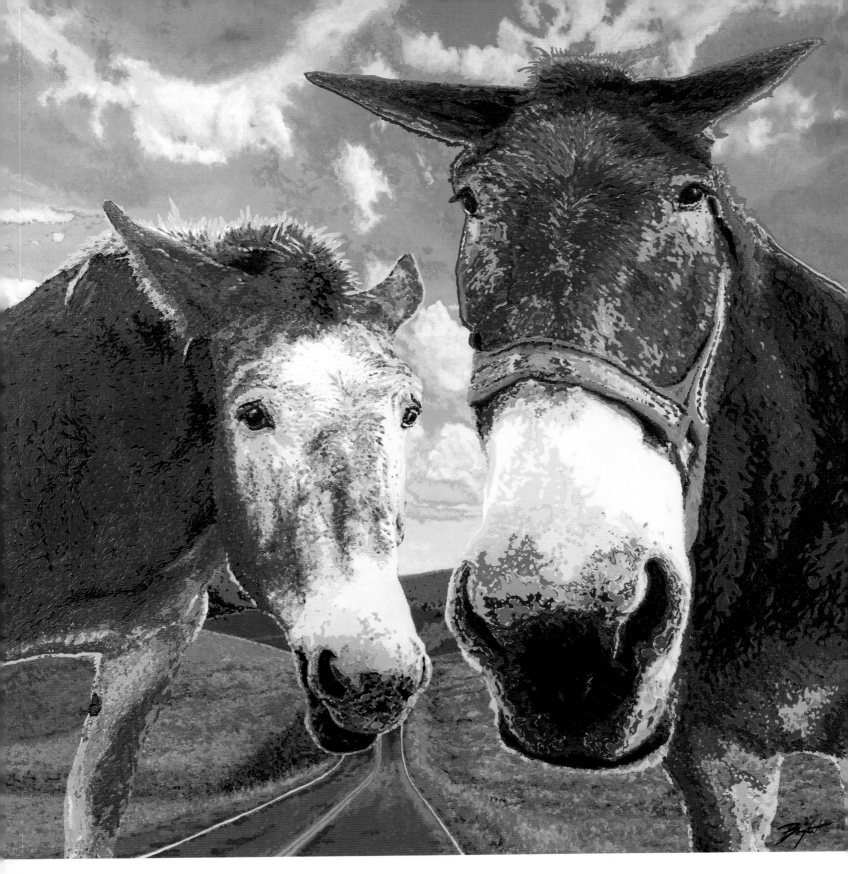

▲ **FOLLOW YOUR MUSES** | Darien Bogart
Acrylic on panel, 36" × 36" (91cm × 91cm)

The sun was casting its magic on a field of curious mules. It was a chance encounter for all of us. I saw them as my muses, or were they friends? Whatever the case I felt it wise to listen and remember our meeting as a lesson. "Be as stubborn as a mule when following your muses for the path is wrought with challenges."

The idea was clear but the interpretation would come with the doing, not thinking. I built up my color, layer upon layer, and the

interpretation became apparent. The abstract areas allowed me the opportunity for ideas and symbolism within the texture. This is usually a mental process, but here in the array of color it could be expressed. Design, idea, process—these challenges in our artistic endeavors are a choice for joy and ideals, not a beast of burden. After all, these were the happiest of muses. (See page 28 to view Bogart's piece *In the Flow*.)

▼ **SUBLIMINAL SLUMBER** | Shirley Jeane
Acrylic on 140-lb. (300gsm) cold-pressed Arches, 22" × 30" (56cm × 76cm)

Subliminal Slumber started from a photograph of my cat sleeping on the arm of a lounge
chair. It became an experimental piece as I toyed with the picture on my computer. I liked
the results so much I just had to follow this lead into the painting. Ignoring tradition, I used
warm colors for shadows and cool colors for sunlit areas. I also decided to play with con-
trast by using color change more than value change. I simplified shapes and used a limited
color set to move further away from reality. Finally, I used texture to add movement. The
result catches my cat's personality better than a traditional rendering would have. She's a bit
eccentric even asleep.

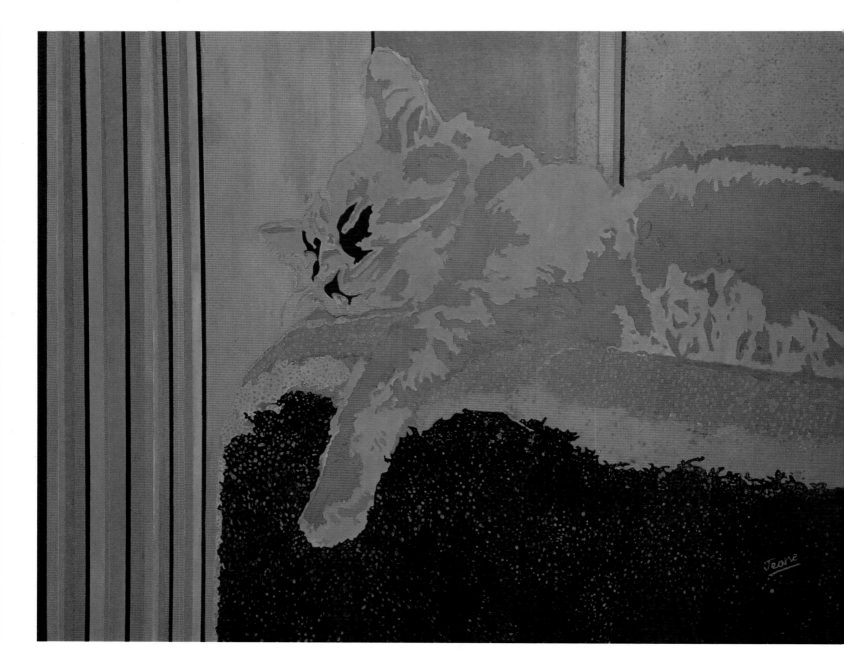

"Breaking the rules leads to discovery. The results may or may not produce your best work, but
the journey will liberate you to be unique and separate you from the pack." —SHIRLEY JEANE

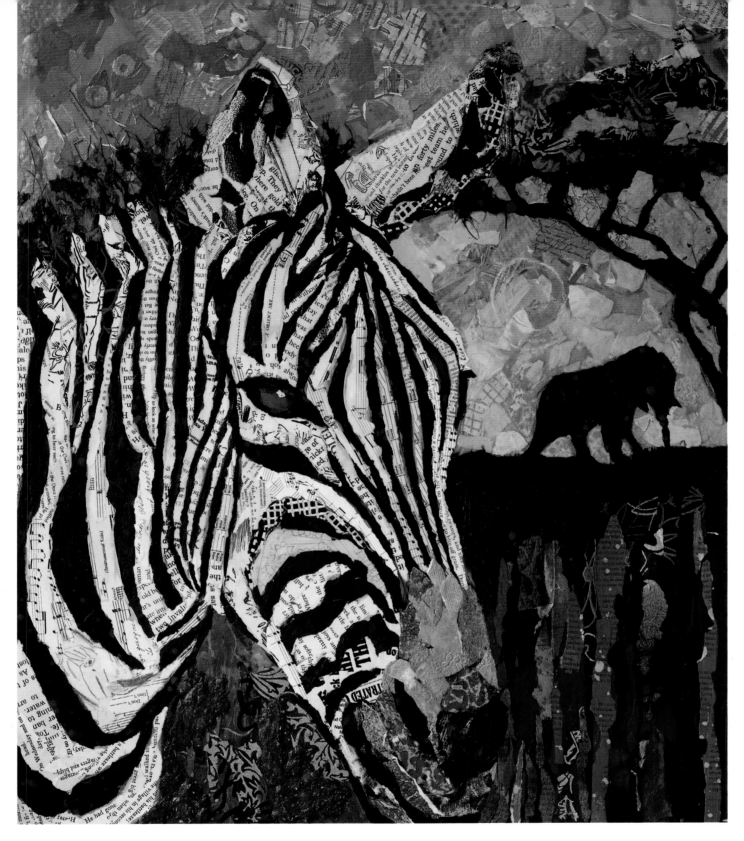

▲ **SEEING STRIPES** | Elizabeth St. Hilaire
Collage of hand-painted paper on deep cradled birch wood panel
24" × 20" (61cm × 51cm)

This piece relies on the pattern of the stripes to define the form and volume of the zebra, more so than the shading. The textured blues and purples of the painted paper in the background contrast in texture to the more flat black and text areas of the zebra itself. The intense colors of the yellows and oranges juxtaposed with the blues and purples are achieved with fluid acrylics.

The overall impressionistic feeling of my work is achieved by treating every tidbit of torn (not cut) paper like a brushstroke,

keeping details loose and using a variety of texture and shades of paper in every color field.

My technique has evolved as a result of experimentation with hand-painted, handmade and a wide variety of textured and patterned papers. Layering and weaving, pushing and pulling the colors, patterns and values make collage liken to music. I go back and forth, alternating and overlapping until the rhythm creates something I love.

▼ **TATIANA** | Akiko Watanabe
Acrylic on stretched canvas, 11" × 14" (28cm × 36cm)

It was on Christmas Day in 2007 that a tragedy struck San Francisco Zoo and affected the entire Bay Area. Taunted and harassed by three young men, Tatiana, a Siberian tiger, jumped out of her enclosure. After mauling her harassers, she was tracked and shot dead by police officers. She was only four years old. I had enjoyed seeing Tatiana every time I went to the zoo. As my tribute to her undeserved end, I tried to paint her eyes and fur as accurately as possible so others could see her as pure and beautiful as she was and so this image will always remind us of Tatiana.

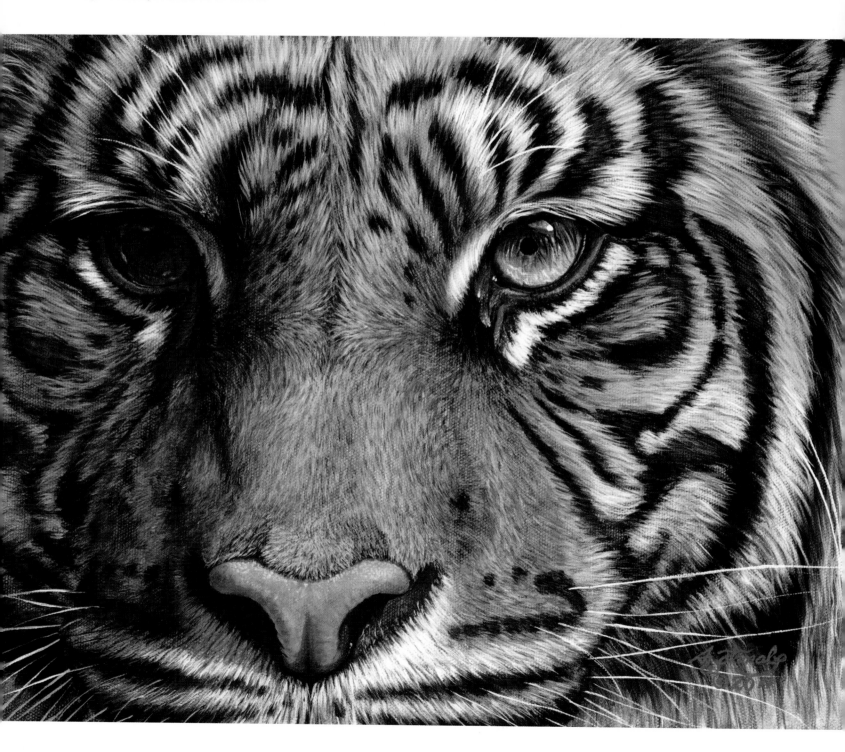

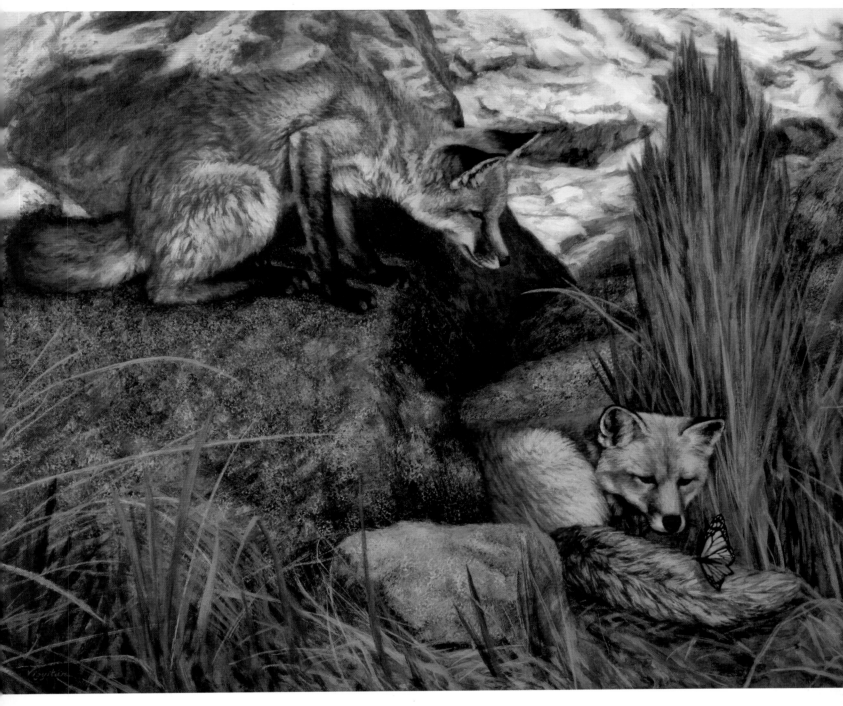

▲ **SUMMER DAYS** | Dean Vigyikan
Acrylic on canvas panel, 18" × 24" (46cm × 61cm)

Wildlife painting presents the opportunity of orchestrating many varied yet harmonious textures into a unified whole. In the painting *Summer Days*, the furry foxes are juxtaposed with rugged rocks and sinewy grass. The delicate wings of the butterfly introduce yet another level of contrast among these many textures, which combine to create a scene and suggest a story. I love imagery and narratives that anthropomorphize animals. While *Summer Days* presents the plausible scenario of two young foxes at play, it's fairly easy to read a parable into the picture with an outcome containing moral overtones, not unlike Aesop's fables. The whimsical scene is set in a shady retreat, but the sunbaked rocks in the background suggest tough terrain, harkening back to the years I spent living amidst the canyons and valleys of the American West.

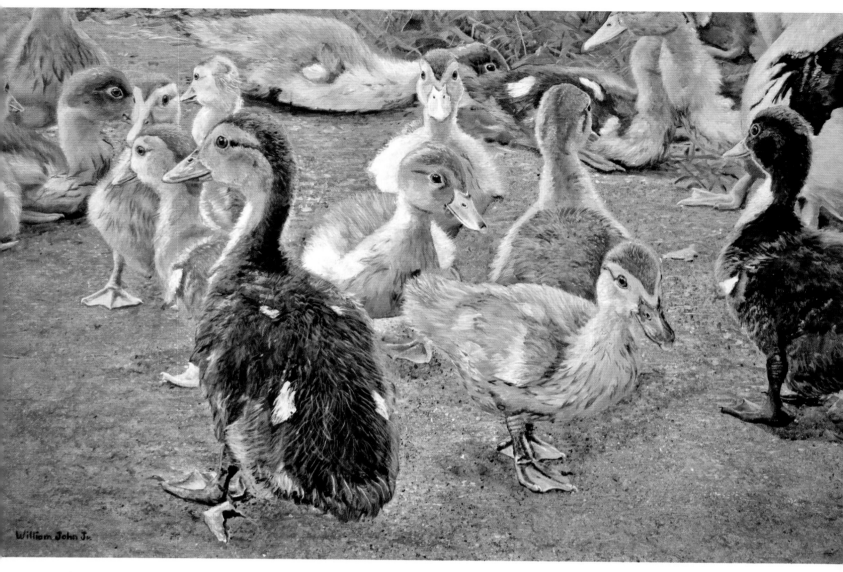

▲ FEELING DUCKY | William L. John Jr.
Acrylic and gesso on Masonite, 20" × 30" (51cm × 76cm)

This painting came from a photograph we took while on vacation. My wife and I saw a baby duck on the wrong side of a wooden fence. My wife tried to shoe it in to the other side through an opening in the wooden fence. But all of a sudden all these baby ducks came out and surrounded us wanting food so we gave them some crackers.

To begin the painting, I started with the background. I applied a color mixture of Ultramarine Blue, Payne's Gray and Raw Umber using a large brush, then used a rag to rub everything down to an even coat. Next I used a stiff brush to flick thin paint washes all over the board to give the appearance of blacktop. To place the baby ducks, I laid cutout drawings on the surface where I wanted them to go. I usually start with the eye then rough in the color emphasizing shape and anatomy. I drybrushed on the feathers, then added layers of glazing over the top of that to help define the ducks' fuzziness.

▶ PERSISTENT CALLER | Layne van Loo
Acrylic on Ampersand Gessobord, 14" × 11" (36cm × 28cm)

For *Persistent Caller*, I began with a theme that I often return to, combining a man-made object with a subject from nature, usually some species of bird. I photographed this door, its porcelain doorknob and hardware illuminated by the low angle of the sun, and thought it would make an interesting composition with the addition of a small bird. I was fortunate to get a few shots of the house wren under similar lighting conditions while it called persistently. To overcome the problem of creating a cast shadow for the wren, I constructed a small mock-up of the doorjamb with some scraps of wood, made a plasticine model of the wren suspended with string and duplicated the angle of the light with a small lamp. To obtain the texture of cracking paint, I applied the acrylic-based product Kroma Crackle and let this dry thoroughly. I then proceeded with the application of multiple layers of opaque acrylic alternated with transparent acrylic washes.

"For textural effects, don't try to control every aspect of the painting; rather try to build on what happens naturally." —LAYNE VAN LOO

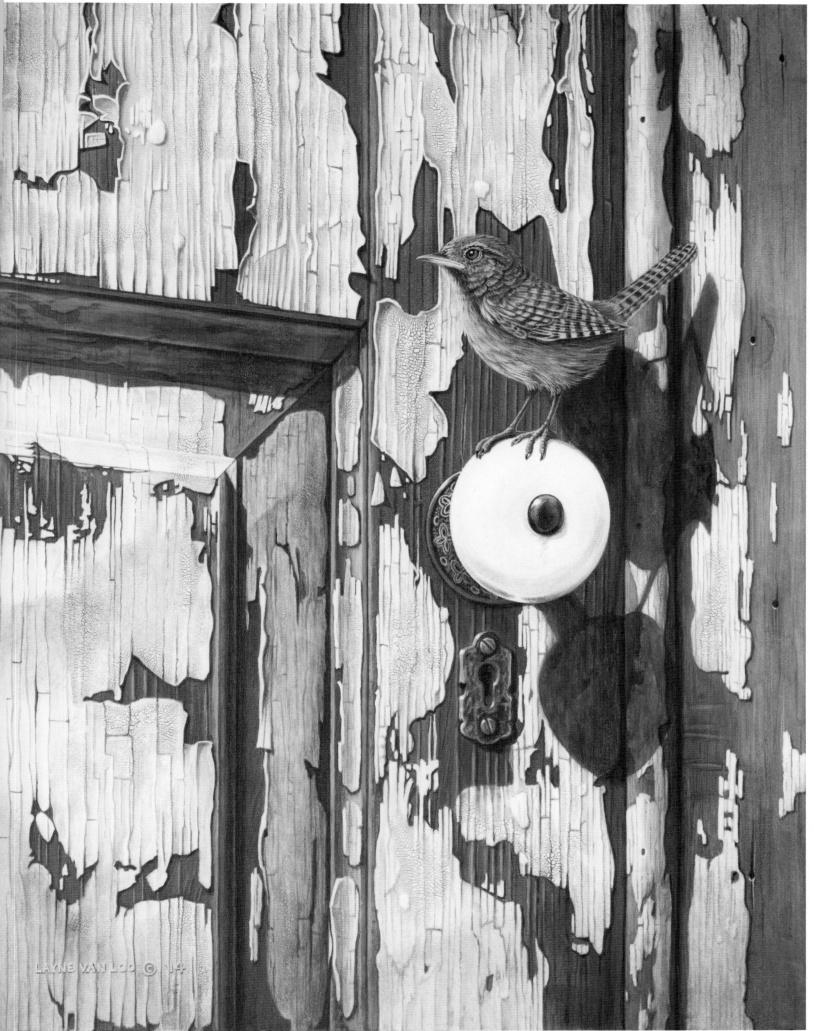

LAYNE VAN LOO © 14

▲ **QUORRA** | r. mike nichols
Acrylics on canvas, 24" × 30" (61cm × 76cm)

Quorra was painted in the studio from photographs. For the most part I paint in transparent watercolors, which require advance planning and precision. The forgiving nature of acrylic paint allows me to be more spontaneous. I find that working back and forth between these water-based mediums gives me balance and a fresh perspective. The billowy clouds, sleek fur and impressionistic ground create textural elements that give this painting a feeling of time and place. We adopted Quorra from a French bulldog rescue group in March 2014. Like Blanca and Lilly, our two rescue dogs before her, Quorra has become my muse.

▶ **WINTER WIND** | Karen Xarchos
Acrylic on canvas, 20" × 16" (51cm × 41cm)

I started painting in watercolors and oils as a child. Acrylics were a natural progression as they lend themselves to watercolor or oil techniques. I work from light to dark in transparent layers, so acrylics are a versatile, practical choice. Painting opaquely allows for changes, while the drying speed lets me scumble for softened edges or glaze layers for depth and luminosity. Limiting my palette increases color harmony. Glazing medium provides viscosity and transparency, while gloss varnish evens out finish irregularities and brings out color nuances. *Winter Wind* represents the "celebrating texture" theme as my layering and scumbling style creates the illusion of fur flying in the wind.

"When a subject truly inspires or touches me, the painting process seems effortless." —KAREN XARCHOS

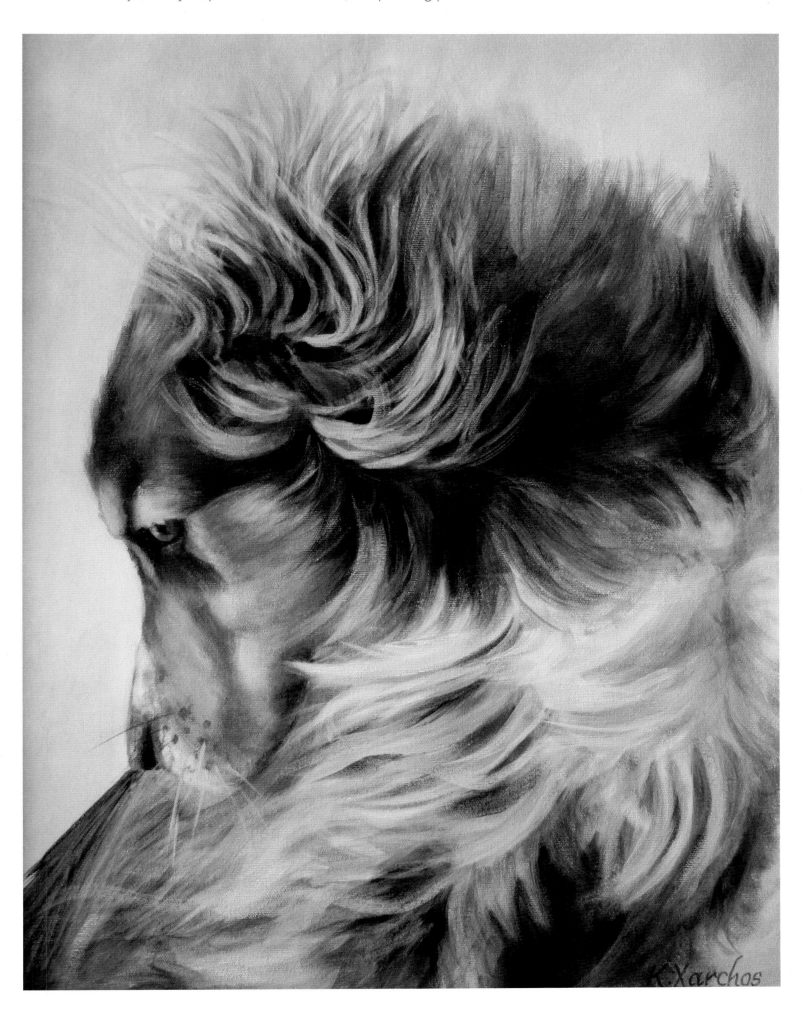

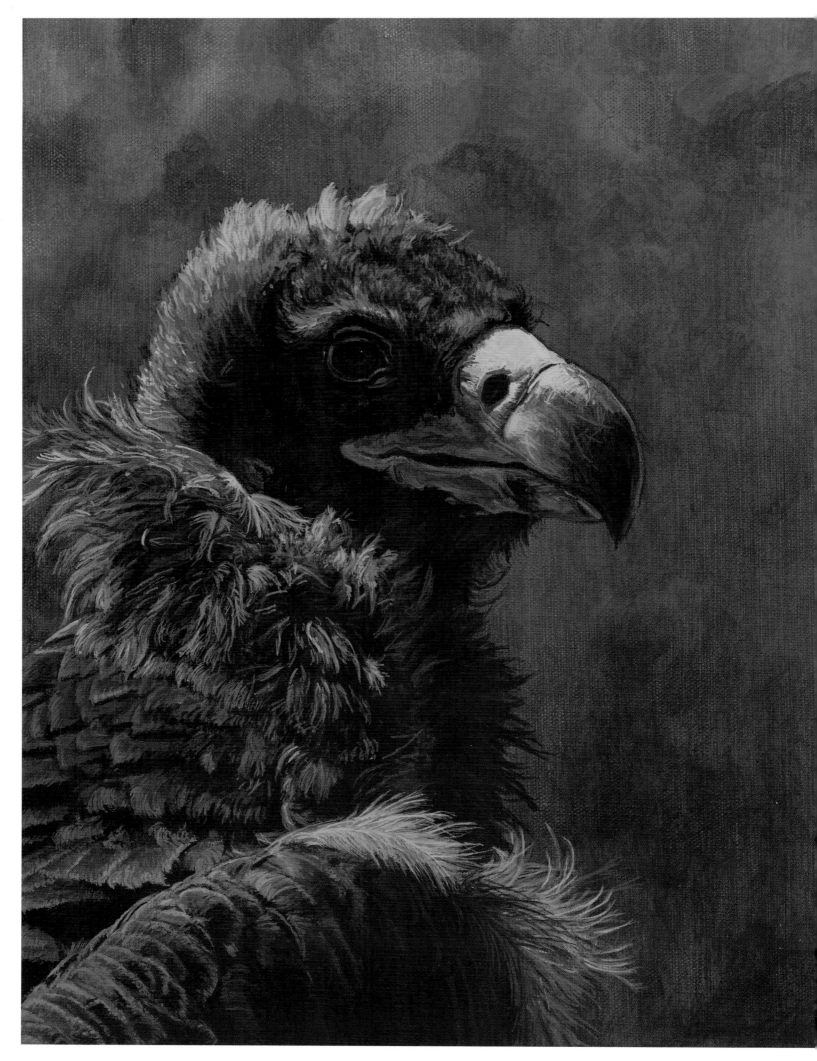

◀ **SURVIVOR** | Danea Fidler
Acrylic on canvas, 14" × 11" (36cm × 28cm)

▲ **A MINE HOLE ADVENTURE** | Joshua S. Franco
Acrylic on canvas, 36" × 48" (91cm × 122cm)

During a weekly zoo sketching adventure, a bright blue beak and a distinctive layered coat of feathers caught my eye, and I knew a painting wasn't far behind. They were features belonging to a cinereous vulture. This painting was done from photos and after numerous pen-and-ink studies from life. It started out with an umber underpainting and then washing color on top. I then took full advantage of the acrylic and gave each individual feather its own look and texture. The ability to really define and detail each animal I paint with its own skin, fur or feather texture in a timely manner is a quality of acrylic paint that I personally find really satisfying.

For larger scale paintings, I typically begin the process on the floor. I like to cover the entire canvas with one to three colors in an intermittent motion. Usually the colors consist of Titanium White, Yellow Oxide and the third color seems to vary from my favorite Light Blue Permanent to another color that is inspiring me at the time. Once the surface is fully covered and dry, the next step is a very fluid technique leaving puddles of color that will dry with a ghostlike result. I feel this beginning stage helps create the mood for building a dreamlike composition of thoughts and ideas of the heart. After the images are selected and rendered onto the canvas with a graphite pencil, an underpainting is completed in black and white before building the values in color.

"You have to have a solid plan for any painting, but always be prepared and not be afraid to change or add anything that will improve it." —FREDERICK SZATKOWSKI

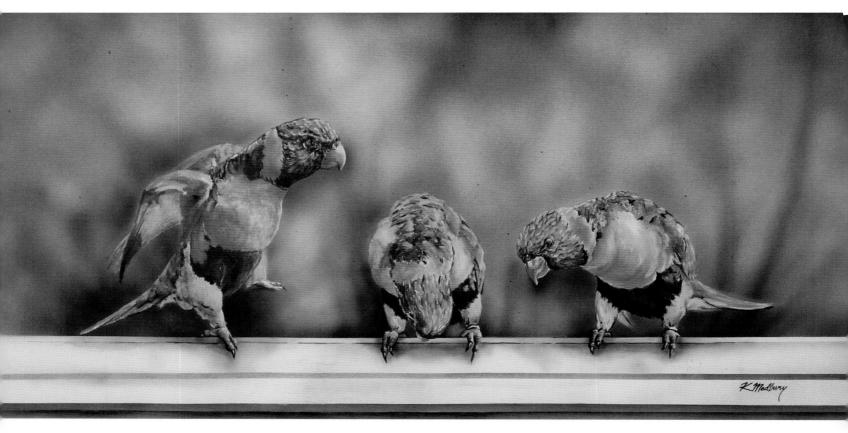

▲ **HEY LOOK AT THIS** | Katherine Medbury
Acrylic Artists' inks and paint on 300-lb. (640gsm) cold-pressed Arches
14" × 29½" (36cm × 75cm)

While on holiday in South Australia my husband and I came across this beautiful, vibrant, cheeky, attention-seeking lorikeet. It was so inspiring that I felt I had to paint this adorable bird. Not having my paints with me, I used my camera to capture him. Back in my studio, I set about composing the lorikeets' various poses into the composition that would best portray this majestic bird. To draw attention to the lorikeets, I airbrushed the background with fluid acrylic inks. Then, I hand-painted the lorikeets with medium acrylic paints straight from the tube to achieve texture and dimension, and to give the lorikeets a vibrant three-dimensional appearance. I love how acrylic's versatile nature allows the artist to experiment with texture and achieve amazing results.

▼ A FLEETING MOMENT | Frederick Szatkowski
Acrylic on gessoed hardboard, 19" × 25½" (48cm × 65cm)

The bobcat was the inspiration for this painting as I observed it up close at a wildlife rehabilitation center. I sought to portray all the intricacies in the fur and the play of light on the animal.

The bobcat was painted with Payne's Gray and white, working dark to light to establish depth. Color was then added using transparent glazes and matte medium. I accentuated shadows with some Ultramarine Blue and "brightened brights" with Titanium White. A light glaze mix of Yellow Oxide and Cadmium Yellow Light was added to warm the highlights.

Having completed the cat itself as a portrait, I realized something more was needed. The rocks were added for more depth and as a contrast to the softer textures of the bobcat. The jewelweed and the ruby-throated hummingbird were added last for some interesting tension.

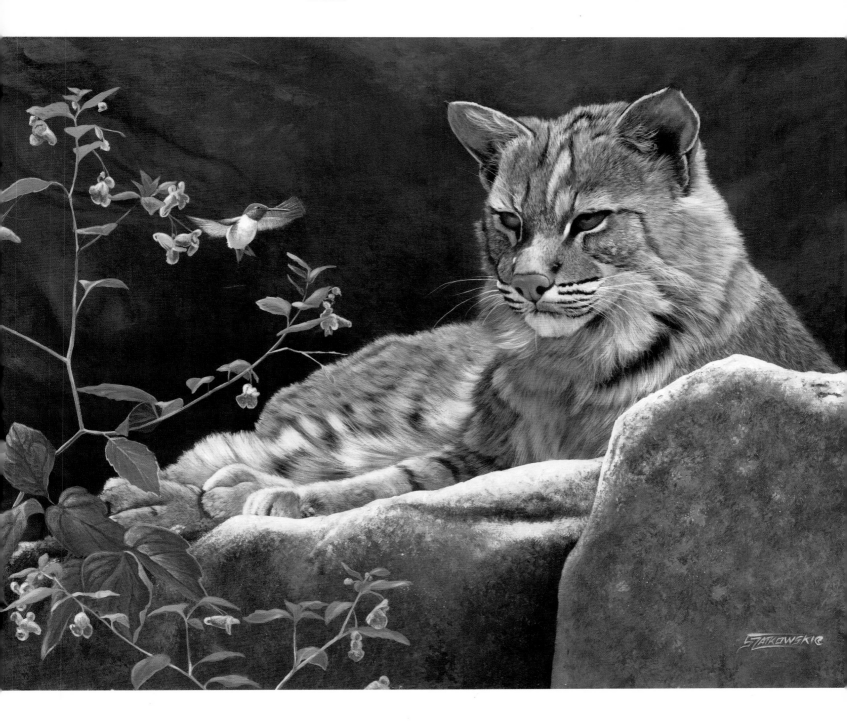

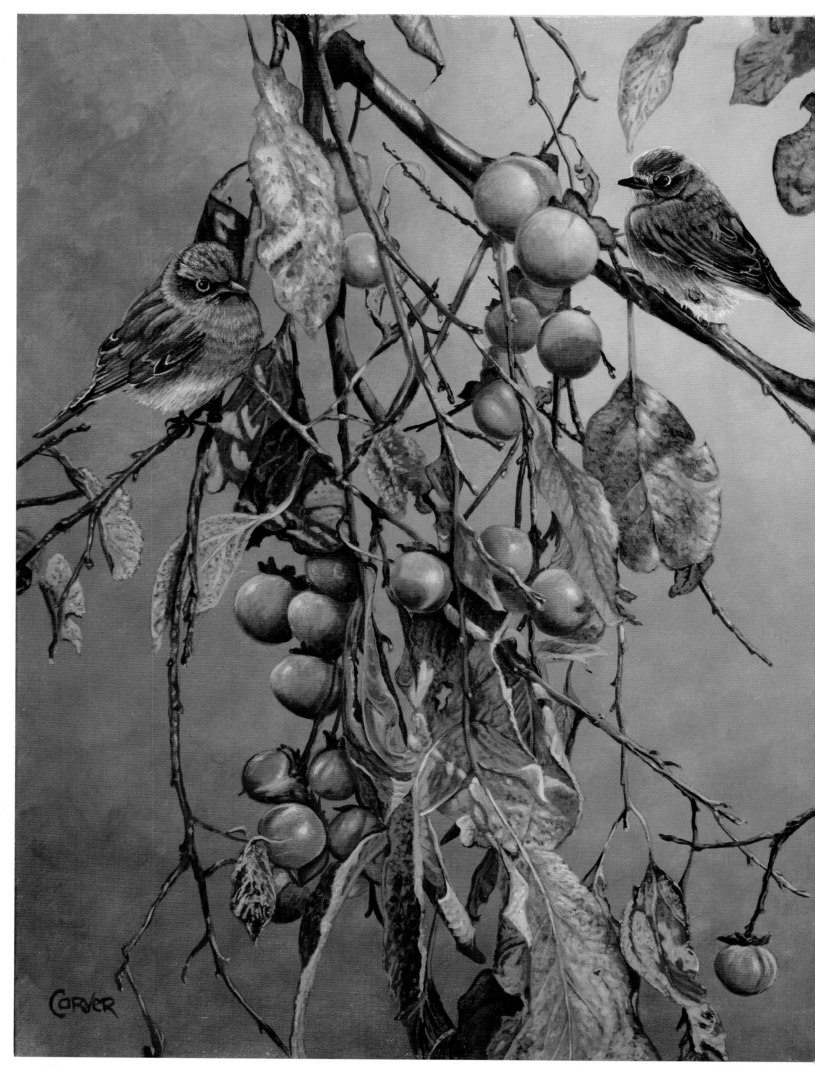

▼ **HORSE (RED, WHITE AND BLUE)** | Michael Swearngin
Acrylic on canvas, 30" × 50" (76cm × 127cm)

I completed *Horse (Red, White and Blue)* in the studio in Scottsdale, Arizona. I intuitively paint using texture, masking fluid and simple shapes to create a strong composition to express the worn, rugged spirit of the American West in my contemporary style. In this piece I celebrated texture by building up layers of paint in the American flag and the American icon of the quarter horse. If one word came to mind to express my connection to this painting it would be *valor*. Every painting is an exploration of this experience of creativity.

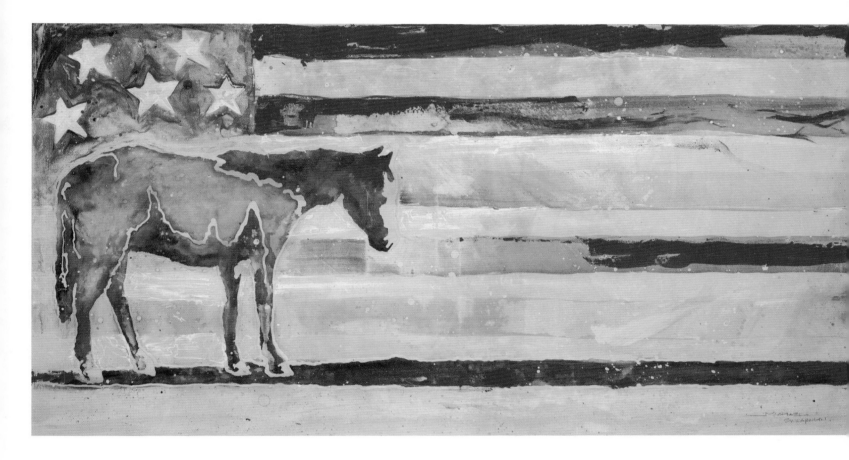

◄ **BLUE VOICES AND WINTER LORE** | Larry Carver
Acrylic on posterboard, 18" × 14" (46cm × 36cm)

I often try to paint with a limited palette to capture fauna and flora with the camouflage and habitat of their surrounds. Feathers and fur are wonderful! My love of the outdoors takes center stage, and sometimes a dynamic day or night sky provides tone for the background. Phthalo Green is a new paint color I've added to my landscape palette. Its mixed variations with Ultramarine Blue and white enhance the depth of sky or water.

Blue Voices and Winter Lore was more than just a painting for me. I worked on the title first. Blue voices were the bluebirds that fascinated me as I watched them land in my backyard during migration and continuously jump straight up in unison when a flurry of leaves landed near them. They needed a composition. Lining my yard was a row of persimmon trees. And the old wives' tale of opening the persimmon to tell the tale of the upcoming winter's length was perfect to represent winter lore. So the aging leaves, the roundness of the translucent skin of the persimmons, the broken limbs and the promise of a bluebird spring became my composition.

▼ **QUEEN B** | Yelena York
Freehand acrylic paint on canvas, 60" × 84" (152cm × 213cm)

The bee was created from my imagination and I brought it to life by working on it for four months in my studio. No sketches were made. It is all freehand painting, including the patterns and triangles.

While working on patterns I prefer using acrylic. It creates nice texture and deep colors. I started from a blank canvas already knowing that I would be using acrylic to create this piece. Making each background pattern by hand one by one, I worked my way into the middle to create the bee. I mixed acrylic paint with mediums to have more control over the paint and created different textured patterns and allowed room to make the colors lighter or heavier.

I painted the bee as the female leader figure *Queen B*. I love women who take control over their lives, who constantly work on themselves to become stronger and more experienced in life. Being a strong leader is very hard work as there are more and more responsibilities that are impossible to ignore. They are constantly facing new challenges in life, and that is what inspires me. One should never feel so comfortable in a situation that it makes her step back from the role of being a leader. She should keep on helping and inspiring others to become better.

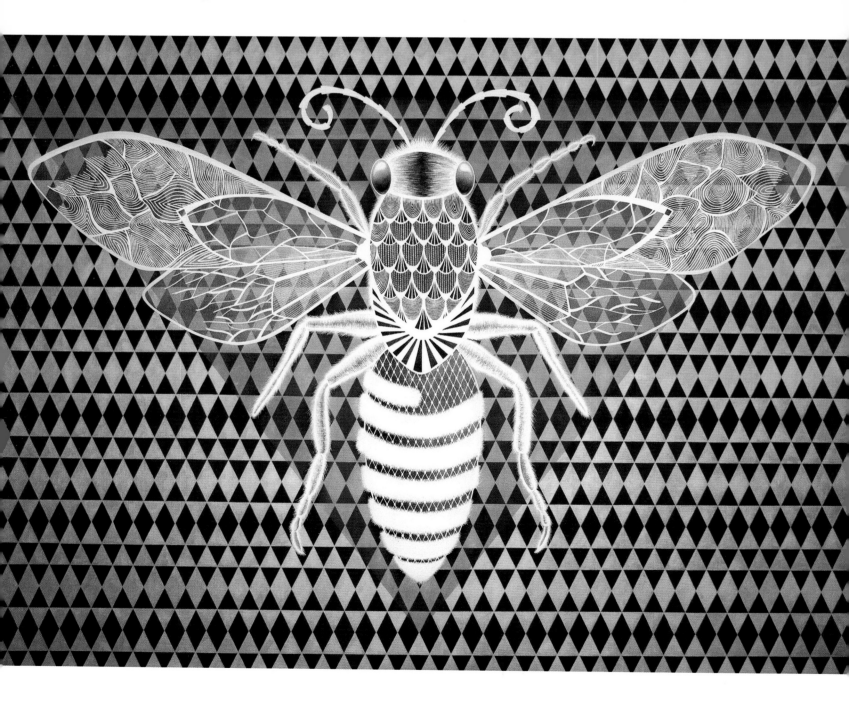

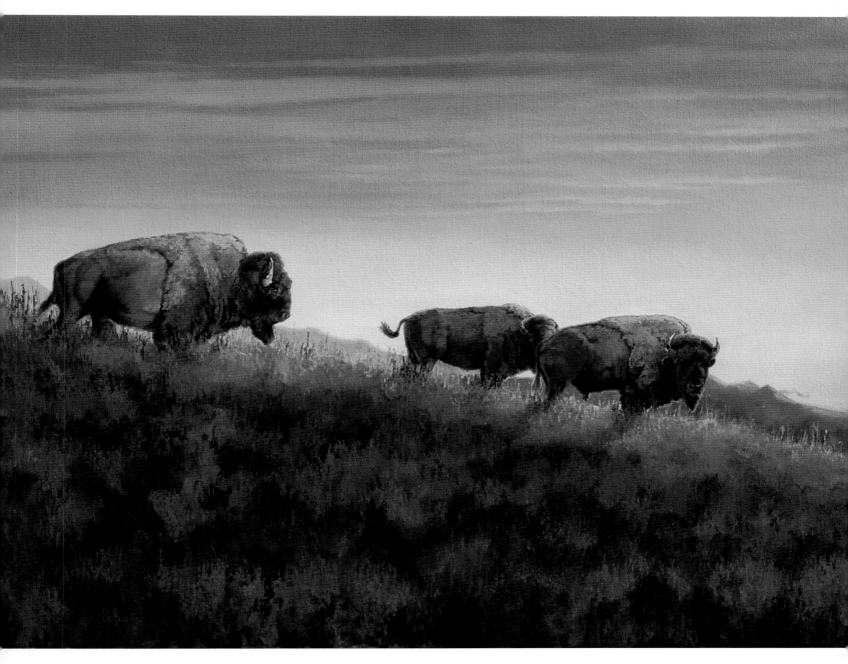

▲ **BUFFALO BEAUTY-BISON** | Edward DuRose
Acrylic on canvas, 30" × 40" (76cm × 102cm)

I have painted with acrylics exclusively for years. I try to paint wet-into-wet initially to give my edges a softer look. It seems that I am always trying to simplify my paintings as I work on them. I like the quick drying time because it enables me to complete large areas of the painting in a short amount of time.

This is a studio painting based on outdoor experiences. I start my paintings on canvas with a rough pencil sketch and then block in the painting with an ultramarine wash on white canvas. I try to keep the paint thin in the sky and in darker areas, reserving the thicker application for highlight areas.

In *Buffalo Beauty-Bison* I wanted to treat each of the individual animals as a separate landscape within the painting, each with a couple of textures—in particular, the thicker, coarse hair on the shoulders and head juxtaposed with the sleeker coat on the rest of the animal and the softness of the sagebrush. I applied the paint thickest on the shoulders and head then placed the bison among the sagebrush. I wanted the sagebrush to appear as a softer setting disappearing out of the rocks on the hillside. I tried to balance the dark areas of the hillside with the light and intense color of the sky. I depicted the sunset's glow by placing highlights on the bison and on a few tops of the sagebrush.

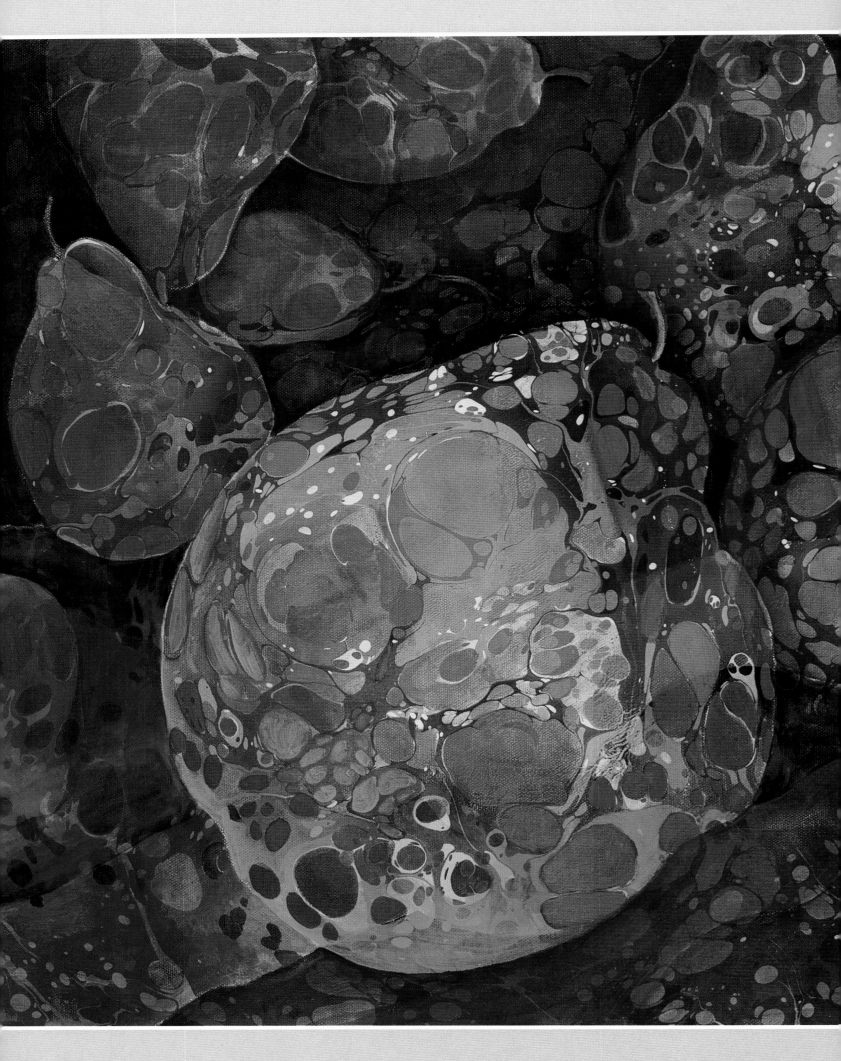

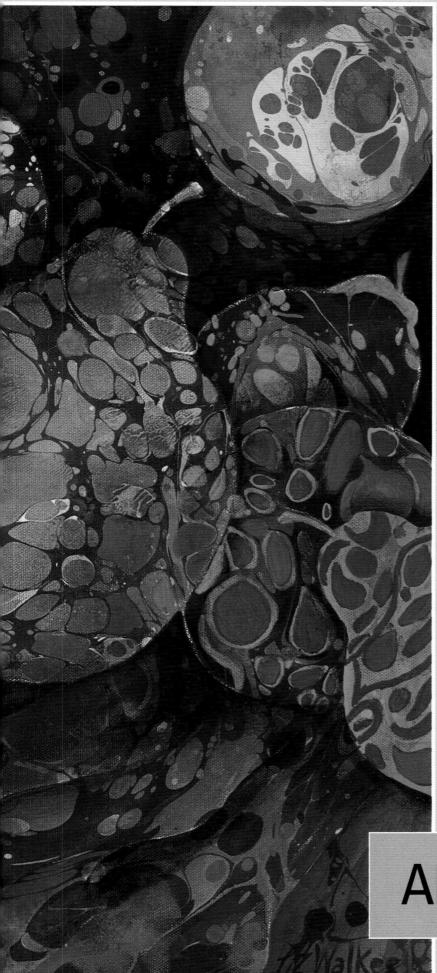

◀ **SPECKLED PEARS** | Liz Walker
Acrylic marbling on gessoed canvas
18" × 24" (46cm × 61cm)

Speckled Pears began as a Cadmium Orange/Pyrrole
Red toned acrylic underpainting on canvas. I decided to
add pattern and texture by marbling over the painting with
acrylic paint. Acrylic marbling can be wildly unpredictable,
but that, for me, is part of its charm. I love the challenge of
turning a marbled pattern into a completed painting.
In order to create contrast on the red/orange underpaint-
ing, I chose turquoise, white and green pigments and
flicked these colors into the prepared marble tray using
plastic broom whisks. Once the droplets filled the surface
of the tray and formed a stone pattern, I dipped my can-
vas into the marbling tray, which transferred the pattern
onto the canvas. Later, I used a Caran d'Ache crayon to
draw in the various sizes of pear shapes and create inter-
esting overlapping areas. Dark washes of violet around
each pear added definition and separation.

Abstractions 5

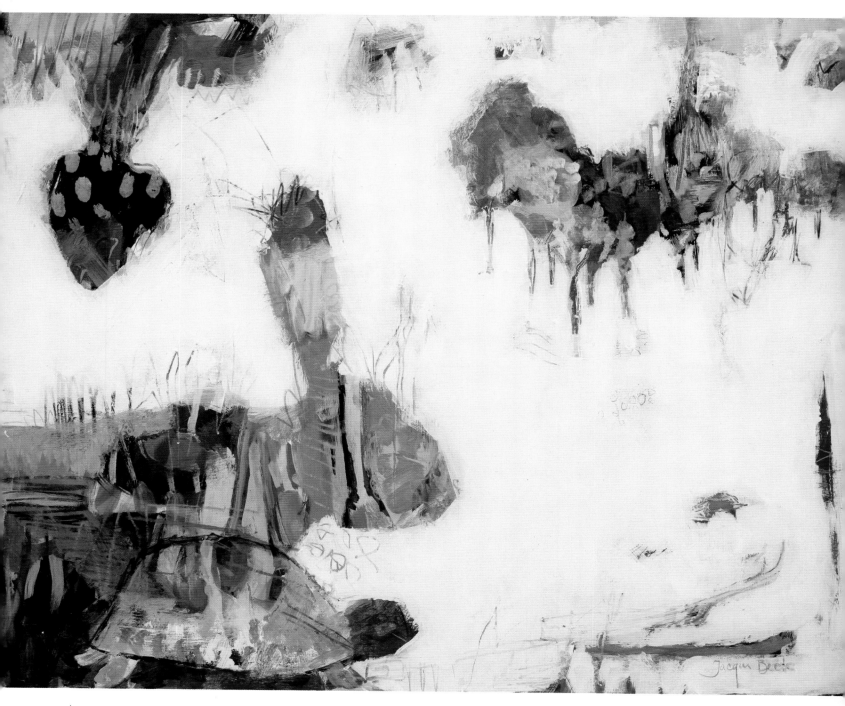

▲ **GETTING STARTED** | Jacqui Beck
Acrylic with Derwent Inktense colored pencils and Caran d'Ache Neocolor II Artists' watercolor crayons on board, 19" × 24" (48cm × 61cm)

Painting for me is like a dance, an interactive process. I take the lead but also respond to what the painting tells me. For this painting I started without a plan, creating a ground of color and visual textures using colored pencils, watercolor crayons and scratching tools. Once I had a complex multilayered ground, I began to discover and create the figures and shapes by negative painting around them using a warm white. I added more texture by scribbling into the surface as I painted around the forms, keeping it from looking too flat and contrived.

This painting *Getting Started*, one of my *Animal Totem* series, depicts the tortoise and the hare at the beginning of their race. It represents possibility. At this point we don't know what will happen but are fairly sure we can predict the outcome. I love the twist in this story where the obvious doesn't happen.

The nature of this work relies on good prep and setup. In my studio, I cover my worktable with heavy plastic sheeting. To control the level of the panel and ease of handling, I use plastic pushpins to set the panel up off the work surface. This also prevents the drippings and runoff from contaminating the bottom of the panel frame and causing it to stick to the plastic.

I start by mixing pure color dispersion into Liquitex Pouring Medium. For the initial texture I spread Golden Clear Granular Gel on the hardwood panel. Once it is dry, I generously pour three to six colors on my wood panel and manipulate the colors by tipping and rotating or leaving the panel flat on the working surface. Just before completion, I drip isopropyl alcohol, which reacts with the moisture in the medium, displacing the pigments.

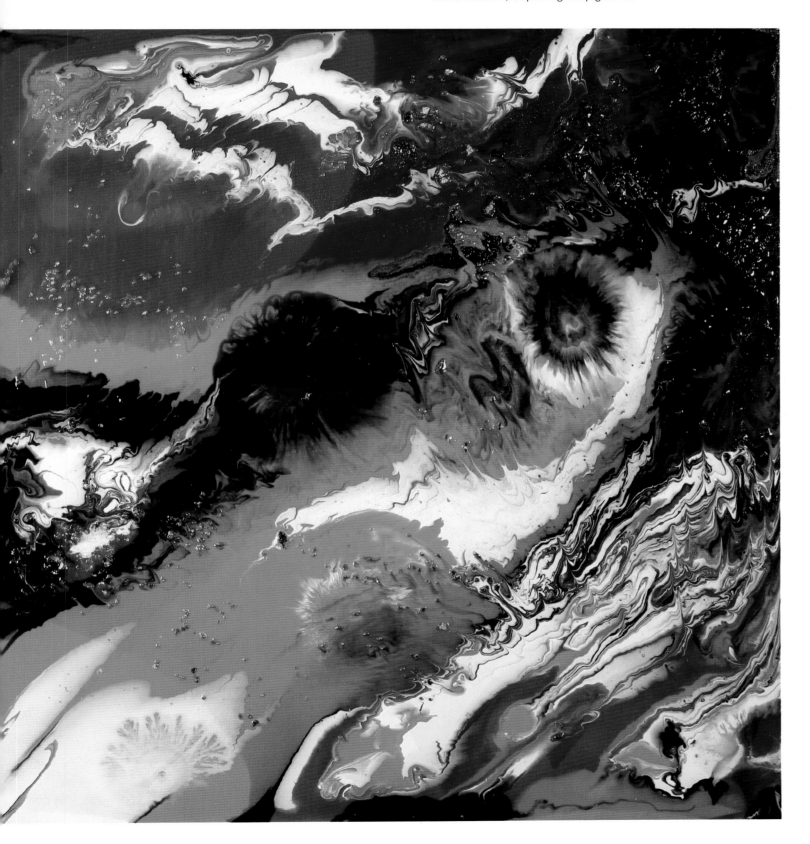

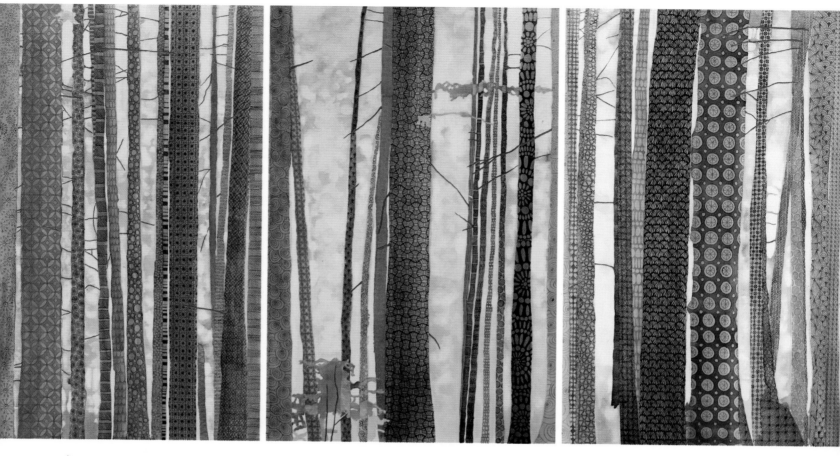

▲ **IMAGINED REALITY** | Sandrine Pelissier
Acrylic on canvas, 36" × 72" (91cm × 183cm) triptych

I started painting with watercolors but switched to fluid acrylics because I wanted to work on larger pieces and also on canvas. I love the fluidity and transparency of liquid acrylics and am working with the same techniques I used with watercolor: layering, painting wet-into-wet, splashing.

Most of my works combine some parts that are painted with some parts that are drawn. This is the case here: I added a lot of hand-drawn textured patterns on top of the trees using a dipping pen and fluid acrylics.

"A striking composition is the first thing that catches my attention." —CHRISTINE FORTNER

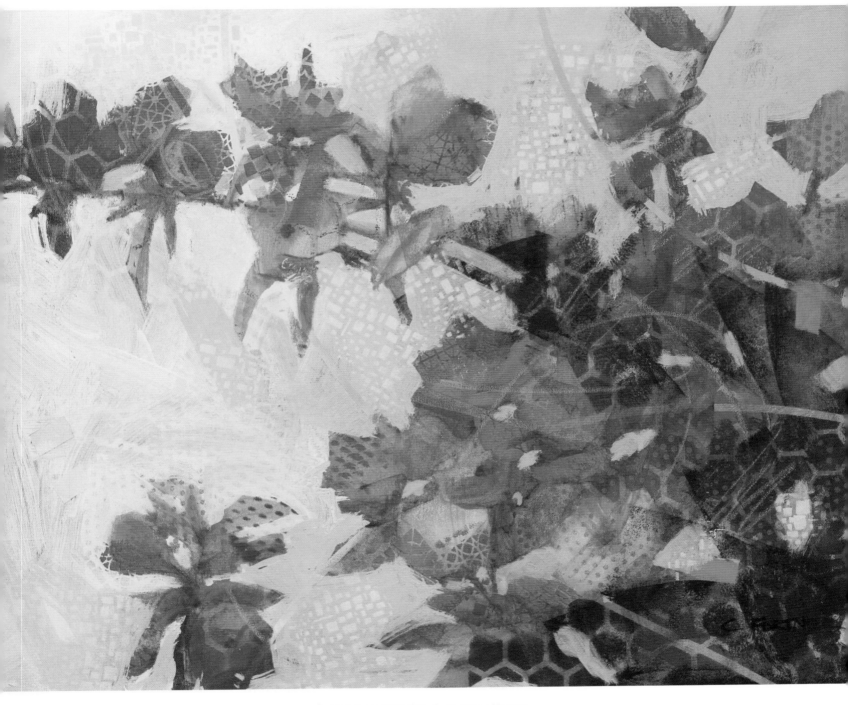

▲ **WILD FLOWERS** | Christine Fortner
Acrylic and mixed media on canvas, 22" × 28" (56cm × 71cm)

For this painting I first did a plein air study with transparent watercolor and opaque gouache. In my studio I chose to use acrylic on canvas because I like to apply several layers of paint to create texture without defining each leaf and petal. The first watered-down washes loosely defined the shapes, colors and composition. With the next several paint layers I built up color and patterns by using stamps, stencils, tape, pencil and/or more brushwork. At this point the painting looked like chaos and was very busy. The final background washes were done with the largest brush possible so I could cut in around the flower shapes to define them. In the end some areas may have had as many as seven layers of paint while other areas might have shown the first transparent wash. My main goal with the finished painting is to reveal my own interpretation of the subject and my original inspiration.

"Painting in acrylics is like riding the wave of an alluvial torrent." —EDWARD KOSINSKI

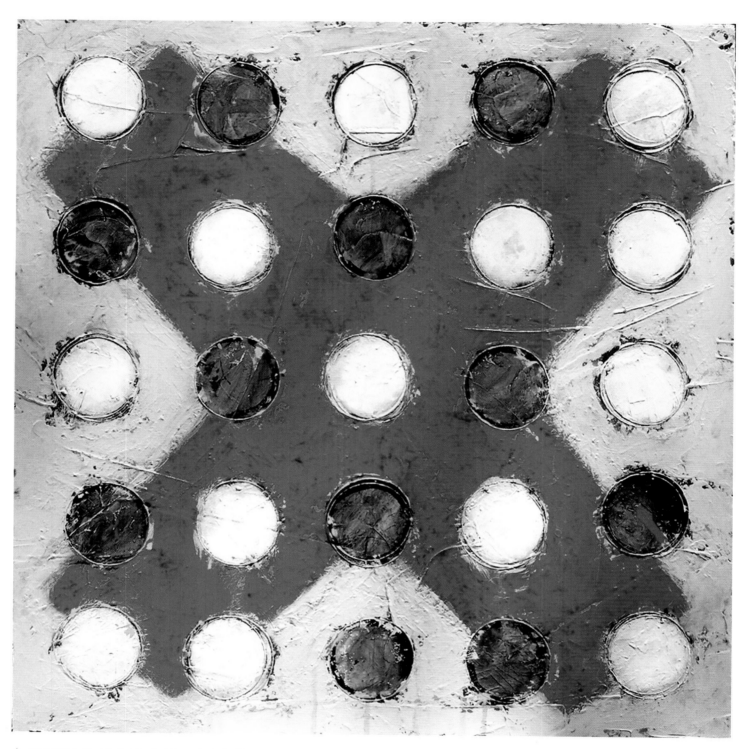

▲ **SUNSPOTS (RED X)** | Edward Kosinski
Acrylic on panel, 24" × 24" (61cm × 61cm)

The Rocky Mountain region is an arid place and water is a very precious medium. That is why I chose to paint with acrylics back in the 1970s, starting with Bocour and Liquitex colors, and now mostly Golden. After college I studied classical realism and had always been a representational painter. But over the past few years I've transitioned into abstracts. I love the freedom to play and work intuitively. I rarely use brushes and canvas anymore, preferring spatulas, trowels and other mark-making implements. I begin by gessoing a birch or composite panel before doing an underdrawing in a layer of modeling paste. The painting proceeds from there like an alluvial torrent. My textural work embodies the physicality of sculpture, and I relate to it quite differently because it exists in the same physical space that we do, rather than just pictorial depth.

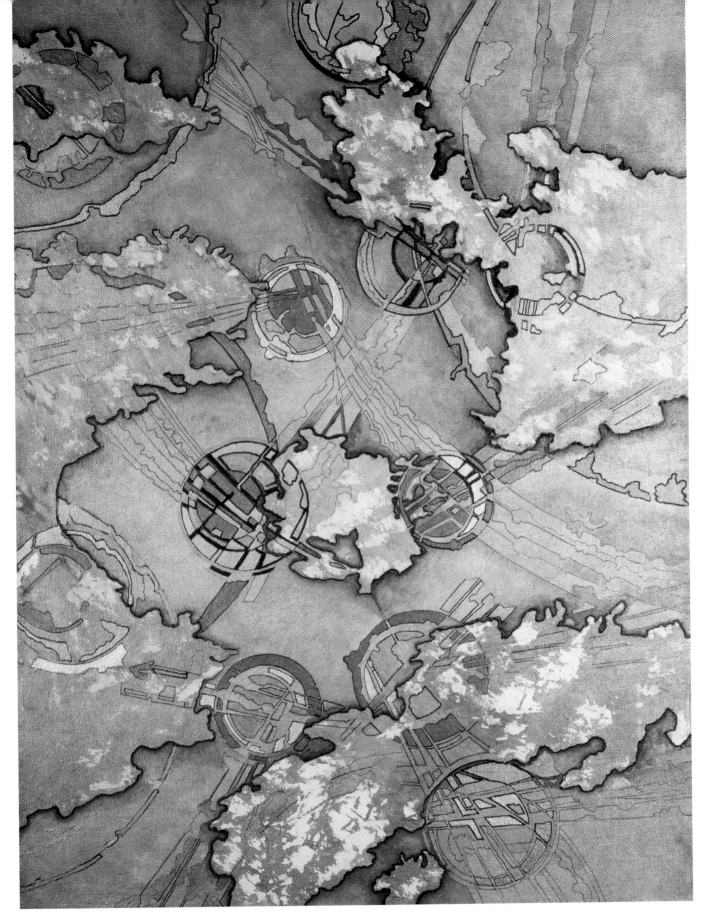

▲ **GREEN DIRECTIONS** | Robert C. Hoppin
Acrylic on canvas, 24" × 18" (61cm × 46cm)

This painting was done using experimental techniques adapting watercolor methods for acrylics. In this case the textures were obtained by using latex resist and later scrubbing the resist off and a few other techniques familiar to watercolor artists. I am an experimental painter and I am fascinated by texture. I constantly research methods of creating textures and experiment with the creation of textures in every artwork. Although this piece was done entirely in acrylics, I often use combinations of ink, watercolor and acrylics.

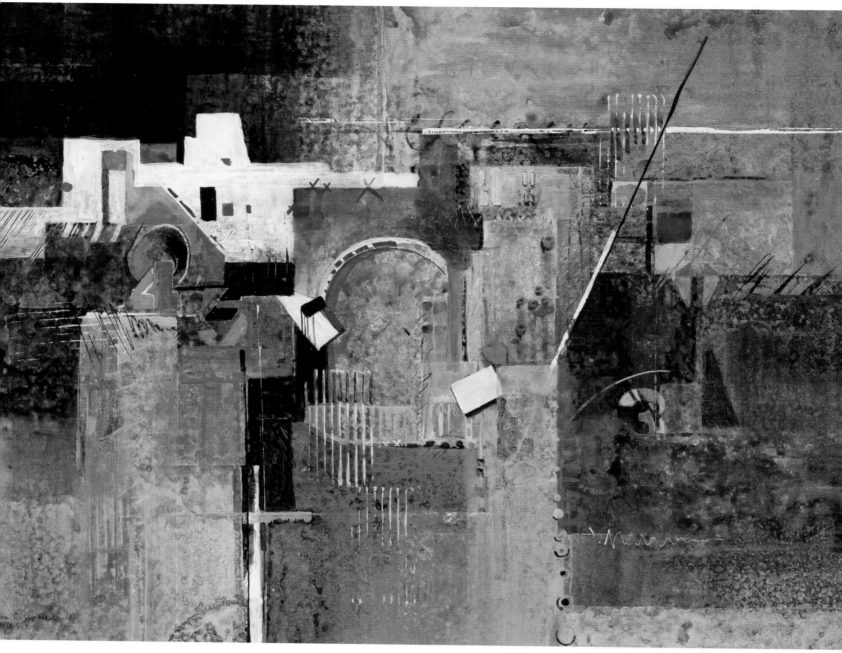

▲ TAPESTRY | Jane. E. Jones
Acrylics on 80-lb. (170gsm) cold-pressed Strathmore Aquarius II
watercolor paper, 22" × 30" (56cm × 76cm)

Painting in acrylics opens up new avenues for experimentation
and adventure as it allows artists to let go of previous set ideas.
I enjoy working with acrylic to create textures I am unable to
achieve with watercolor. I use no imagery or idea in advance; I
let my feelings dictate. To create textural effects, my techniques
include spritzing alcohol over wet acrylics and using hand-carved
stamps. To begin *Tapestry*, I applied two coats of a mixture of
gloss medium and water, letting each layer dry before adding
another. I added a thin layer of color and spritzed with alcohol.
When dry, I repeated this three times. After mixing a light value of
dominant color with white gesso and water, I painted the lights.
White gesso was used at the focal point. Supplies included
Golden liquid acrylics, white gesso, gloss medium, alcohol and
stamps. *Tapestry* was painted in my studio.

▶ ADMIROLOGY | Rick Rogers
Acrylic mixed media (acrylic gesso, graphite, acrylic modeling paste,
cotton, acrylic pouring medium, liquid acrylic paints) on stretched
cotton canvas, 48" × 36" (122cm × 91cm)

Admirology is a painting that focuses on using texture to engage
the viewer. Texture has the remarkable ability to trigger our sense
of touch indirectly through our memories and our ability to inter-
pret what we see. Our expectation of what we will feel if we touch
can be a powerful tool for artists. The inspiration for this piece is
my admiration for the painters in the Group of Seven. The intent is
to evoke the raw untamed Canadian landscape like they did but
with texture. These iconic artists often achieved a sensitivity and
elegant simplicity that I hope to infuse into my work.

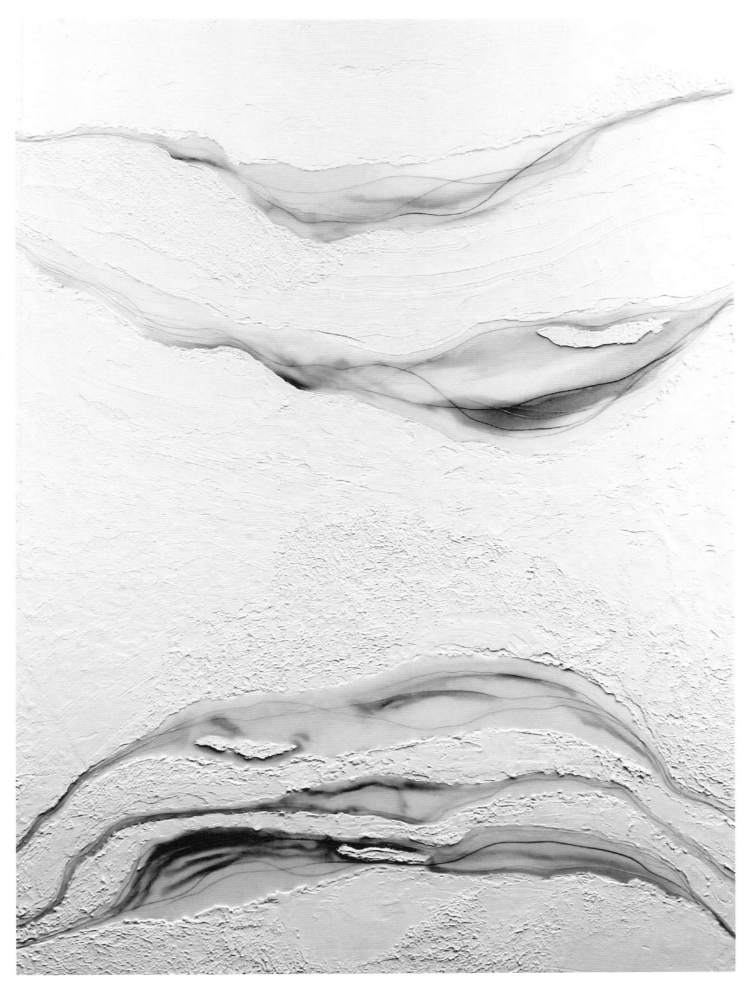

"A compelling or familiar texture engages the viewer to touch and feel with their eyes!" —RICK ROGERS

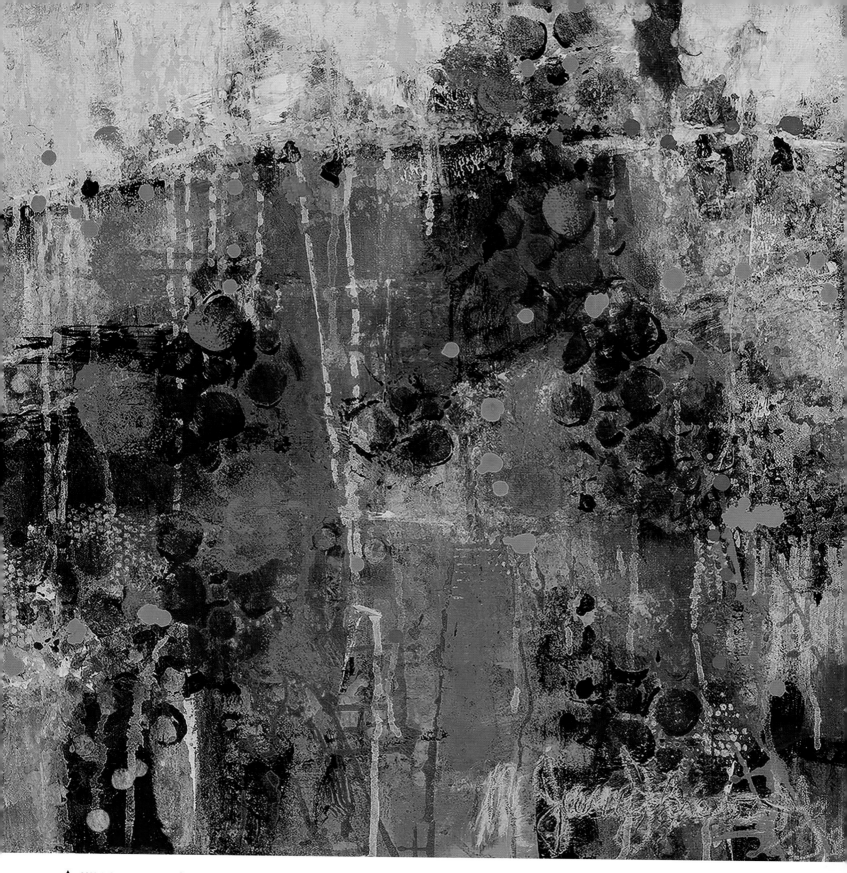

▲ **HILLS & LAKES** | M. Jane Johnson
Acrylic, collage, oil pastel, oil on canvas, 20" × 20" × 1" (51cm × 51cm × 3cm)

Hills & Lakes spent a number of hours on my studio floor allowing the layers and textures to dry. My paintings are construction projects built from acrylic paint, collage and drawing, giving each painting interesting depth, mystery and texture. Color and texture are my two driving forces, impacting everything I create. When I am starting a piece, color goes down first to develop the palette of the painting. Texture follows as I use different materials and mediums to form the texture through stencils, plastic wrap or other mark-making tools. I want the viewer to be attracted to the color but also to be pulled into the textural quality of the painting to look closer at the art.

122

▼ **WITHIN BOUNDS** | Denise Athanas
Acrylic on 300-lb. (640gsm) hot-pressed Arches, 22" × 30" (56cm × 76cm)

I never know in advance what will appear on my painting surface. It is the process of painting that makes me discover what is going on inside me. It is like an irresistible urge to try and experiment with new ideas, methods and materials that will eventually lead me to the finished work. I am always experimenting with texture and different mixtures of color. I work the surface over and over, layering and editing marks as I go. I respond to the lines, shapes and forms. I keep reworking the surface until I discover my design. Indeed my painting does represent the theme "celebrating texture" because my process of layering colors, and mark-making with color shapers, allows me to drag and swirl the paint, thus creating texture. The creation of a finished work is always a journey.

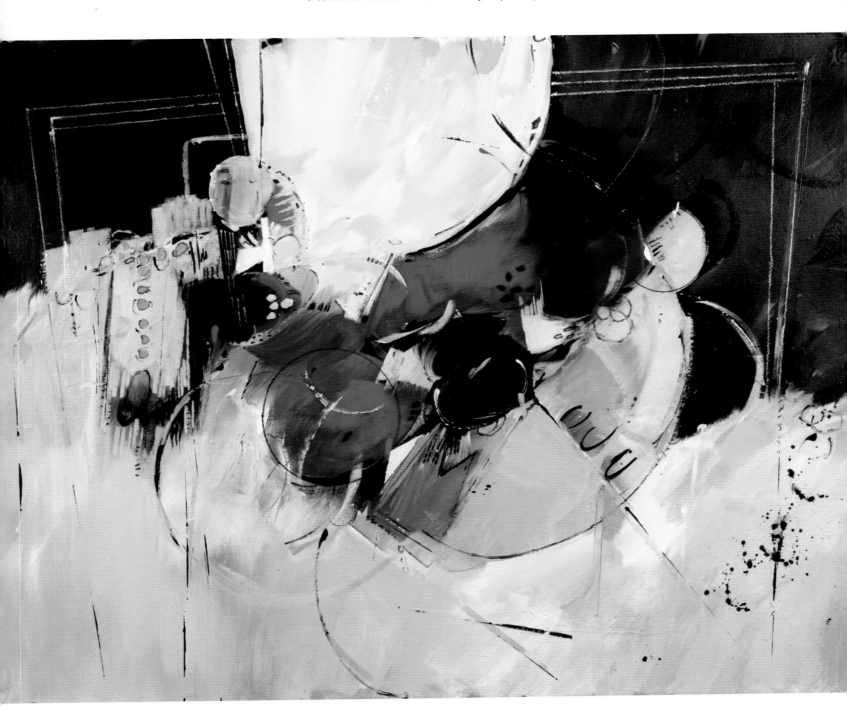

Collage, gesso and acrylic on Kraft paper, acrylic image transfers, wax crayons, acrylic glazing heat fused to canvas, 36" × 36" (91cm × 91cm)

Creating collage papers for my work becomes a very physical process, especially if I'm working larger. Answering the question, "I wonder what would happen," stencils were laid out with large sheets of paper over them. Using a bowl spreader, I dragged the gesso and acrylic over the surface, delighted and very excited to see the textures emerge.

While I was creating this collage some states were addressing the change in laws allowing same-sex marriages. At the time Spring Fashion brought us a full spectrum of crop pants. Combing this together I felt it fitting to have the women in the colors of the rainbow.

"Stay open to the daily; one never knows how it will inspire your next creation."
—LAURA LEIN-SVENCNER

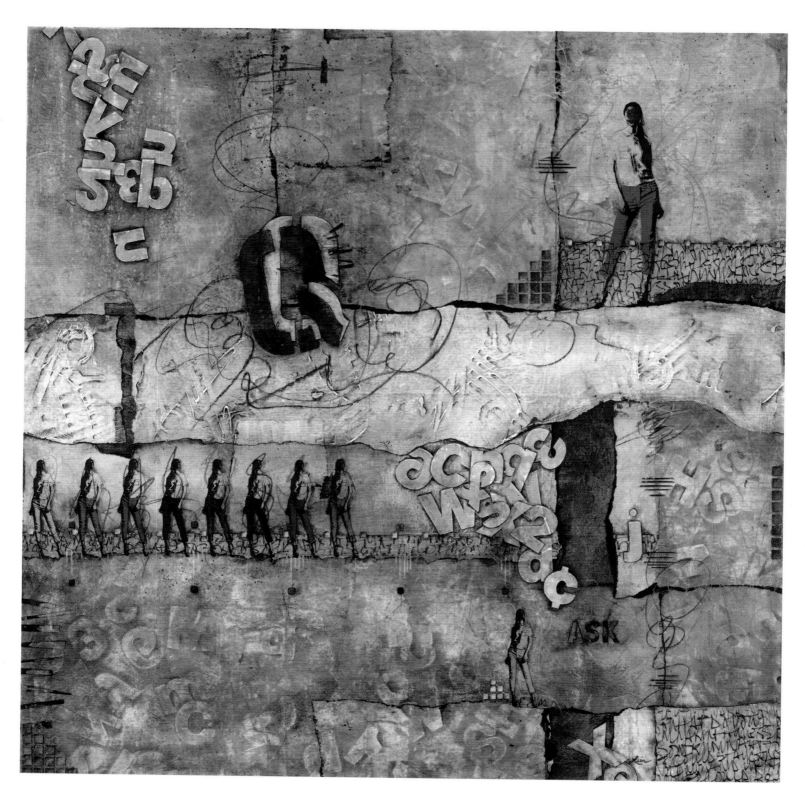

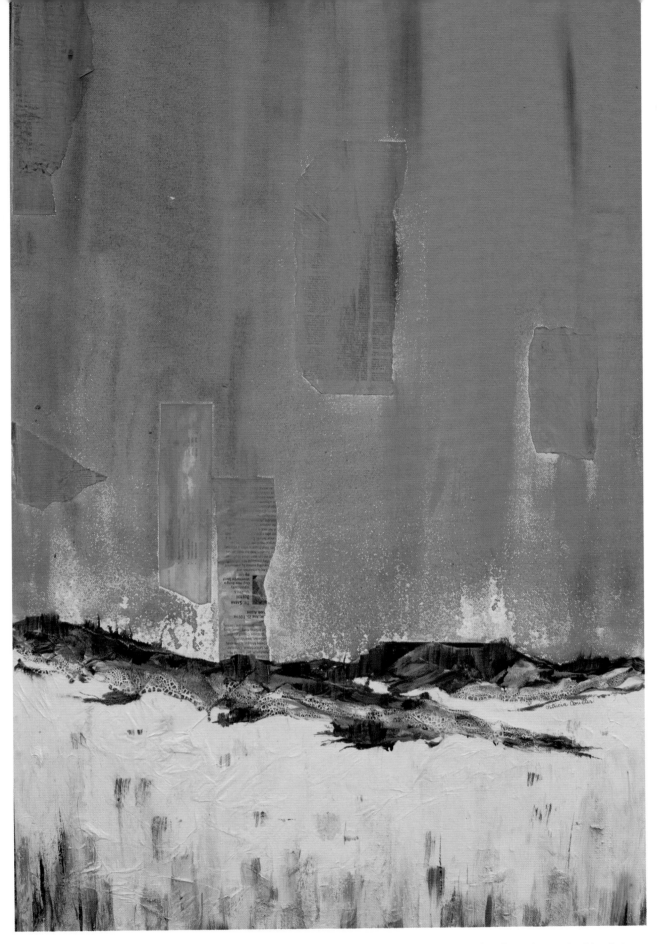

▲ **BIG SKY COUNTRY** | Patricia Coulter
Acrylic and mixed media on canvas
36" × 24" × 1" (91cm × 61cm × 3cm)

I was inspired to create *Big Sky Country* when I was to meet a friend at a restaurant one evening. When I got there, my friend had been delayed and the restaurant was closed. While I was waiting outside, I started looking up at the sky and began to marvel at the incredible imagery going on above me! I used paper from the ephemera of my daily life along with some crackle paste, inks and paints to capture the vastness of that evening sky.

▲ **APRICOT SALMON** | Theresa Girard
Acrylic with combined media on canvas, 18" × 18" (46cm × 46cm)

I set an intention to deepen my practice by painting several smaller works, adapting the same freedom I use in the larger pieces. Moving through each canvas, I energize and then simplify until I have explored and exhausted all possibilities. Working through the challenge opened the door to a warmer palette in *Apricot Salmon*. Living at the beach, my comfort zone tends toward the blue and cool tones. This particular experiment provided surprising results with the warmer tones and textures provided with soft pinks and orange-reds.

"Challenging myself to work in smaller scale has enriched my process and broadened my palette." —THERESA GIRARD

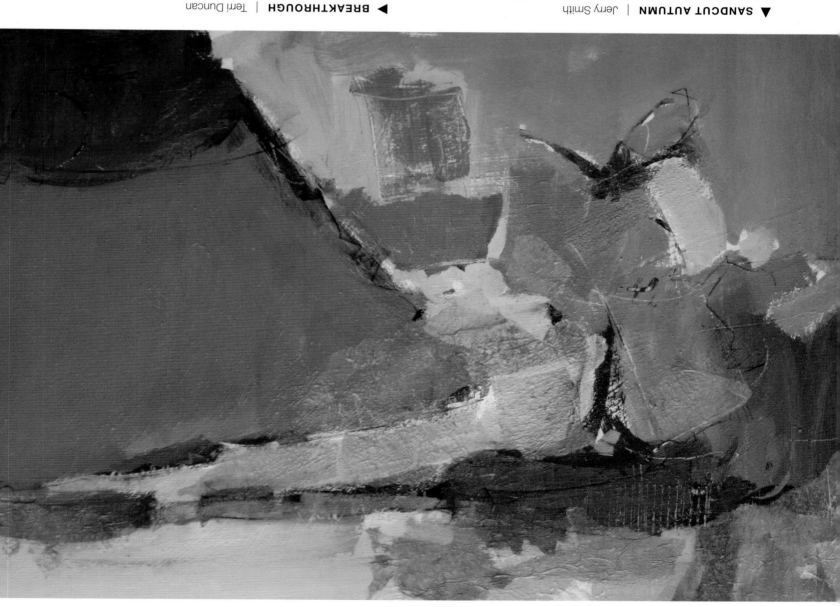

▲ **SANDCUT AUTUMN** | Jerry Smith
Acrylic on mixed-media board, 20" × 30" (51cm × 76cm)

My surface for *Sandcut Autumn* was prepared with gesso and randomly placed pumice gel for texture. I then used a combination of acrylic paint and layers of tissue stained with watercolor prior to application. The painting was started with large shapes and a landscape frame of mind. When a composition began to emerge, it was developed and completed with acrylic paint and charcoal pencil. The title is simply a tribute to my hometown, and the result is not really an attempt to visually depict the area. It was just a connection that occurred to me as I was completing the painting.

▶ **BREAKTHROUGH** | Terri Duncan
Acrylic and mixed media on gallery-wrapped stretched canvas
48" × 24" (122cm × 61cm)

Artists often resolve personal dilemmas through the creation of artwork. I had an exhibit deadline approaching while struggling with a life-changing decision. Generally these circumstances open you up to your nerves and emotions. Creating texture is always my go-to starting point, so I liberally spread modeling paste, various acrylic mediums and collaged materials on canvas. Acrylic is the perfect medium for me because I love vivid color and building multiple layers to create a tactile depth. As I continued adding texture and paint, the interesting ridges and shapes started to symbolize the layers of life—sometimes smooth, sometimes rough. Each successive layer led me closer to my "aha" moment. After collaging additional papers around the fractured opening and adding bronze and copper acrylic metal paint, my breakthrough was born.

"Found and recycled objects imprinted in acrylic mediums create some of the most unusual and interesting textures." —TERRI DUNCAN

▶ IN THE GARDEN WITH BUTTERFLES | CariAnn
Boulware-Workman, Liquitex gloss fluid medium on canvas
30" × 24" (76cm × 61cm)

I was inspired by spring colors when I created this painting, and it was truly a labor of love. As I added on thick blocks of primary colors and blended them in, it started to take on a life of its own. Thick body acrylic was used to layer flowers of different colors and design, which created a wonderful texture. During the process I began to notice the silhouette of a woman in the dark colors, and I decided to blend and layer her into the background.

This painting is a product of what my mind's eye could see on the canvas. Inspiration came from what nature gives us every spring.

▼ ROLLING MY CHILDHOOD MEMORIES | Tiffanii Chentai
Acrylic and pastel on canvas, 36" × 46½" (91cm × 118cm)

Rolling My Childhood Memories was born from the memories in my childhood. There were both sad and joyful times. My parents usually helped remind me to notice the important times. When in the classroom I wished I could fly freely like a butterfly and always expected myself to be a beautiful princess. All these factors formed the image in this painting. I love the transparent effects of acrylic colors. I enjoy the freedom to blend colors in a short time and create bright, fanciful results. I enjoy exploring the happy acidents that result from mixing acrylic with pastel, powders and gels. This painting is a celebration of texture because of the visual effects created by mixing my favorite color, Lemon Yellow, with Crimson Lake. Thus created the bright orange and sprinkle effects.

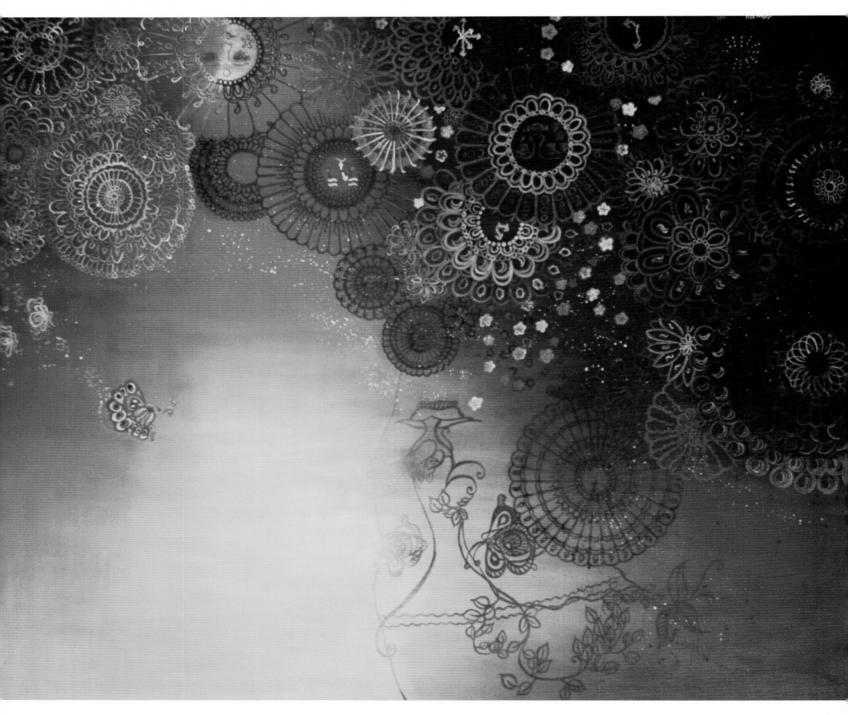

"Take breaks. If you sit back and really look at your canvas, sometimes it will show you the way to proceed."

—CARIEANN BOULWARE-WORKMAN

"Texture provides a tactile
surface that can be redefined
with each pass of the medium."

—THERESA GIRARD

Many of my paintings are driven by the weight of current circumstances, feelings or intentions. I begin by energizing the surface until all of the marks have freed me of any distractions. This can be accomplished with collage, polymers or paint. Once energized, I simplify, looking for a soft conflict in color. Often the process repeats, developing a fast "impulse, energy and observation" pace. This allows me to be a part of the painting from beginning to end and onward. As long as it feels right to me, I put it out there daring greatly.

▲ **SUN KING** | Theresa Girard
Acrylic with combined media on canvas, 36" × 36" (91 cm × 91 cm)

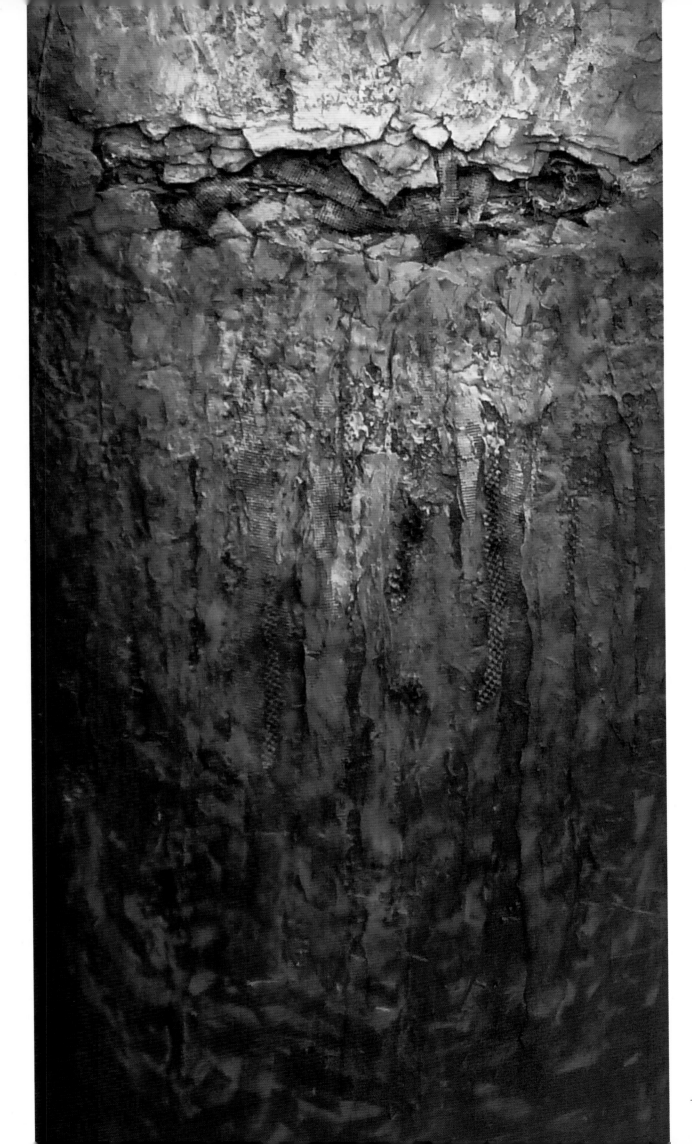

▼ PARTY FAVORS FOR HONEY BEES | J. Jordan Bruns
Acrylic, resin, spray paint and shellac on panel, 48" × 72" (122cm × 183cm) diptych

Acrylic typically is the intermediate stage in my mixed-media paintings. Typically I lay down a possible composition in watercolor (or acrylic ink), allowing the fluid medium to do its job by roaming the painting surface. Once the initial layer has dried, heavy-body or Golden OPEN acrylics are used to fine-tune the composition before acrylic resins, shellac, spray paint and other mediums are added to enhance the surface textures and colors. I do love ending the painting with oil paint in select areas but not before adding a layer of clear gesso first.

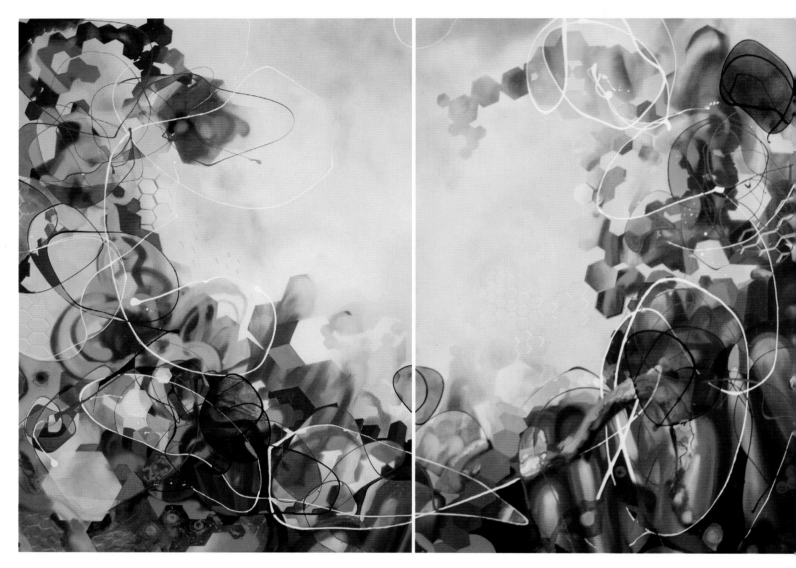

▶ LOST BEACH | Ara (Barbara) Leites
Acrylic on paper, 21½" × 14¼" (55cm × 36cm)

As a former watercolor painter, I now enjoy the versatility and transparency, the thin layering options, the textural effects and the opaque applications that acrylic paint offers. The control of emotional content is enhanced even when switching from realism to abstract/non-objective subject matter. Being able to combine these two approaches after moving from plein air to studio painting is a welcome expansion in personal vision.

Climate change is a real issue in our world. Living in California, it is ever more apparent as we enter into a fourth year of drought. We have not had the cyclical rains we expect during the winter months, which has impacted our landscape, rivers, water storage, people, lifestyles, farming, animals, sea life, shorelines and our ocean. *Lost Beach* is a real possibility going forward as less rainfall and pollution of our land and sea are taking place faster than previously recorded.

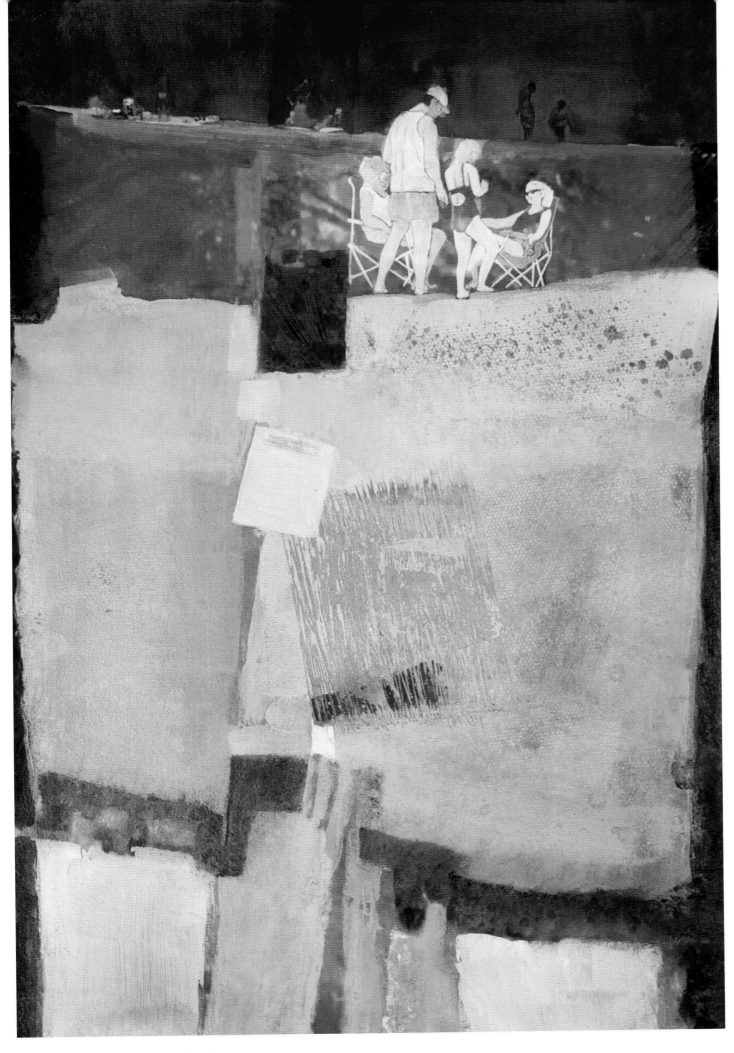

"Climate change IS a reality." —ARA (BARBARA) LEITES

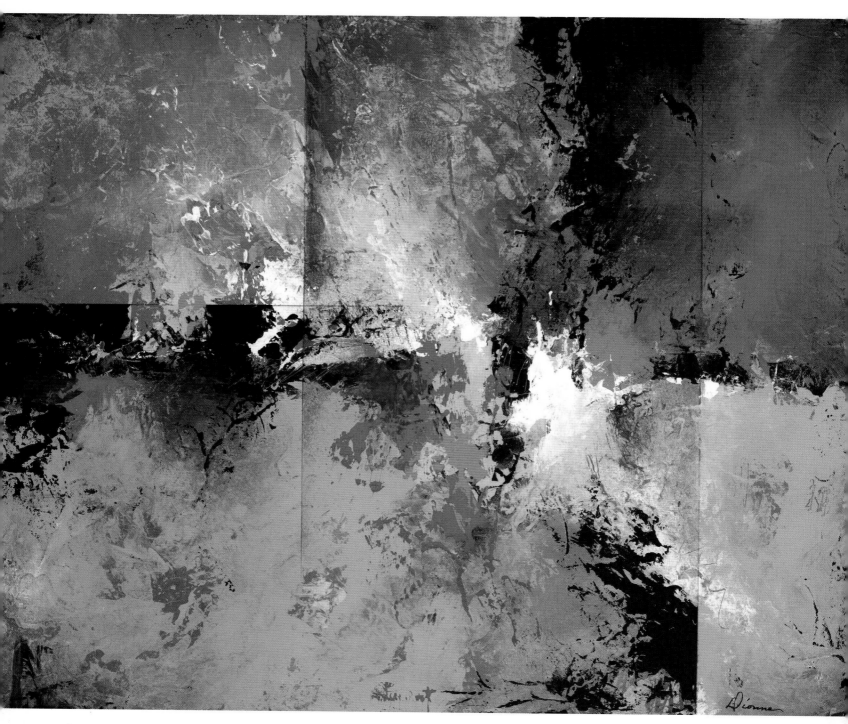

▲ **SUN GONE** | Donna Dionne
Gesso undercoat, acrylic on cradle board using a palette knife
16" × 20" (41cm × 51cm)

The majority of my paintings begin with a thick layer of gesso applied with a palette knife employing a patternless design. After allowing the gesso to dry, I start with an underpainting of one color (applied with a cloth or soft mop brush covering the entire cradle board), which will eventually peek through the painting in strategic places. After using acrylic paint on the surface, I add lines using tape and a T-square to define separate areas and ideas. I finally add the white splashes of color that capture the explosive energy of my work.

Sun Gone jumps on the theme "celebrating texture" as the basis of the entire process begins with layers of gesso in no apparent pattern. The texture become visible as the paint is applied with a palette knife creating valleys, mountains of color and small hills of distinguished hues.

▼ WILD TALES | Jane Tracy
Acrylic on canvas, 30" × 48" (76cm × 122cm)

Subject matter, realism and representation are of no interest to me when I sit at the easel. Actually, nothing seems to matter but the color. I'm seduced by color and acrylic paints allow me to paint to the max … the maximum palette available. In much of my work I include the textures of various mediums to define the quiet areas, those areas that are used to stress and amplify the strong color portions of the painting.

Of course there's often a struggle. Color is not always my friend though I ultimately end with that mysterious twinge of joyful satisfaction. I'm finished when the color allows me to express a grateful sigh and experience the ultimate joy I feel as a painter.

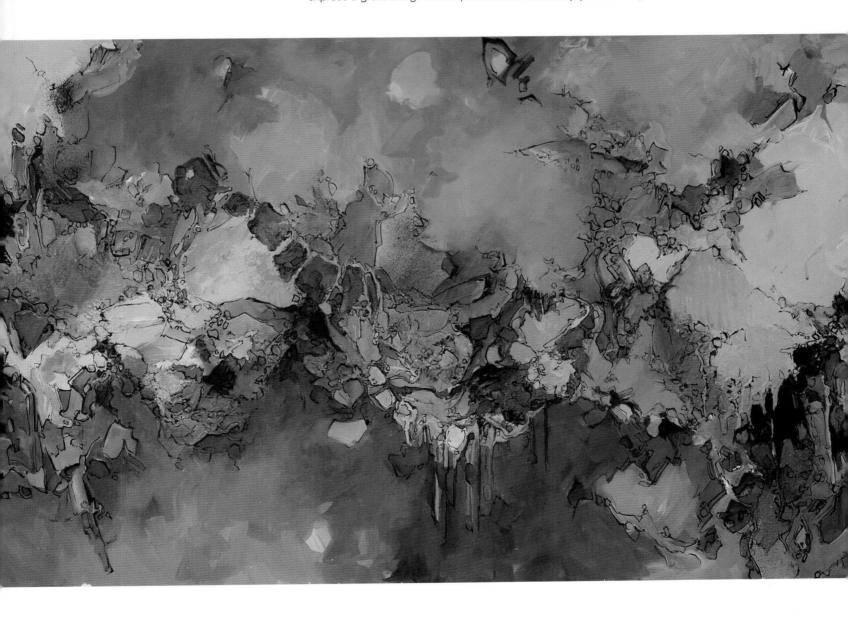

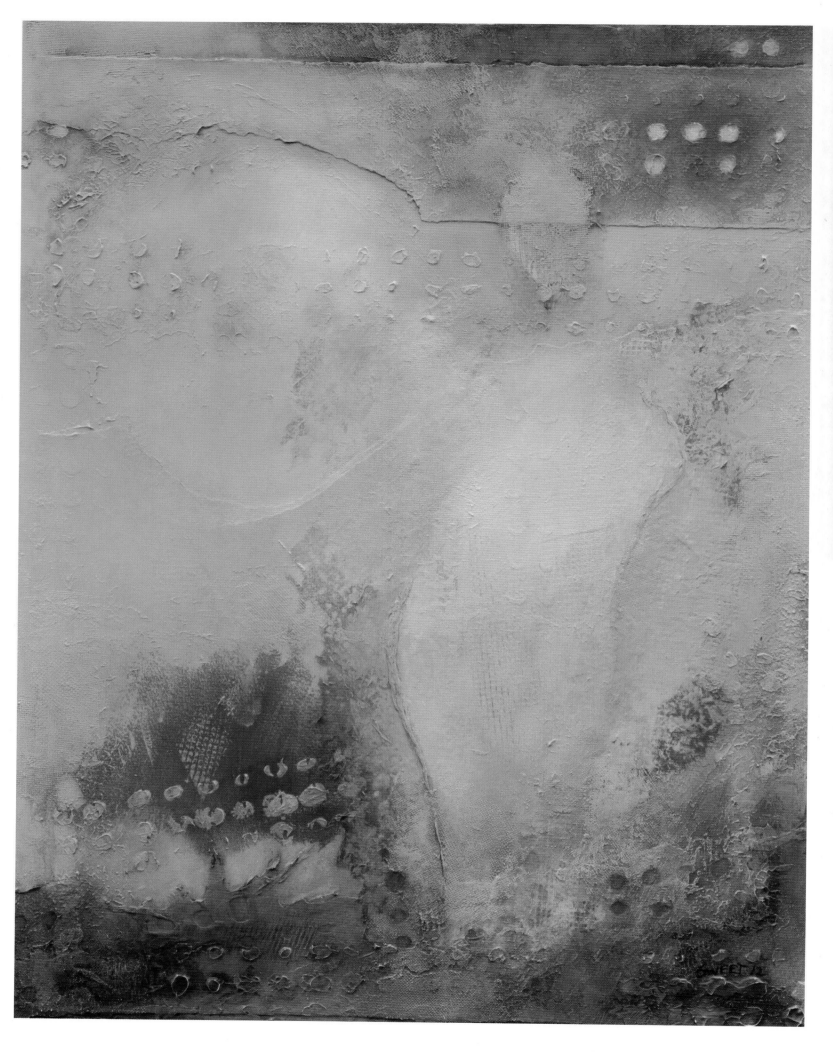

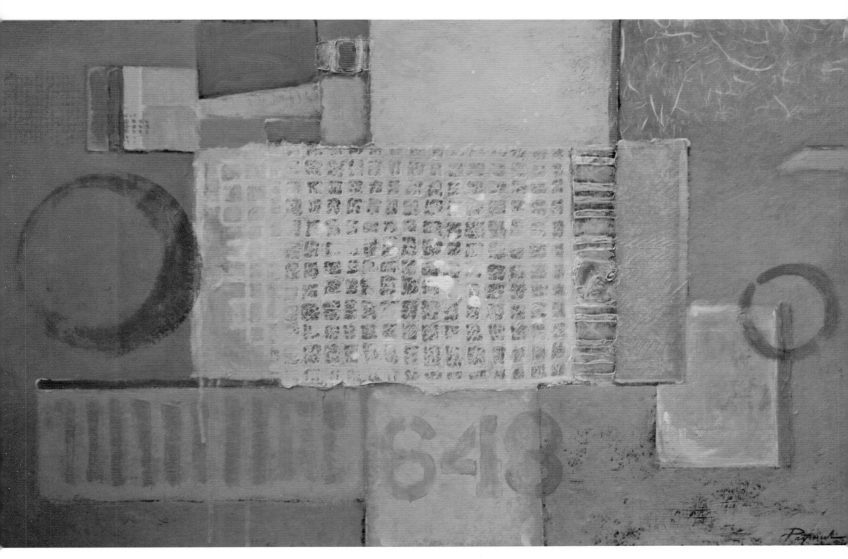

◀ **RELEASE** | Susan Sweet
Acrylic, mixed media and paper on canvas
30" × 24" (76cm × 61cm)

My background in sculpture and love of textural papers and printmaking have evolved into working with acrylics, collage and texture on canvas. Acrylics are wonderfully suited for my rapid style of collaging, texturizing and painting. The fast drying time allows me to work in a series, moving from one painting to the next in quick succession. This keeps my painting process intuitive and enlivening. Metaphor and the topography of the texture inform my choices as my paintings evolve into an abstract or figurative piece. Nature and the Bay Area Figurative Movement have always inspired me, and I enjoy creating the suggestion of a figure emerging from a layered environment. *Release* was part of a series of paintings where I began each piece with an underpainting of Burnt Sienna and Carbazole Dioxazine Violet. This color combination sinks directly into the underlying texture and always creates a rich and grounded foundation.

▲ **648TH STREET** | Pat Moseuk
Acrylic, mixed media and paper on 100% rag board
18½" × 31" (47cm × 79cm)

In my studio I created a series of paintings called *My City*. The painting *648th Street* is a reflection of what I see, feel and interpret. In this piece I started with a theme and then engaged in a dialogue working intuitively on 100-percent cotton rag board. First I work out a grid balancing shapes and form, then use all kinds of tools—for example wire, sticks, assorted palette knives, placemats or whatever I find—to make interesting textures with heavy and fluid gel mediums. In this piece I used assorted handmade papers to add even more texture! I love bold, bright colors and paint with many thin layers called glazing, until I achieve a three-dimensional quality in my work. I have been using acrylic paints for years and love the versatility you can achieve with this medium. Plus you can never make a mistake!

contributors

MARCO ANTONIO AGUILAR
Ocean Artists Society
marcozart@gmail.com
marcozart.com
p 86 *Ink Master*

DENISE ATHANAS
AWS, NWS, AAA
Mt. Pleasant, SC
deniseathanas@comcast.net
deniseathanas.com
p 123 *Within Bounds*

WM. KELLY BAILEY
WAS-H, TWS-PS, WFWS
Meadows Place, TX
w.k.bailey@sbcglobal.net
Wm. Kelly Bailey Fine Art (Facebook)
p 75 *Three Green Amigos*

JACQUI BECK
Seattle, WA
jacqui@jacquibeck.com
jacquibeck.com
p 114 *Getting Started*

RICHARD BELANGER
SCA, AWS, CSPWC
East-Bolton, QC, Canada
richardbelangersca@hotmail.com
richardbelanger.ca
p 19 *Resting*

DARIEN BOGART
Pueblo West, CO
darienb@msn.com
bogartstudio.com
p 28 *In the Flow*
p 95 *Follow Your Muses*

CARIEANN BOULWARE-WORKMAN
pipercaries.studio@gmail.com
p 128 *In the Garden with Butterflies*

J. JORDAN BRUNS
The Yellow Barn Studio and Gallery; Long
View Gallery, Washington, DC
Glen Echo, MD
jjbruns.com
p 132 *Party Favors for Honey Bees*

BRIAN BUCKRELL
Courtenay, BC, Canada
bbuckrell@shaw.ca
brianbuckrell.com
p 12 *Behind Canmore*
p 13 *Whistler Slope*

DAVID CAESAR
info@davidcaesar.com
davidcaesar.com
p 34–35 *Arrow*

BRUNO CAPOLONGO
OSA, OCAD, MFA-V
Grimsby, ON, Canada
bc@brunocapolongo.com
brunocapolongo.com
p 68 *Royal Blue (Japanese Arita)*

LARRY CARVER
MOWS
Jefferson City, MO
larry.carver@modot.mo.gov
p 108 *Blue Voices and Winter Lore*

TIFFANII CHENTAI
tiffanyhm9412@gmail.com
p 129 *Rolling My Childhood Memories*

VICTORIA CHIOFALO
SWA, CWA
victoria@victoriaart.com
victoriaart.com
p 81 *ARIA*

PAUL MORGAN CLARKE
Fulwell, Sunderland, Tyne and Wear, Great Britain
paulmorganclarke@hotmail.com
paulmorganclarke.com
p 23 *Tracks*

JOAN COFFEY
CAC
joan@coffeycreations.com
coffeycreations.com
p 89 *City Kitty Enjoys Her View*

CRAIG COSSEY
Eaton Rapids, MI
craigcossey1@gmail.com
craigcossey.com
p 51 *The Blue Years*
p 80 *Father and Son*

PATRICIA COULTER
Visual Arts Alberta
Cold Lake, AB, Canada
780.813.4660
pcoulter08@gmail.com
patriciacoulter.com
p 125 *Big Sky Country*

RON CRAIG
roncraig@roncraigart.com
roncraigart.com
p 31 *Train Depot*

MARTIM CYMBRON
Ponta Delgada, Azores, Portugal
martimcymbron@sapo.pt
martimcymbron.com
Martim Cymbron (Facebook)
p 14 *Amor Perfeito*

LISA L. CYR
Society of Illustrators, NYC, Artist Member
lisa@cyrstudio.com
cyrstudio.com
lisalcyr.blogspot.com
figureoftheimagination.blogspot.com
p 47 *Mademoiselle du Carnaval*

ANITA DEWITT
Portrait Society of America
Cañon City, CO
nitadee20@hotmail.com
anitadewitt.com
p 61 *Engaging Her Intellect*

DONNA DIONNE
NMWS, RGAA, SLMM
Albuquerque, NM
djdionne41@gmail.com
dionneart.com
p 134 *Sun Gone*

CHRISSEY DITTUS
NCA
Lake George, NY
chrisseydittus@gmail.com
chrissey-dittus.fineartamerica.com
Dittus Designs Art (Facebook)
p 17 *Slate Truck*

SANELA DIZDAR
Kitchener, ON, Canada
sanela.art@gmail.com
p 11 *Icebound*

VICKIE DORSAM
PWCS
West Chester, PA
vickie.d.artist@gmail.com
p 45 *Rhys*

CHRISTOPHE DROCHON
France
christophe@drochon.com
drochon.com
p 84–85 *Need for Rest (Siberian Tiger)*

TERRI DUNCAN
Lafayette, IN
terri@terriduncanart.com
terriduncanart.com
p 131 *Breakthrough*

index

Other fine North Light Books are available from your favorite
bookstore, art supply store or online supplier. Visit our website at
fwcommunity.com.

a content + ecommerce company

20 19 18 17 16 5 4 3 2 1

Distributed in Canada by Fraser Direct
100 Armstrong Avenue
Georgetown, ON, Canada L7G 5S4
Tel: (905) 877-4411

Distributed in the U.K. and Europe
by F&W Media International, LTD
Brunel House, Forde Close, Newton Abbot, TQ12 4PU, UK
Tel: (+44) 1626 323200, Fax: (+44) 1626 323319
Email: enquiries@fwmedia.com

DISTRIBUTED IN AUSTRALIA BY CAPRICORN LINK
P.O. Box 704, S. Windsor NSW, 2756 Australia
Tel: (02) 4560-1600; Fax: (02) 4577 5288
Email: books@capricornlink.com.au

ISBN 13: 978-1-4403-4127-4

Production edited by Sarah Laichas
Designed by Clare Finney
Production coordinated by Jennifer Bass

FRONT COVER IMAGE: *Shoreline Study 00514 (Sandy
Beach, New Brunswick, Canada)*, Carole Malcolm, p20

BACK COVER IMAGE: *1999 Broadway, Denver,*
Robert Gratiot, p8

about the editor

Jamie Markle is the Vice President and Group Publisher for
the Fine Art Community at F+W. He works closely with the
editorial teams to provide art instruction from the world's
best artists in all formats: magazines, books, videos, digital
downloads and online content. In addition to his 25 years in
product and media development, Jamie holds a degree in
Fine Art with a concentration in Painting and Drawing from
Xavier University.

Metric Conversion Chart

To convert	to	multiply by
Inches	Centimeters	2.54
Centimeters	Inches	0.4
Feet	Centimeters	30.5
Centimeters	Feet	0.03
Yards	Meters	0.9
Meters	Yards	1.1

Ideas. Instruction. Inspiration.

Receive FREE downloadable bonus materials when you sign up for our
free newsletter at artistsnetwork.com/newsletter_thanks.

Find the latest issues of *Acrylic Artist* magazine on newsstands, or visit artistsnetwork.com.

These and other fine North Light products are available at your favorite art & craft retailer, bookstore
or online supplier. Visit our websites at artistsnetwork.com and artistsnetwork.tv.

Follow Artist's Network for the latest news, free wallpapers, free demos and
chances to win FREE BOOKS!

Get your art in print!

Visit artistsnetwork.com/competitions for
up-to-date information on AcrylicWorks
and other North Light competitions.